W9-BJE-662

Blue and Yellow
Don't Make Green

by Michael Wilcox

The Michael Wilcox
School
of Colour
Publishing

Artist Quality products created by Artists

SCHOOL OF COLOUR PUBLICATIONS
www.schoolofcolour.com

Acknowledgements

The ideas behind the first edition of this book had been with me for some time, but it took a team of very special people to turn them into printed pages.

I would particularly like to express my gratitude to Peter Riordan for his invaluable expertise, energy and patience. The production team, Philippa Nikulinsky, Karen Grove, Danka Pradzynski and Lynn Callister deserve special mention, their professionalism and hard work made the project possible. Thanks also to Bill and Rosemary Cranny for their constant help and encouragement. I also wish to thank Paul Green-Armytage and Ron Price for their kind help and advice.

This revised edition was only made possible by the hard work, patience and dedication of the Editor, Maureen Bushby.

Original edition

Editor:
Peter Riordan

Designer:
Danka Pradzynski

Illustrators:
Philippa Nikulinsky
Michael Wilcox

Finished Artist:
Karen Grove

Assistant Artist:
Anthea Ratcliff

Typesetting:
Key West Photosetting
Western Australia

Colour separations:
C.H.Colour Scan Sdn. Bhd.
Kuala Lumpur, Malaysia

Printing:
KHL
Singapore

First published in 1987
Reprinted 1988, 1989,
1990,1991, 1992, 1993, 1995, 1998, 1999
Revised edition 2001, Reprinted 2002, 2003,
2004, 2005, 2006, 2007, 2008, 2009

Revised edition:

Editor:
Maureen Bushby

Scanning and colour balance:
Leon Wilcox and Rheza Pardede

Technical assistance:
Jo Holness, Denver Wilcox
and Karen Duggleby

Printing:
Imago Productions F.E. Singapore

Print coordiation:
Siva Balan
Theresa Ng

Text, illustrations, arrangement and
Colour Bias Wheel Copyright ©
Michael Wilcox

Published by School of Colour Publishing
ISBN 0-9679628-7-0

Distributed to the trade and art markets in the USA and Canada by:
F&W Publications, Inc. 4700 East Galbraith Road, Cincinnati, OH 45236 USA

Distributed to the trade and art markets in the UK and Europe by: The Roundhouse Group, Maritime House, Basin Road North, Hove, East Sussex, BN41 1WR United Kingdom.

Distributed to the trade and art markets in Australia by: Keith Ainsworth Pty. Ltd Units 9 & 10, 11 Robertson Place, Penrith, NSW 2750 Australia

All rights reserved worldwide. No part of this material may be reproduced for any purpose without the prior written permission of the Michael Wilcox School of Colour Publishing Ltd. No part of the material may be reproduced or transmitted in any form or by any means by print, photoprint, photocopier, microfilm or in any other way, either known or as yet unknown, or stored in a retrieval system without the previous written permission of the School of Colour Publishing.

Website www. schoolofcolour. com

Colour has long aroused strong emotions. It has a powerful and direct impact on the brain giving rise to responses varying from aggression to tranquillity.

There is every reason for anyone using colour to understand and take control of this very forceful means of communication.

Artists, designers, printers, craft workers and other users of colour would invariably agree that the selection and use of colour is of paramount importance in their work.

And yet, despite growing interest in colour's potential, a great deal of misunderstanding surrounds colour mixing.

As children we are told that there are three colours - the primaries - which can be mixed to make all other colours. The teacher provides a red, yellow and blue and we quickly find that we can mix them and obtain further colours. (We also find that it is very easy to mix a colour usually described as 'mud').

Those of us who become further involved find this approach too limiting, we desire a wider range of colours to cater for our more sophisticated requirements.

Yet it seems that however many colours we purchase and whatever we read on the subject, at the end of the day it still remains very much a hit and miss affair.

The need to be able to mix any desired result quickly, accurately and without waste is readily apparent but unfortunately very few are able to do this. Even after many years of experience most people find difficulty in mixing colours.

Are there reasons for these difficulties? Can they be overcome?

I believe that the three primary system on which we rely so heavily has in fact created many of the stumbling blocks to mastering colour mixing. It is a very rough, crude guide which offers help with one hand and takes it away with the other.

The problems associated with colour mixing can be overcome but first we need to discard the notion of primary colours and replace it with a more up-to-date conceptual framework.

Michael Wilcox

The School of Colour

Reaction to the first editions of this book led to further research and consultation with artists, designers, printers, craft workers and educationalists. The result has been the formation of a School of Colour.

The School is concerned, first and foremost, with the supply of accurate and useful information aimed at removing the many barriers to creativity

Few people are able to realise their full creative potential due to the incredible confusion which surrounds most aspects of colour use.

This confusion has been compounded throughout this century and we now find ourselves with less understanding of this vital area than the Impressionists of the 1800s.

The intention of the School is to remedy this situation and remove the barriers. Coming to a full understanding of the potential of colour should be both enjoyable and straightforward.

Further information on the School of Colour is given at the end of this book.

Contents

Contents

If we are ever to gain control over colour
mixing, the three primary system
will have to be abandoned and replaced with
an entirely new way of thinking.

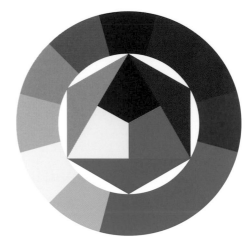

In the late 1700's it seemed to many that the search for an answer to accurate colour mixing had at last been found - the 'Three Primary System' had been invented.

At that time most artists and craft-workers relied on long experience and a limited palette in order to gain some control over colour mixing. The new invention promised to make life a lot easier.

As it is still in universal use and heavily relied on, we should examine it before deciding whether it has lived up to its earlier promise or not.

Have you ever wondered why it is so difficult to mix the exact colours you need? And why it is so easy to mix dull, greyed colours, commonly known as 'mud?

There is an obvious need for the artist, designer, print-maker and craft-worker to be able to mix any desired colour quickly, accurately and without waste.

Unfortunately few are able to do just this. Even after many years of experience most people have difficulty in mixing colours.

What are the reasons for these difficulties? Can they be overcome?

To start with, we should examine current practices and teaching methods.

Take your mind back to the way that colour mixing was originally taught to you, whether at school or later at art class.

A colour mixing wheel was developed at the same time as the 'Three Primary System'.

The universal explanation that has followed is that there are three main colours: red, yellow and blue (the primaries) which, when mixed, produce a further three colours: green, orange and violet (the secondaries).

The primary colours, together with the secondaries, are found on all basic colour mixing wheels. Although a wide range of such wheels have been published, they all give the same basic information as the wheel shown here.

The three *Primaries*, red, yellow and blue will, we are told give the *Secondary* colours, orange, violet and green. In turn these will give the *Tertiaries*, such colours as yellow orange and red-orange.

Do you agree that the standard colour mixing wheel suggests that red, yellow and blue are the base colours from which all others are mixed and that blue and red, for example actually combine to form a new colour, violet?

The heavy reliance on this system cannot be claimed, however, to have led to generations of skilled colour mixers. On the contrary, it has led to muddled, confused frustration.

It seems that colour mixing is simply difficult to master. That there is no alternative but to improve gradually through practice. Until now this has certainly been the case. We have been locked into the belief that the primaries produced other colours because the evidence was before our eyes.

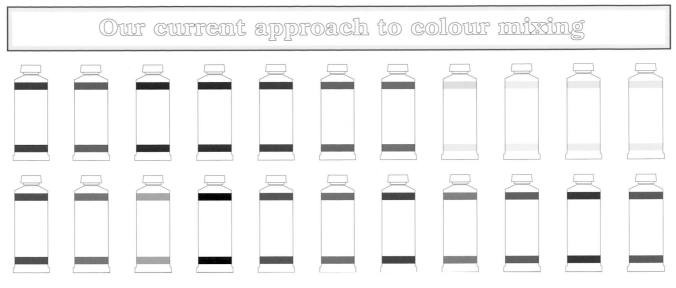

In order to obtain a wider range of colours we purchase a variety of reds, yellows and blues, together with several greens, oranges, violets, browns and greys. Painting starts to become expensive and confusing.

But what if we have been wrong all this time? What if our basic understanding of colour mixing has been faulty?

After an initial introduction to the three primary system, those of us who become involved in colour use find the approach too limiting.

In order to obtain a wider range of colours to cater for more sophisticated needs, we purchase a variety of reds, yellows and blues, together with several greens, oranges, violets, browns and greys.

When working, a common approach is to squeeze small amounts of each of the colours onto the palette. Ten, fifteen, twenty or more colours are commonly put out at the commencement of work.

Many of the paints are used as they come from the tube, with little or no modification.

There soon comes a time, however, when a particular colour is required that is not available ready mixed.

Obtaining a specific colour through mixing can be particularly difficult.

Whatever colours are blended the desired hue tends to elude us. Frustration is often the only result.

If this is all too familiar to you, take heart, because many artists and craft workers will sympathise with your predicament.

They also compromise by using mixed colours that are less than satisfactory.

This severely limits expressive potential, exhausts patience and diminishes the level of satisfaction gained from the work.

Colour mixing, it would seem, must simply be 'picked up' through experience.

For all the advice around, the majority of painters, faced with disorder on the palette, blunder along hoping to improve gradually.

The three primary system, on which we rely so heavily, has in fact created many of the stumbling blocks to mastering colour mixing.

Although the three primary system does seem to have an irresistible logic, it is a very rough, crude guide which offers help with one hand and takes it away with the other.

Confusion is caused by the range of secondary colours available from the primaries.

Such a wide selection of greens, oranges and violets are produced, that forecasting the final result is no easy matter.

They are all useful colours but how can we be sure of mixing them to order?

So we experiment with various 'sets' of primaries.

The pairings from Alizarin Crimson, Ultramarine Blue and Cadmium Yellow, for example, will make clear violets but very dull oranges and greens.

Cerulean Blue, Lemon Yellow and Cadmium Red pairings give bright greens, but the oranges are still dull and the violets more like grey browns.

7

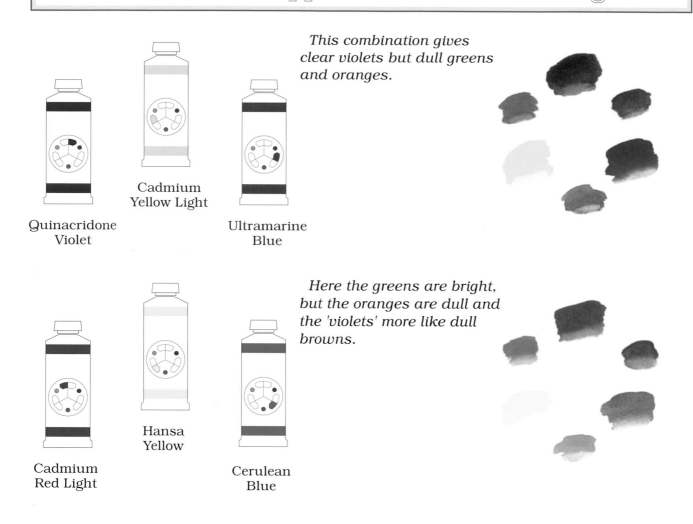

This combination gives clear violets but dull greens and oranges.

Quinacridone Violet

Cadmium Yellow Light

Ultramarine Blue

Here the greens are bright, but the oranges are dull and the 'violets' more like dull browns.

Cadmium Red Light

Hansa Yellow

Cerulean Blue

It is impossible to find three 'primary' colours which will give a full and satisfactory series of clear, bright secondary colours. So what alternatives are there?

It is possible to use several versions of each 'primary' colour. We are told that this is necessary because there are no paints as yet that are pure in colour.

Manufacturers announce that they now have the answer and offer the 'Three *Pure* Primary Colours', suggesting that they will give a full range of mixes.

If they ever do produce 'pure' colours they will be useless as far as colour mixing is concerned as they will only ever produce blacks or greys.

Many art instruction books contain colour samples together with information of the various reds, yellows and blues that were mixed to achieve them.

Typical advice runs along the lines: mix red 'A'

with yellow 'B' and store the result, orange 'C', in your memory for future use.

There are usually dozens of such examples. The colours from one particular make or another are invariably recommended.

The reader is expected to absorb the information, remember the mixed colour and have total recall when working.

This approach cannot work because we are all equipped with a very poor colour memory. We quickly forget all but the most general features of a colour as soon as we look away from it.

Our colour memory certainly helps to achieve very basic results but is quickly overwhelmed when a fuller repertoire is required.

This is why it is difficult to remember successful colours that we previously mixed ourselves. It is even harder to mix colours once seen in a book.

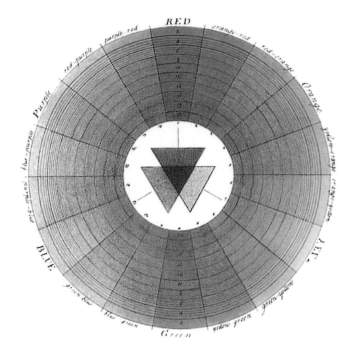

In 1776 Mosses Harris published the first organised colour wheel in an attempt to replace the then current understanding of colour, which he described as being 'so dark and occult'.

Throughout this book we will be examining and reinterpreting colour mixing so as to turn it from a hit or miss affair into a thinking process.

Traditional thinking will be turned upside down and there will be quite a few surprises in store.

Among other things, you will discover that yellow and blue do not make green, that the artist's primary colours, pure red, yellow and blue, do not exist and that virtually everything that has ever been written about colour mixing has been inaccurate.

As the subject is of such importance to the colourist, we will proceed step by step, examining each topic in detail.

By the end of the book you should be able to mix any colour that you require, in any medium, quickly, accurately and without waste. Your work can only improve.

I realise that most creative people will resist coming to terms with the theoretical side of colour mixing.

To this I would have to say that we have not gained control through earlier methods.

The colour user with a determination to master mixing will always make the effort.

Thanks to our present wasteful colour mixing practices, the only people to benefit are the paint manufacturers.

Even when things do go well and the required hue is mixed, the colours and quantities are usually impossible to recall another time.

9

Before attempting to control colour mixing, the artist should understand the nature of colour.

The visible light that reaches the earth is made up of wavelengths that, although similar in character, vibrate at slightly different speeds or frequencies.

Varying light wavelengths represent different colours and together they reach us in the form of white light.

This white light is the natural light we call daylight.

Since the various colour wavelengths that constitute daylight are travelling in a combined form, they must be broken down, or decoded, if they are not to remain simply as white light.

One way of separating the individual colours is to pass them through a prism.

You might remember from your school days, that when the colours that make up white light are split by the prism, they become visible.

Surface colour

The colours contained in natural or artificial light can also be made visible if the light strikes a surface.

But why do surfaces reveal different colours when they are struck by the same white light?

The answer is due to the nature of matter and the fact that light is a form of energy.

Every object is made up of atoms which are seething with invisible energy.

The energy contained in white light is often compatible with the energy within a surface and when that happens, they merge.

The energy within the surface absorbs the energy within the light.

Exactly what happens when light strikes a surface depends on the molecular make-up of that surface.

Some surfaces efficiently absorb all the different 'colour waves', reflecting very little back. Such surfaces appear black.

The energy contained in the light which a black surface absorbs is turned into heat.

A black surface will absorb the energy of the light.

A white surface, on the other hand, has a molecular make-up that rejects or reflects almost all 'colour waves' equally.

The 'colour waves' therefore remain as white light.

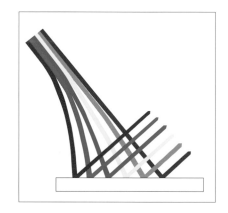

A white surface will reflect almost all of the energy in the light. It looks white because it is reflecting the combined 'colour waves' of white light.

A yellow surface absorbs nearly all 'colour waves' except the yellow which is rejected and reflected back from the surface to our eyes.

As we can now only see the reflected portion of the light, the object appears to be yellow.

The other 'colour waves' have been absorbed and turned into heat.

Since all the 'colour waves' contained in the white light arrived at the surface at the same time, the 'yellow waves' are reflected over the entire surface area.

A yellow surface appears that colour only because it is able to absorb most of the 'colour waves' apart from the yellow ones, which it reflects back to the eye.

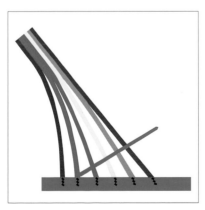

If a surface appears blue, it follows that the other 'colour waves' have been absorbed and the 'blue waves' reflected back to the eye.

When we describe an apple as being red, what we are really describing is that part of the light left after the rest has been subtracted.

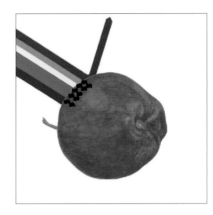

The molecular make-up of its surface is such that it absorbs every light ray exept the red.

The apple itself does not somehow possess the red. The colour is generated only by the light falling on it.

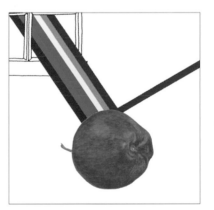

The redness of the apple is carried through the window in the light, is reflected from the skin of the apple (after losing its travelling companions, the other colours of the spectrum), it then travels to the eye, and passes on to the brain where it is turned into a sensation of redness.

Colour only ever exists in our brain, we are, fortunately, able to convert certain types of energy into a sensation of colour.

Artists, by their very nature, often avoid most things to do with science.

But, without a doubt, we rely on the way that light behaves to give us our final colours.

The effort required to understand light and colour will be repaid many times.

In order to understand colour mixing and how best it can be employed by the colourist, we need to study the processes actually taking place within the paint film.

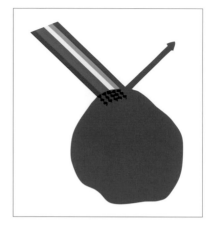

In the same way that the apple reflected red light, so to, will a speck of pigment.

Pigments, the colouring matter of paints, are tiny particles which reflect certain colours very efficiently.

A cross section of a layer of red oil paint would show that each tiny speck of pigment is surrounded by a binding substance, the vehicle which holds the pigment particles together to form a paint. Gum is the binder in watercolours, linseed in oil paint, and so on.>

Let us now isolate just one of the pigment particles and consider what takes place when light arrives at its surface. The red light reflected from just one tiny particle would be difficult to see.

But combine thousands of such particles and the collective red light becomes easily discernible.

Yellow particles in a layer of yellow paint would each be reflecting a tiny amount of yellow light.

Each tiny speck of pigment in a film of blue paint would reflect a tiny amount of that colour.

If the paint appeared green it would be due to the collective green light being reflected from the pigment particles.

Practical work
Materials required
The following paints - Cadmium Red Light, Cerulean Blue, Cadmium Yellow Light.
Clean dilutant and a clean brush.

CADMIUM RED LIGHT

Ever since colour mixing began we have been trying to remember the result of mixing several colours together. This approach has not taken us very far.

If we take an imaginary journey inside the paint film, we will discover what actually *happens* when colours are combined.

This will lead to total control in this otherwise difficult but vital area.

It is very important that you have a clear idea of what colour actually is and how a paint film takes on a particular colour, before proceeding.

Exercise
It is not essential to carry out the exercise shown on this and the following page, but it will be useful to do so. The exercise shown above can be painted out onto a piece of paper or oil painting board, depending on your chosen media.

Apply an area of Cadmium Red Light, as above. Do not put the paint on thickly, a medium weight layer will be fine.

As you apply the paint, think of it as a layer of coloured powder held together by a clear 'glue'. Gum Arabic in the case of watercolours, a drying oil with oil paints, acrylic polymer emulsion for acrylics etc.

The moist 'glue', or binder, as it is correctly known, is workable as it comes from the tube or jar.

As the binder comes into contact with the air, it will start to harden. The final paint layer consists of the hardened binder in which thousands of tiny pigment particles are trapped.

Take the exercise sheet to the window (during the day) and try to form a mental picture of what is taking place within the thin layer of paint. When it is quite clear to you what is causing the paint to appear red, it would be a useful exercise to describe the situation, in your own words, on a note sheet.

Describe the whole process, from the moment that the light leaves the sun, to the sensation of redness that has been formed within your brain.

CADMIUM YELLOW

CERULEAN BLUE

Apply a thin wash of Cadmium Yellow onto your paper or oil painting board.

Place the exercise sheet under artificial light, (such as a table lamp) and describe, on your notes page, the processes involved from the light leaving the lamp to the sensation of yellowness that occurs in your brain.

Next paint out a layer of Cerulean Blue into the right hand box.

If possible, place the exercise sheet under a red coloured light, (a red lamp perhaps or the tail light of a vehicle).

Describe the colour that you now have in the box and the reasons for that colour. Does it still look blue or is it closer to black?

If you do not have access to a coloured light, work out the probable colour the blue would appear under a red light and the reasons for that colour.

Now that the basic mechanics of the paint film have been examined, we can consider the sequence of events within the paint layer when we physically mix colours.

We will learn a great deal by mixing the three traditional painter's primaries and investigating the reasons for the resulting dark grey, (almost black) colour.

The mix of red, yellow and blue particles would look very similar to the above. Now we will find out what happens to the light when it arrives at the surface of the paint and sinks into the transparent binder (gum, oil etc.).

Light which strikes the yellow pigment in the mix is absorbed, apart from the yellow, which is reflected.

Light arriving at the blue pigment is destroyed in the same way, with the exception of its blue component.

Every colour contained in the light, with the exception of red, is absorbed by the red pigment.

We have just seen that the red, yellow and blue pigments convert the light into red, yellow and blue light respectively.

But where do these coloured lights go from here? Deep within the paint film their options are limited.

If the yellow light reflected by the yellow pigment happens to meet up with another yellow particle, it is reflected again and is therefore temporarily safe.

If, however, it strikes a blue or red speck of pigment, it is absorbed.*

Suddenly, there is no more yellow light.

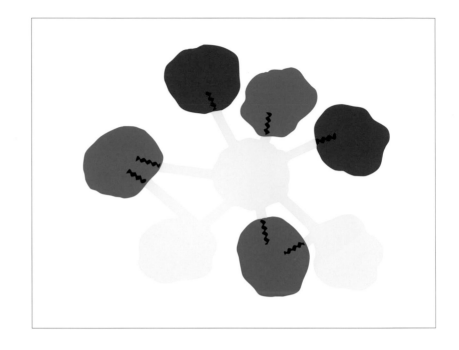

* Blue pigment, of course, only looks blue because it reflects blue and *absorbs* such colours as yellow. Likewise the red pigment appears red because it will *absorb* colours such as yellow and only reflects the red.

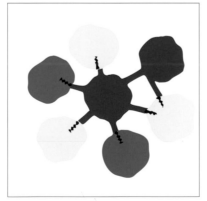

In the case of the blue light reflected by the blue pigment, it too can bounce off other blue particles, but is absorbed by either red or the yellow.
No more blue.

Similarly the red light will soon become absorbed by the blue and the yellow.
Goodbye red light!

All the white light which initially sank into the paint was absorbed, except the blue, yellow and red.

When they in turn are absorbed, what is left? The simple answer is - nothing

The conclusion, therefore, is that if the three traditional painter's primaries are mixed in equal intensities, the light energy reaching the surface is absorbed.
The result is a very dark grey, approaching black.

16

Materials required
Cadmium Red Light, Quinacridone Violet, Ultramarine Blue, Cerulean Blue,
Hansa Yellow, Cadmium Yellow Light and White. Clean dilutant and a clean brush.

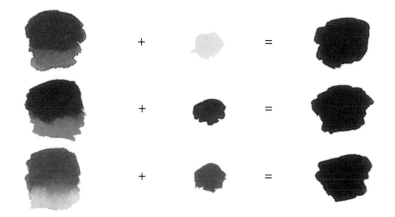

*If at first the result is a very dark violet, add yellow; if it
leans towards orange, add blue; and if greenish, add red.*

It will be a useful exercise to mix the three 'primaries' together and observe the results.

a) Mix Quinacridone Violet, (you could use the unreliable Alizarin Crimson if you do not have Quinacridone Violet), Ultramarine Blue and Cadmium Yellow Light. Proportions are not important. Add one colour or the other until you have a very dark colour, approaching black.

Do not be concerned if you cannot obtain a dark straight away, since paints can vary enormously in intensity of colour.

Thin a portion of the mix near its edge to see if one or even two of the 'primaries' are dominating.
If they are, add small amounts of the colour or colours being swamped until you have a dark, blackish grey.
If at first the result is a very dark violet, add yellow; if it leans towards orange, add blue; and if greenish, add red. As in the above illustration.

By mixing the three 'primaries' in near equal intensities, so much incoming light is destroyed that very little escapes from the paint surface.

Once you have a particularly dark colour, approaching black, apply it into your paper or board. As a finishing touch, paint out small areas of the contributing colours in the top three boxes.

17

Mix Cadmium Red Light, Cerulean Blue and Hansa
Yellow until you once again have a very dark colour.

Now combine any red, yellow and blue to give a dark colour. Each of the 'blacks' that you have mixed will be slightly different due to the nature of the various pigments involved.

The main point of the exercise is to mix three bright, 'clean' colours and observe the light disappearing as they 'attack' each other.

Add white to any of the 'blacks' that you have mixed and paint out on your paper or board. You should have a dull, flat grey. This of course was produced from three bright colours, the so called 'primaries'.

It will be a useful exercise to, in your own words, describe the sequence of events that took place when the three colours were mixed in the exercises. When we come to study the result of mixing *two* of the 'primaries', you will see why it is vital to know what happens when *three* are mixed.

18

To recap; when red, yellow and blue paints are mixed in nearly equal intensities, they make a very dark grey, almost black.

This can easily be demonstrated and the reasons for the destruction of the light explained.

If just two pure 'primary' colours were to be mixed, the result would be most unexpected.

Take the example of a pure yellow and a pure blue.

We will follow the same line of reasoning, exactly, that we employed to explain the loss of light when three 'primaries' were mixed.

It is important to realise that we are using the same approach.

The yellow pigment absorbs all light except the yellow.

The blue pigment likewise absorbs all but the blue portion of the light.

The next event in the sequence is that the yellow pigment absorbs all the blue light and vice-versa.

The result is a dark grey, almost black. But how can this be? Everyone knows that blue and yellow make green.

But blue and yellow do not make green:
Blue and yellow (as such), make black.

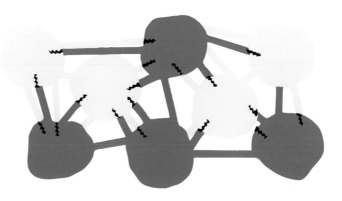

19

Again we will follow the same reasoning that gave us black from three 'primaries'.

This time another pair of 'primaries' will be mixed, pure red and pure yellow.

Traditional colour mixing theory tells us that red and yellow will combine into a new colour - orange.

The yellow pigment in the mix will absorb the red, orange, green, blue and violet part of the light and reflect only the yellow.

Similarly the red pigment will absorb all other colour but red, which is reflected.

The light which arrives at the surface of the paint is converted into yellow and red light. These two colours then absorb each other. Red pigment will of course absorb yellow light and the yellow will destroy the red.

We can confidently state that yellow and red make black.

Once again we can make a journey into the paint film.

A cross section of a mixture of red and blue would look very much like this. In practice the pigment would be packed a little tighter together, but the basic structure would remain the same.

Once you are familiar with visualising a paint mix from the inside, you will be half way to controlling the final result.

The red pigment only appears that colour to us because it is able to reflect red light and absorb colours such as blue.

The blue speck of pigment contributed by the blue paint will reflect blue light but absorb all other colours.

You will be well ahead of me by now and have worked out just why a mix of pure red and pure blue would produce black.

The flaws in our traditional way of thinking about colour mixing are starting to show.

The so called 'secondary' colours, green, violet and orange must obviously come from somewhere. Before moving on to discover the source of these colours, it is important to realise that they do not materialise from a combination of the 'primaries'. New colours are not formed at all.

The present system is unable to cope - it leads to frustration,
limited colour expression and an enormous waste of
expensive paint.
There is a simple answer: Abandon the Three Primary System and
replace it with an entirely different way of viewing colours - we have
to change the way that we think.

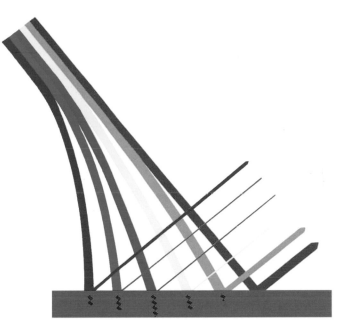

Of all the pigments available to the painter, none can be described as being pure in hue. There is simply no such thing as a pure red, yellow or blue paint.

Paints may appear as a single hue and are often described as pure, but this is inaccurate.

When we first looked at why an object appeared a certain colour, we did so in a simplified form . Let us now go back over earlier reading and add more detail.

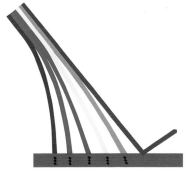

Up until now we have said that a colour such as say, Cadmium Red is created by the surface absorbing every colour except its own, in this case red. >

In reality the majority of the red portion of the light escapes, but so too will varying amounts of every other colour contained in the light. The red light is reflected together with a relatively large amount of orange light. Some yellow escapes and a small amount of green, blue and violet.

Every spectrum colour is represented in the final colour that we perceive.

The two major components reflected are red and orange, whilst the rest of the colours are found in relatively tiny amounts. Pure colours simply do not exist, and certainly not in pigment form.

Every red that you will ever come across will either be an *orange*-red or a *violet*-red. *Every* blue will either be a *violet* blue or a *green* blue. And *every* yellow will be a *green*-yellow or an *orange*-yellow.

To take this a little further, we find that other colours are also combinations. Pure green, for example, does not exist, it will always be a mixture of the full spectrum.

Green looks that colour because most of the reflected light is green. The other colours are largely swamped by this reflected green.

We can show the 'colour lightwaves' in another way to the previous page: The 'colour lightwaves' shown under the dotted line can be ignored as they are reflected in such tiny 'amounts'.

An *orange-red* such as Cadmium Red, reflects red very well, quite a large amount of orange and a smaller percentage of violet.

Violet-red, as the name suggests, reflects a lot of red followed by violet.

A useful amount of orange is also reflected. Quinacridone Violet and Alizarin Crimson are typical violet-reds.

Ultramarine Blue is a *violet-blue*. A large amount of blue is visible and the violet content is noticeable. Less obvious is the smaller amount of green which is also reflected.

Green-blues such as Cerulean Blue are very efficient reflectors of blue and reasonable reflectors of green.

A smaller measure of violet light also leaves the surface.

Green-yellow, usually called Lemon Yellow, reflects an obvious measure of yellow, a noticeable percentage of green and a lesser amount of orange.

Orange-yellows such as Cadmium Yellow are very good reflectors of yellow, reasonable reflectors of orange and will also return a useful amount of green.

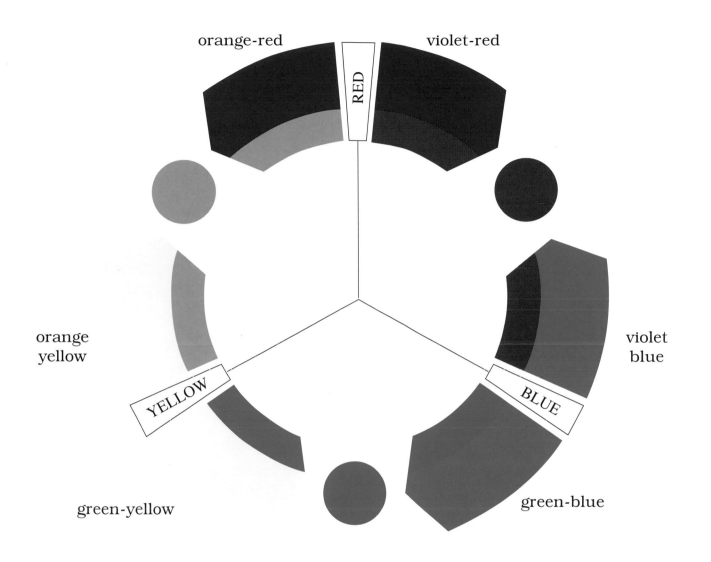

orange-red

violet-red

RED

orange
yellow

YELLOW

violet
blue

BLUE

green-yellow

green-blue

The 'Colour Bias Wheel' will become the central focus for the rest of this book.

To simplify things for now we will only concern ourselves with the two main colours involved.

Do not forget about the third colour which is also reflected, such as the touch of violet in orange-red, it will come into the picture later.

You will notice that the positions marked RED, YELLOW and BLUE have been left blank.

This is because we do not have these colours in any paint ink or dye, to place within them.

Yet they are shown on virtually all other colour mixing wheels, as if they existed and were of value.

To recap briefly, when red, yellow and blue are mixed in near equal intensities, they make a very dark grey, almost black (page 17).

This can easily be demonstrated and the reasons for the destruction of the light explained.

Following the same reasoning we find that a *pure* blue and a *pure* yellow would also make a very dark grey, almost black, not green as we have been led to believe.

Let's now examine very closely what happens when *impure* yellow and *impure* blue pigments are mixed. For this example: Hansa Yellow and Cerulean Blue.

Hansa (Lemon) Yellow

Broadly speaking it can be said that a green yellow such as Hansa Yellow or Cadmium Lemon Yellow reflects some *green* as well as the yellow.

If you now refer to page 24 you will see that the main colours that are reflected from Hansa (Lemon) Yellow are:

Yellow - a large measure.

Green - a lesser amount.

Orange - a tiny amount.

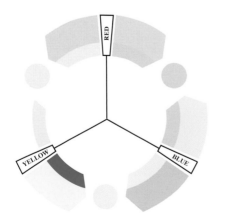

On the Colour Bias Wheel (previous page), the two main colours are identified as being yellow and green.

For now we will concentrate on these colours, yellow and green, and ignore the tiny amount of orange.

Visualise the sequence of events depicted in the diagram above.

1) White light arrives at the surface of the paint and sinks into the clear binder.

2) This white light is made up of the full range of colours in the spectrum. (As shown).

3) The yellow pigment absorbs varying proportions of the colours in the light but does reflect most of the yellow and a reasonable amount of the green.

These two major colours are shown 'bouncing' off of the green-yellow pigment.

26

Cerulean Blue

As the diagram on page 24 will show, a green-blue such as Cerulean Blue reflects a large measure of blue, a reasonable amount of green and a tiny amount of violet.

Again we will concentrate on the two main colours being reflected - blue and green.

We can analyse the situation and say that the light which enters the paint film is largely absorbed, apart from most of the blue and a fair measure of the green.

Inside the mix

The yellow and the green reflected by the Lemon Yellow are treated quite differently as they strike the Cerulean Blue.

The yellow is absorbed because a blue surface absorbs yellow.

But the *green is reflected* because here we have a type of blue which also reflects green.

Cerulean Blue pigment reflects both blue and green light and when the two arrive together at the yellow particles of paint, the blue is absorbed, *but the green is reflected*. (Because Hansa (Lemon) Yellow is a type of yellow which rejects, or reflects green).

It would be worth a brief re-read of this section so as to form a strong mental picture of the situation.

When the two colours are mixed, it does not matter that the blue and the yellow will destroy each other.

We are only interested in what happens to the green light that both of the colours reflect.

Some of the green light is reflected immediately by these two colours and leaves the surface of the paint film. The remainder 'bounces' around between the blue and yellow pigments.
Eventually it makes its way to the surface of the paint film and escapes. The surface will appear green to an observer.

Can you see that the yellow and blue do not themselves mix into a green?

It is simply that green is the only colour able to survive the subtractive process, and it is present because neither the yellow nor the blue were pure 'primaries'.

We might think that we can imagine what they would look like, but as yet we have not set eyes on them. They are only ideas.

Do not lose sight of the fact that although we are working with diagrams and studying the theory of colour mixing, we are nevertheless talking about what happens when actual colours are mixed.

In the same way that blue and yellow do not themselves combine to form green, so a mix of red and yellow will only produce orange if they carry orange as an 'impurity'.

Pure red and pure yellow, if we had them, would be quite incapable of producing an orange.

Similarly, red and blue, as such, do not make violet. If the blue and red both 'carry' or reflect violet, the violet will escape when the red and blue are mixed.

The red and blue themselves actually 'cancel each other out' or absorb one another.

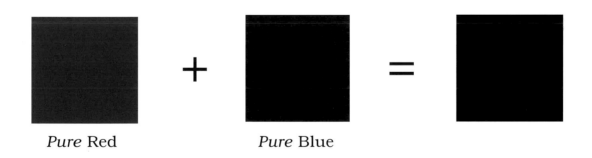

Pure Red *Pure* Blue

Can you see that the blue and red, as such, do not make a new colour, violet? If we had a *pure* blue and a *pure* red, and mixed them, the result would be black, as in the diagram above.

(We cannot do this as we do not have such colours at our disposal. In fact we have never seen a *pure* red or a *pure* blue in pigment form.

The closest that we can get to pure colours is by using coloured lights.

But when another colour is involved, in this case violet, and that colour is 'left behind' after the cancelling out is completed, we are able to see that other colour and it becomes the result of the mix, top right above.

Having established that pure 'primaries' do not exist (and that even if they did, they would only result in very dark grey when evenly mixed), traditional colour mixing wheels start to look inadequate and antiquated.

The artists' primaries have been given pride of place on countless colour mixing wheels, *as if these colours actually existed.*

We now know that they do not exist, either in pigment form or in nature.

For this reason the *red, yellow* and *blue* positions are left blank in the 'Colour Bias Wheel'.

Artists and those who mix colours have been struggling with this system for a long time. It has led to utter confusion and colour mixing has become based on trial and error, with far more of the error. If colour mixing is to be mastered, the old methods and ways of thinking must be abandoned and a completely new way of working adopted.

I am very aware that what we have covered to date might seem to some to be a little too scientific. To this I would have to say:

The painter relies on the way that light behaves, yet often (understandably, given the emphasis on 'immediate painting') has little understanding of it.

The scientist, on the other hand, too often thinks that painting is for others. If we can bring the two together comfortably, we will all benefit.

The artist will, for the first time, really understand the way colour and light work, and we might find those with a more scientific approach taking up the brush. In the next section we will start to put the information covered so far to work.

You will see, I feel, that understanding what takes place inside the paint film is really the key to mastering colour mixing. It is the only way.

1 2 3

We now know that 'pure' primaries do not exist and that even if they did they would only be of limited value.

Pure 'primaries' would, and could, only give dark greys when evenly mixed.

We rely on the 'impurities' in the colours that we mix to give the final result. Without these, we would be severely restricted.

It becomes obvious that traditional colour mixing wheels, based on the three primary system, are of little value. In fact they usually mislead.

In this section we will study an alternative method of guidance, based on fact, rather than on vague hope: *The Colour Bias Wheel*.

Diagram 1

Although used universally, the 'three primary wheel' is of limited value as it suggests the existence of colours that simply are not available, namely, *one* red, *one* yellow and *one* blue, which together will give good, clear predictable 'secondary' colours.

If you have ever tried to paint such a mixing wheel, perhaps as an exercise in art class, you will have realised the problems involved.

Diagram 2

Let's stay with the basic format but use two types of red, an *orange* red and a *violet red*; two blues, a *violet* blue and a *greenish* blue; and two yellows, one an *orange* yellow and the other a slightly *greenish* yellow.

Diagram 3

The wheel can be further modified by forming the colours into arrows: Arrows that point either towards or away from the 'secondaries'.

31

The final diagram, which we will call the *Colour Bias Wheel*, shows the six colour 'types' that we will use throughout this book to replace the traditional three colours.

These six are the minimum number of colours needed for a wide selection.

Each of the colour types leans or is biased towards a 'secondary' colour as shown by the arrows. We can use the Colour Bias Wheel to reveal the make up of the individual colours.
On page 28 you will remember, we found that a green-yellow, such as Hansa (Lemon) Yellow, and a green-blue, such as Cerulean Blue, will release a green when mixed.
The green from this combination will be relatively bright because both colours contain a high percentage of green.

Notice that on the Colour Bias Wheel, both colours point *towards* the green position.

Violet-red (Quinacridone Violet) and violet-blue (Ultramarine Blue), both containing a good measure of violet, will give a bright, clear violet. Again both colours point towards violet.
Similarly, Cadmium Yellow, an orange-yellow

and an orange-red such as Cadmium Red, will give a good, vibrant orange.

Again the two colour types point towards the relevant 'secondary' colour.

The particular colours mentioned here are only typical of the 'colour' types.
All other reds, yellows and blues will fit into one 'arrow' or another. Vermilion, for example, is an orange-red.
Do not concern yourself at this stage with these colour combinations as we will explore them in detail later. They are given as examples only.

To recap briefly
1. Pure primary colours do not exist.
2. Every red is either a violet-red or an orange-red.
3. Blues are either violet-blue or green-blue.
4. All yellows have to be either green-yellow or orange-yellow.
5. We can form these six colour types into a mixing guide wheel.
6. By showing the colours in arrow form we can indicate the bias or leaning of each colour.

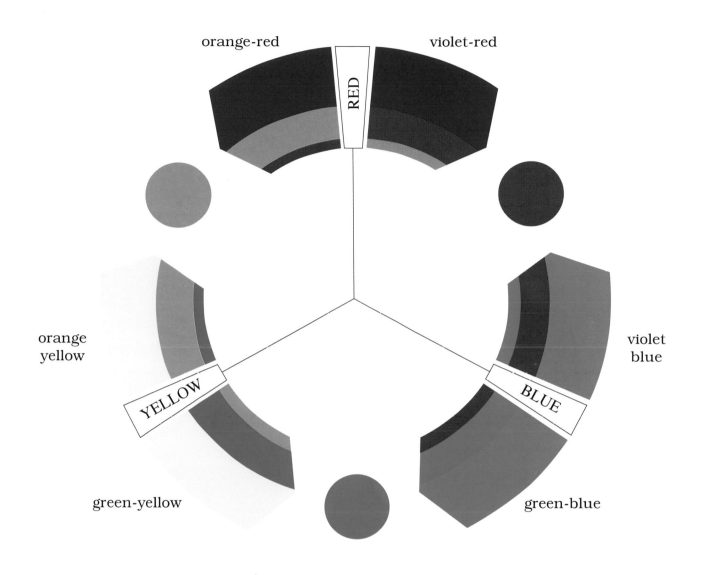

orange-red

violet-red

RED

orange
yellow

violet
blue

YELLOW

BLUE

green-yellow

green-blue

The Colour Bias Wheel, which is central to this method of working can be viewed in different ways.

On page 32 the six colour-types were shown as they appear. On page 25 the *two* main colours in the make up of our six colour-types were shown. Here we can see the *three* main colours which are always reflected. The colours first described on page 24.

At the moment this diagram might look a little like a multi-coloured nightmare. Do not let this concern you.

The Colour Bias Wheel will very soon become familiar and you will, I hope, find yourself thinking of the make up of colours in the same way.

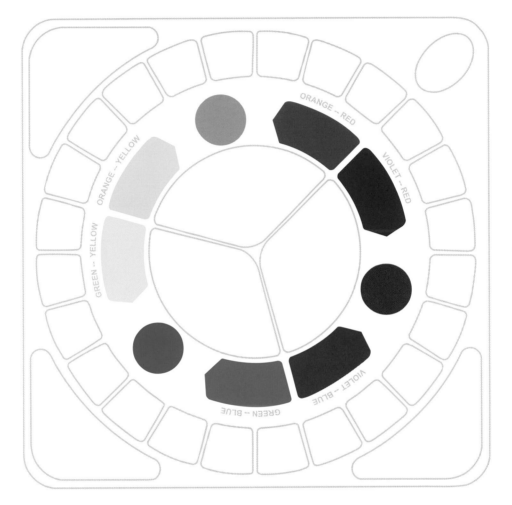

In order to transform theory into practice, a mixing palette has been designed which offers constant guidance to the artist.

The palette takes its basic design from the 'Colour Bias Wheel' which is the backbone of the system. In the illustration, the palette and the 'Bias Wheel' are merged to show their relationship.

Each of the six colour types is written alongside the relevant paint well on the palette.

This will indicate to the user where the particular paints are placed.

It must be emphasised that the use of this palette is not necessary in order to make full use of this book. Colour mixing can be learned if you use an old plate, or any other surface as your palette. It is shown throughout the book as many artists make use of it and the diagram alone can help in further understanding.

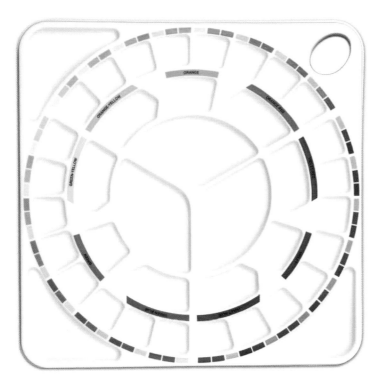

There are two types of palette, one intended for water soluble media such as watercolour, gouache, casein, water-based inks, water-based dyes and diluted acrylics.

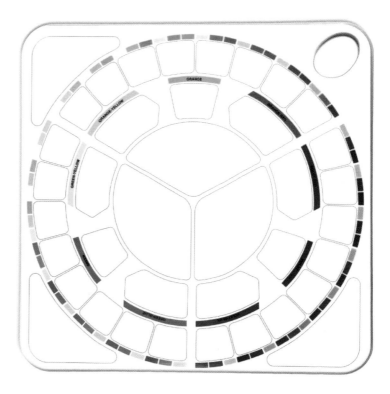

The other, (which is flat), has been designed for use with oil paints, alkyds, oil-based inks and slightly diluted acrylics.

If you are not entirely sure of all that has been covered so far, it will be beneficial to re-read any sections which are not quite clear.

It would be wise to avoid rushing ahead.

If you proceed step by step it will all fall into place that much easier.

Much of the theoretical part of the book is now behind you, certainly the most difficult part.

Although it might have been an unusual experience to have visualised the 'goings on' inside a paint mix, I believe that you will find a knowledge of the processes is very necessary.

Materials required
Cadmium Red Light, Quinacridone Violet, Ultramarine Blue
and Cerulean Blue.
A clean brush and dilutant.

We will now start to explore the vast range of colours that are obtainable from our six colour types: orange-red, violet-red, violet-blue, green-blue, green-yellow and orange-yellow.

Whenever I give colour mixing demonstrations I usually start by asking the participants to mix a bright violet.

After a lot of rummaging around in paint boxes, a red and blue are produced and mixed. The resulting colours usually range from dull greys to browns. Seldom is a bright violet produced. >

This suits my purpose very well, for it demonstrates the extreme care that has to be taken when choosing mixing partners.

It also reinforces my belief that in order to gain control of colour mixing, we really have to understand the make up of individual colours.

We will now take a close look at a typical blue red mix, using colours that are often selected when a bright violet is sought: Cadmium Red and Cerulean Blue.

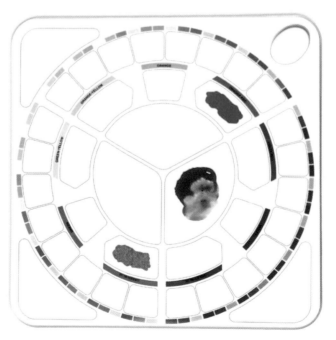

Orange-Red
+
Green-Blue

Place small amounts of Cadmium Red Light (orange-red) and Cerulean Blue (green-blue) onto whatever palette you are using.

Blend a portion of the two colours as shown. By adding more of one or other hue, try to produce a colour as close to violet as possible. Neither too red or too blue.

Apply some of the colour onto your paper or oil painting board.

The resulting mix is hardly a pure violet, in fact it is nearer to dull brown.

What went wrong? After all, a blue and a red were mixed and they should have made violet.

The answer lies with the particular colours that were chosen.

As discussed on page 24, Cadmium Red (orange- red), reflects red efficiently, orange moderately well and violet very inefficiently.

Cerulean Blue, (a green blue), reflects blue very well, is reasonably successful at reflecting green, but a poor performer when it comes to violet.

A breakdown of the Colour Bias Wheel shows that neither Cadmium Red nor Cerulean Blue was a suitable contributing colour for mixing violet.

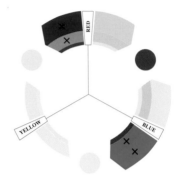

Both point *away* from the violet position as neither reflects much of that colour.

When the two paints are unleashed inside the mix, they set about attacking each other's reflected light.

Cadmium Red absorbs the blue and green light but reflects the small amount of violet coming from the Cerulean Blue.
Cerulean Blue absorbs the red and orange but not the violet sent to it by the Cadmium Red.

The final result is a very subdued colour with a slight leaning towards violet. It is subdued because nearly all the light entering the paint film has been absorbed (the yellow, blue, red, green and orange). Very little is left to give brightness.

The colour leans towards violet because both pigments have reflected their small violet content. You will notice that two factors are involved here: The *amount* of light and the *colour* of that light. These two factors are vital considerations with any mixture.

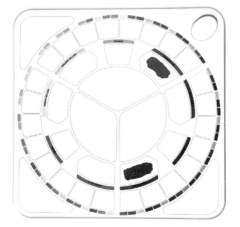

In the previous mix, a very dark colour resulted because most of the light arriving at the surface of the paint was destroyed.

It was slightly violet because the orange-red and the green-blue both left a trace of violet behind, (after they had all but destroyed each other.) >

You will notice that violet was the only colour common to both the red and the blue.

This time we will select the contributing colours a little more carefully and use a blue which is *known to be a good reflector of violet*, while staying with the Cadmium Red.

What we will be doing in effect, is to use the blue to introduce more violet into the mix.
The blue will be used as a 'carrier' of violet.

In order to select the appropriate blue we must be aware of its *colour-type*.

The usual practice of choosing by colour name (Ultramarine, Cerulean Blue etc.), can only lead to confusion.

Similarly, describing a blue as being 'warm' or 'cool' will be of little help.

Orange-Red
+
Violet-Blue

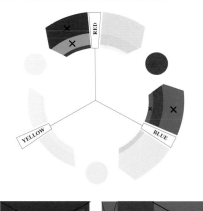

*Apply the mix onto your
paper or oil board.*

Put out small amounts of Cadmium Red Light (orange-red) and Ultramarine Blue (violet-blue).

Mix them to produce a colour as close to a violet as possible.

The 'orange', 'red', 'green' and 'blue' lightwaves reflected by these pigments are absorbed, leaving only the violet. A great deal of light is lost inside this mix, but a reasonable amount of violet manages to escape.

Much more so in this mix since Ultramarine Blue is an efficient reflector of violet.

The 'Colour Bias Wheel' predicts this result: one arrow points *towards* the violet position and the other points *away* from it.

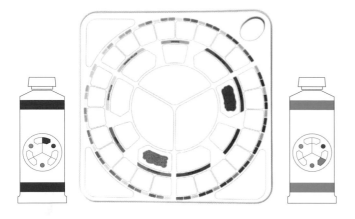

Alternatively, the violet can be introduced by the red. Place small amounts of violet-red (Quinacridone Violet) and green-blue (Cerulean Blue) onto your palette.

Combine the colours with the aim of mixing a mid-violet. Add more of either paint until the colour does not lean either towards red or blue. >

The violet that results is another mid intensity hue.

It is a mid - intensity violet because only one of the colours is an efficient carrier of violet, (the red). The red paint will add a generous amount of violet whilst the blue contributes very little.

There will be differences between this and the previous mix. This is due to the nature of the pigments.

The overall colour type will still be a mid-intensity violet because again only *one* of the contribution colours carries a worthwhile amount of that colour.

The subtle differences between the two mid violets that you have now mixed will be explored later. For now we are only interested in the basics of colour mixing.

There are several ways of describing the various mixes in this exercise.

In the first mix, (Page 37), orange-red and green-blue, we could say that:

1) The two 'arrows' on the Colour Bias Wheel point *away* from the violet position.

2) The word 'violet' is not mentioned. We used an *orange*-red and a *green*-blue.

It would be better however to know what is happening within the mix.

In the second combination, (page 39), orange red and violet-blue we could say that:

1) One 'arrow' points away but the other points *towards* the violet position. Suggesting a mid violet, or

2) The word violet is mentioned at least once, orange-red and *violet*-blue.

Again it would be better to know what is happening within the paint film.

The final mix, (this page), can also be similarly analysed.

Look at the 'arrows', go by colour-type, or *ideally understand what is happening in the mix.*

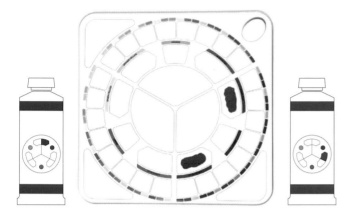

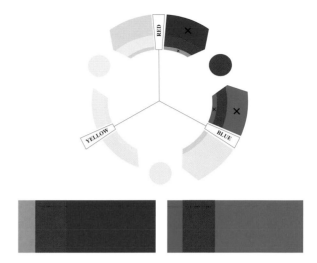

In order to mix a bright violet we must select the contributing colours carefully and for good reason.

Apply violet-red (Quinacridone Violet) and violet-blue (Ultramarine Blue) to whatever palette you are working on.

With a clean brush and clean dilutant, mix the two paints to produce a violet. >

Paint out a sample of this violet, (which should not lean either towards blue or red), onto your working surface.

Violet-red and violet-blue produce the most intense of mixed violets, and for this reason:

The light that enters this mix is robbed of its blue, red, green and orange content, but the violet, *which is reflected by both pigments*, escapes unhindered.

All we see of the original light which entered the paint film is that part of the spectrum *common to the contributing colours*; violet. In two large doses.

As the 'Colour Bias Wheel' indicates, a relatively pure violet can be expected as both arrows point *toward* the violet position.

Alternatively we can say that a bright violet can be expected as we mixed a *violet*-blue and a *violet*-red. The word violet is used twice which suggests that both colours carry a generous amount of violet.

Can you see how important it is to describe colours correctly?

If we were to describe the mix as Quinacridone Violet and Ultramarine Blue, we would not have the first clue as to the final result.

Colour-type is always far more important than colour-name.

Although the Colour Bias Wheel will guide you towards the final result, (and knowing the colour-type is always a help), it is better in the end to understand the processes that are actually taking place inside the mix.

As soon as you automatically think of what will take place when colours are mixed you are most of the way towards full control.

Let us go back to the mid-violet that was produced from a mix of orange-red and violet blue. The blue was selected, you will remember, because it was rich in violet.

If the blue does in fact carry so much violet, if it is so abundant in this hue, why should we bother to even add the orange-red?

Why not be content with the amount of violet in the blue? After all, we are only looking for a mid intensity-violet.

We know that the orange-red has *some* violet but too little to make much difference. (Hence the very dark, dull violet from the first mix) So why even add the red? What use is it?

There is only one real reason to add the red, we need it to *absorb* or remove the blue.
Red and blue are mutually destructive, that is the basis of this approach to colour mixing.
As the red is added to the violet-blue *it removes the actual blueness*, leaving the violet that it contained.
This of course is quite the opposite of just about everything we have believed about colour mixing, beliefs that have sprung up through our reliance on the now defunct three primary system. Red and blue, as such, do *not* make violet.

A very useful exercise would be to paint out some violet-blue, (Ultramarine Blue), and add some orange-red, (Cadmium Red Light) whilst the blue is still wet.

As the red is added, wet into wet, you can almost see it destroying the blueness and releasing the violet content.

Then try mixing some green-blue, (Cerulean Blue), into a wet violet-red, (Quinacridone Violet), as per the last mid-intensity violet that you mixed.
The green-blue will *absorb the red content* leaving the violet unscathed.

As with all of the mixes that you might be producing (it is not essential to carry out these mixing exercises, although it would be useful), take a moment to work out what is happening within the blend.
This exercise in particular, does, I feel, illustrate quite dramatically that colours destroy each other rather than combine into new colours, as we have always been taught.
An understanding of what is actually happening inside a paint mix will lead to full control.

The violet colour resulting from a mixture of red and blue is essentially just the residue of the light which entered the paint film.

It is most certainly not a 'new' colour which somehow results when the two colours are blended.

The 'three primary system' would have us believe that the red and the blue combine to form another, quite different colour.

In much the same way that flour and water make dough.

Depending on the amount of light destroyed during the subtractive process, the final colour will be lighter or darker.

There are two factors involved in every mix, the amount of light that emerges and the colour of that light.

There is, of course, a certain amount of light reflected from the paint surface, light which does not penetrate the paint, and this will lighten the result.

This is particularly so in the case of smooth, shiny paint surfaces.

It should now be clear why such care must be taken with the selection of contributing colous. You will undoubtedly not be alone if you have struggled to mix a violet with just any red and blue that comes to hand.

The following is intended for those who wish to actually produce the mixes described in this book. The exercises can be painted out onto paper, oil paper or oil painting boards. >

Alternatively you might prefer to use one of our 'Colour Mixing Workbooks'. Their use is not at all essential but they might be convenient.

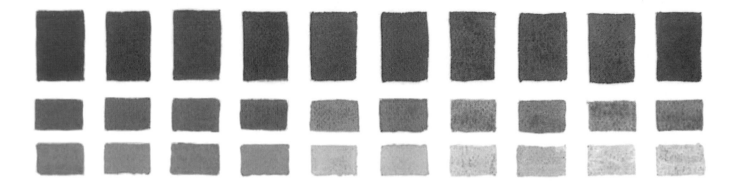

As in the example above, do not worry if your mixes are 'all over the place'. It is not easy to produce a series of gradually changing mixes.

As long as you obtain the range of mixes, with reds to the left, blues to the right and greyed colours in the centre, you will be on the right track. So relax, enjoy your colour mixing and do not aim for perfection, it really is not important. The mixing illustrations throughout the book are intended as a guide only.

The colours that you blend from your paints will be different in certain respects, due to the limitations of conventional colour printing.

It is suggested that you make notes at the end of each exercise to record your observations.

Comment on the way one colour influences another or how you might employ the mixes in your future work.

Making such notes will also help you to concentrate on the results.

A B C D

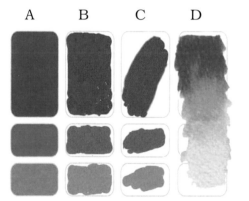

If using one of our Workbooks, you might choose to paint each box in carefully (A). Complete the exercises in a freer fashion (B). Just add touches of colour (C) or make a continuous tint (D). It really does not matter, as long as you can see what is actually happening with each mix.

Tints

Create tints of each colour as you go along. These are produced by either thinning the paint or adding white.

There are very definite differences between tints created via a light coloured background and those produced by adding white. These differences, which are covered later in the book, should be taken into consideration before deciding how to proceed. (Please see page 176).

Practical work

Materials required
Cadmium Red Light, Quinacridone Violet, Ultramarine Blue, Cerulean Blue.
A clean brush and clean dilutant.

Exercise 1 - greyed violets
opaque orange-red + opaque green-blue

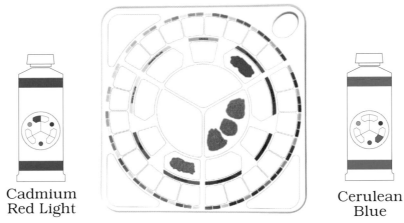

Cadmium
Red Light

Cerulean
Blue

Place small amounts of each colour onto whatever palette you are using and blend them together.

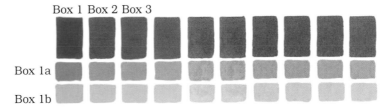

Box 1 Box 2 Box 3

Box 1a

Box 1b

We will now get down to some serious colour mixing. This will probably come as a relief after all the theory that you have waded through. Put a little fresh orange-red (Cadmium Red Light) and green-blue (Cerulean Blue) onto your palette.

With a clean brush apply a full strength (fully saturated), layer of the orange-red (unmixed) to box 1 of the exercise. (Please also see next page for the illustrations).

Thin a little of the paint and apply a medium tint to box 1A. Now thin the colour even further (or add white), to give a paler layer for box 1B. Continue down through the exercise, creating ever paler tints.

Alternatively you might wish only to create 2-3 tints for reference, leaving the rest blank.

Next, add a tiny amount of blue to the red. Apply this colour into box 2.

Create another two tints for boxes 2A and 2B and continue down if you wish to create a fuller reference.

Add a little more blue to the mix and apply into box 3. Continue in the same way until you reach the final box, (which will be unmixed Cerulean Blue).

In effect you will be starting off with unmixed orange-red in the first box, then adding more and more blue to this red for each of the following boxes. Finally you will have unmixed blue in the last box (Box 10).

45

Exercise 1 - greyed violets
opaque orange-red + opaque green-blue

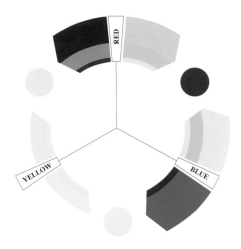

Please see previous page for directions on completing the 'boxes'. This diagram relates to the colour swatch below. It is shown separately for clarity.

The result is forecast by the Colour Bias Wheel. With a little practice you will be able to forecast the result of mixing different 'colour types'.

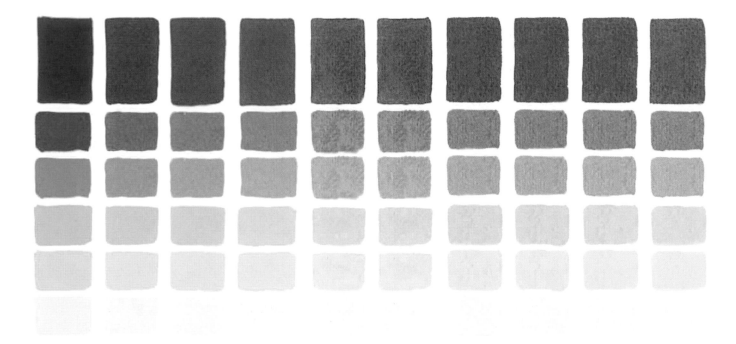

The finished exercise will appear similar to the above. I say 'appear' quite deliberately as there will always be differences between printed and painted colours. As with all of the exercises shown in this book, do not try and match your mixes exactly, treat the printed colours as a guide only.

There will, of course, also be differences due to whether you choose to work formally, as above, or informally.

Exercise 1 - greyed violets
opaque orange-red + opaque green-blue

As both the orange-red (Cadmium Red Light) and the green-blue (Cerulean Blue) are opaque, it follows that their mixes will also be opaque. This can be a useful factor when covering other hues.

The varying opacity of colours is seldom taken full advantage of by artists.>

This is due, I believe, to the problems associated with mixing the colours in the first place. There is more than enough to keep in mind when trying to work with the established method, (the three primary system), without trying to take into account the transparenc or opacity of a colour.

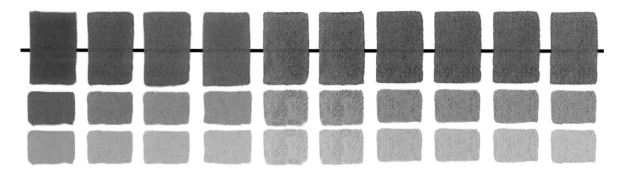

The transparency/opacity of a paint can be determined in a general way by applying an even layer over a black line. Opaque paints cover the line well, the more transparent show it clearly. The varying degrees of transparency between these extremes are also revealed, semi transparent, semi opaque etc.

In order to produce dull, darker colours we need to select contributing hues which are poor carriers. Please see the 'Colour Bias Wheel' diagram on the previous page.

In this case neither the red or the blue reflect much violet. When they are mixed, the redness and blueness, as such, cancel each other out, leaving behind the two tiny amounts of violet. Dull, greyed violets such as these can certainly have their place, in fact they can be most useful in all types of colour work.

But they are not so welcome if they turn up uninvited when a bright or mid-intensity violet is required. With control they are invaluable.

47

Exercise 2
opaque orange-red plus transparent violet-blue

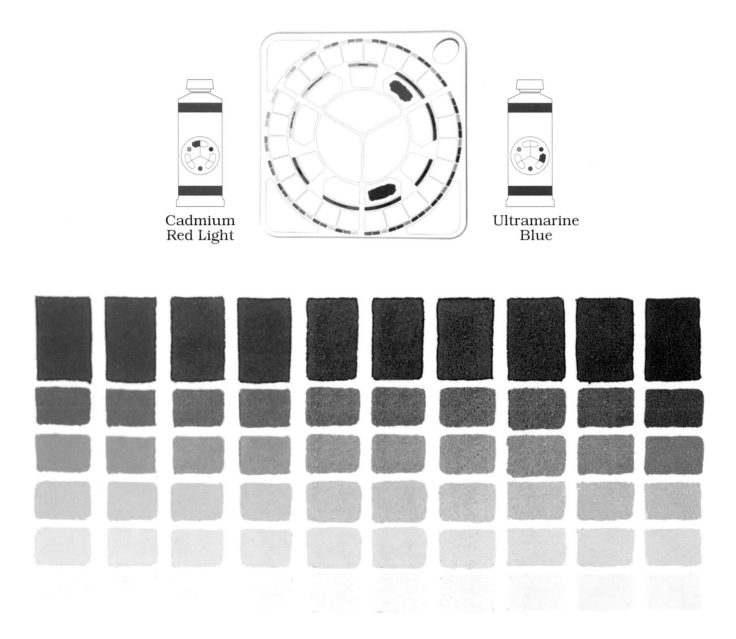

Cadmium
Red Light

Ultramarine
Blue

As you mix Cadmium Red Light (orange -red) and Ultramarine Blue (violet-blue) you will produce a series of mid-intensity red violets to mid-intensity blue violets.

A mid-violet will emerge around the centre of the range. This of course will be a dark colour as the red and blue contents will have largely destroyed each other.

I will describe all such *mid intensity* colours simply as mid from now.

I will also refer to colour-type rather than colour name. So in this exercise you will be mixing *orange-red* and *violet-blue*.

48

Exercise 2
opaque orange-red plus transparent violet-blue

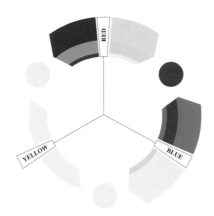

The result is forecast by the Colour Bias Wheel.

As you mix each colour think about what is actually happening inside the paint on your palette.

In this exercise, as the blue is added to the red its 'blueness' starts to absorb the 'redness' in the first few mixes.

About the middle of the range the 'blueness' and 'redness' cancel each other out, fully > revealing their total violet content.

As more blue is added to the right of the range much of the blueness 'escapes' along with the violet to give the violet-blues.

It 'escapes' as there is no longer enough 'redness' to absorb it.

It takes some thinking about but it is worth the effort.

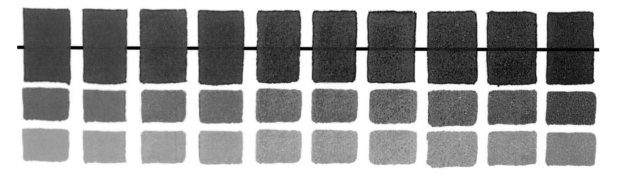

The mixes will be opaque at the orange-red end of the scale, moving towards transparent at the violet-blue end.

As you will see, to produce mid-intensity violets, one contributing colour, the orange red, points *away* from the violet position on the Colour Bias Wheel, the other, the violet-blue, points *towards* it.

One away and one towards indicates that the result will be a mid intensity colour. (As *both pointing towards* indicated that a *bright* colour would emerge).

As a further indication, the description, an orange-red and a violet-blue, only mentions the word violet once.

Exercise 2
opaque orange-red plus transparent violet-blue

Although we have already covered this exercise, I would like to revisit and re-examine it as it is of vital importance.

The only reason for adding the red is to remove the blueness. As the red absorbs or cancels out the blue we are able to see the violet. In other words we have gone from a violet-blue to a violet simply by removing the blue component with the red.

This is quite the opposite approach to that put forward by the Three Primary System. Instead of mixing red into the blue to somehow create a *new* colour from a mix of blue and red, we are using one to destroy the other so that the hidden 'impurity' (the violet) can be revealed.

Exercise 3
transparent violet-red + opaque green-blue

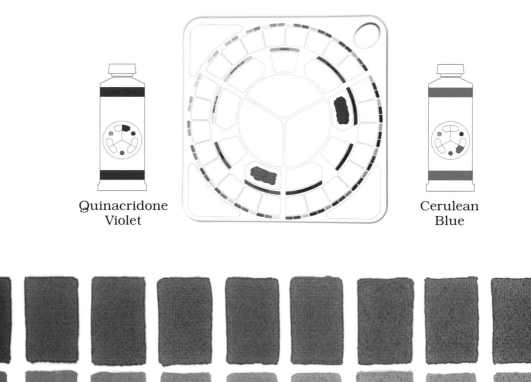

Quinacridone
Violet

Cerulean
Blue

For a slightly different range of mid-violets we will now use the red to introduce the violet and go back to using the green-blue from the first mix.

Again the name suggests the make up of the colour, violet-red carries, or reflects, a good measure of violet. When they are mixed we get another mid-violet, different to the first mid-colour due to the nature of the pigments, but still a mid-violet.

In this case the red did nearly all of the work, It carried most of the violet to the mix while the blue provided very little. By varying the blue or red content the range can be extended.

Exercise 3
transparent violet-red + opaque green-blue

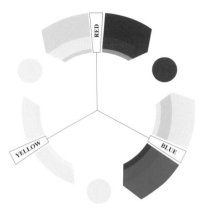

Although we can describe these colours as being *mid-intensity* violets, they differ markedly from those produced in the previous exercise> due to the nature of the pigments involved. But both exercises produced mid intensity colours, neither very dull or very bright.

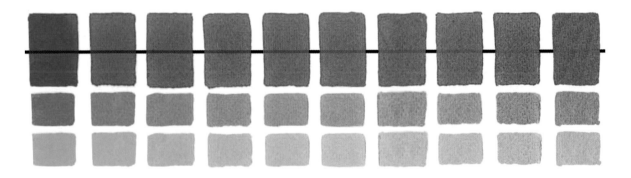

This time the opacity sequence is reversed, the mixes being transparent at the red end of the scale, moving towards greater opacity at the blue end. As you will discover later, the opacity of a colour has a definite impact on the final result.

Place a little violet-red and green-blue onto your palette and complete this exercise in the usual manner.

Once again we can say that with one mixing arrow pointing *towards* the violet position on the Bias Wheel, and the other *away*, plus the fact that *violet* is only mentioned once in the 'colour-type' descriptions, the result will be a range of *mid intensity* violets.

Can you see the importance of describing colours correctly when mixing?

If we had described these two colours using the traditional names of Quinacridone Violet and Cerulean Blue, we would have had no indication at all of what to expect.

Exercise 4
transparent violet-red + transparent violet-blue

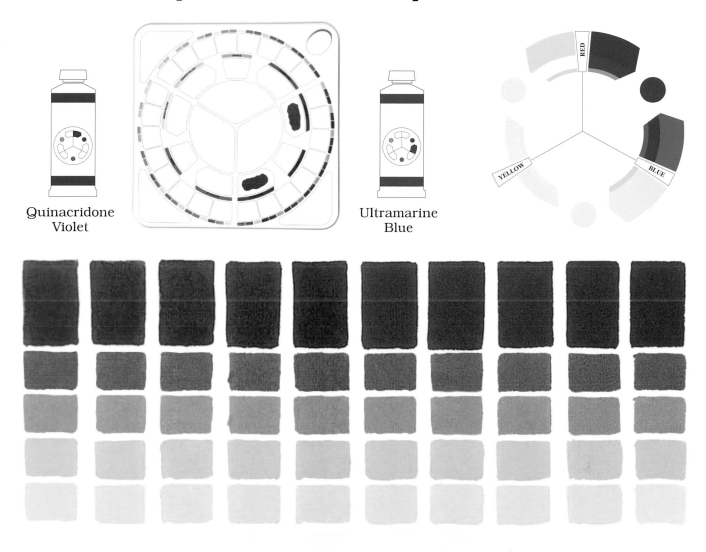

Quinacridone
Violet

Ultramarine
Blue

A violet-red and a violet-blue will give us the brightest mixed violet.

Following the same mixing sequence, violet red is placed into the first box. (Tints are made as usual). A little violet-blue is now added for the next mix. Violet-blue is added progressively and the red-violets gradually becomes violet and then violet-blues. Eventually pure violet-blue, as it comes from the tube, is used for the last box.

Around the mid-point of the series you will produce a violet which leans neither towards red or blue. If you compare the mid-colours

from this range with those from exercise 1, you will find two main differences.

Here the mid-colours, (around box 5-6) are:
1) Brighter.
2) More violet.

The colours are brighter because *less light is absorbed.*

In exercise 1, most of the light was destroyed leaving only tiny amounts represented by the violet content.

The colours here are more violet of course because larger amounts of that colour have been left behind.

Exercise 4
transparent violet-red + transparent violet-blue

Alizarin Crimson tends to fade when applied as a wash or when mixed with white, as shown on the right.

If you are using an alternative violet-red to Quinacridone Violet, I suggest that you make certain that the colour is lightfast and is a good 'carrier' of violet.

The most commonly used violet-red, world wide, is Alizarin Crimson.

Genuine Alizarin Crimson will fade quite rapidly when applied in thin layers or when mixed with white. >

Alizarin Crimson plus Ultramarine Blue

Quinacridone Violet plus Ultramarine Blue

It is also a poor 'carrier' of violet. When mixed with the same violet-blue as above it will, at best, give mid-intensity rather than bright violets.

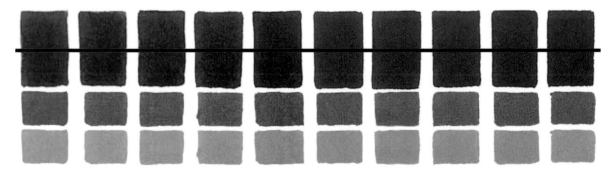

This time both colours are transparent as the indicator line clearly shows.

As we have found, violet-red (Quinacridone Violet) and violet-blue (Ultramarine Blue), give a bright violet; the brightest of all mixed violets in fact.

The aim of this and the following exercises is to give a basic sample range of the colours which will emerge from the contributing hues.

As I am sure you will appreciate, many more colours could be mixed between those shown and a far greater range of tints are available, as you will discover when you start to put this approach into practice. The exercises should be treated as an *indication* of the available range of mixes from each pair.

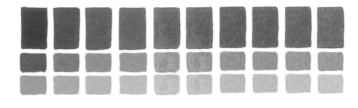

Orange-red and a green-blue for dull, greyed violets.

Orange-red and *violet*-blue for mid intensity violets.

Violet-red and green-blue for further mid intensity violets.

Violet-red and a *violet*-blue for bright, clear violets.

Let's look at the situation another way. We started by mixing a very dull, greyed violet from an *orange-red* and a *green-blue*.

The word violet was not mentioned once in these descriptions.

To produce mid intensity violets we introduced extra violet via either the blue or the red.

Orange-red and *violet*-blue or *violet*-red and green-blue. The word *violet* was mentioned once in each mix.

To mix a bright violet we then simply selected two good carriers of violet, a *violet*-red and a *violet*-blue. By describing the colours this way we actually say the word violet twice, *violet*-red and *violet*-blue.

Describing colours by 'colour-type' helps when selecting mixing partners.

As the two colours in the final exercise were combined it did not matter that the red and blue, as such, disappeared, because they both left behind large 'amounts' of violet as they did so. As you saw, a bright violet emerged from this mix.

As soon as you start to select colours for clear and definite reasons you will gain control over colour mixing.

The old idea that red and blue make a new colour only leads to endless experimenting and large amounts of a colour normally described as 'mud'.

I realise that it is not always easy to change established thinking, but it is the only way to ever control colour mixing.

Practical work

Materials required: Ultramarine Blue, Cadmium Yellow Light,
Cerulean Blue, Hansa (Lemon) Yellow. A clean brush and dilutant.

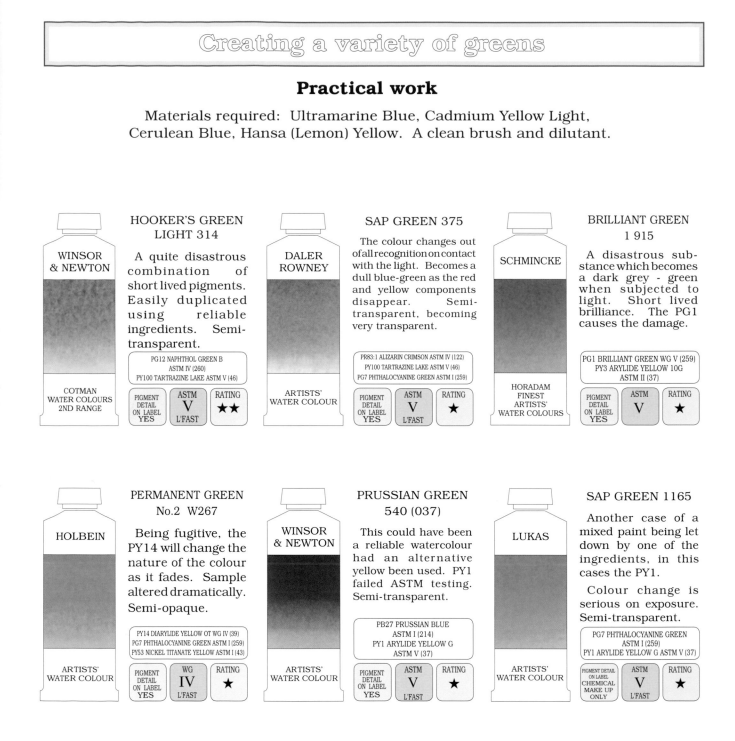

HOOKER'S GREEN LIGHT 314

WINSOR & NEWTON

A quite disastrous combination of short lived pigments. Easily duplicated using reliable ingredients. Semi-transparent.

COTMAN WATER COLOURS 2ND RANGE

PG12 NAPHTHOL GREEN B ASTM IV (260)
PY100 TARTRAZINE LAKE ASTM V (46)

PIGMENT DETAIL ON LABEL YES | ASTM V L'FAST | RATING ★★

SAP GREEN 375

DALER ROWNEY

The colour changes out of all recognition on contact with the light. Becomes a dull blue-green as the red and yellow components disappear. Semi-transparent, becoming very transparent.

ARTISTS' WATER COLOUR

PR83:1 ALIZARIN CRIMSON ASTM IV (122)
PY100 TARTRAZINE LAKE ASTM V (46)
PG7 PHTHALOCYANINE GREEN ASTM I (259)

PIGMENT DETAIL ON LABEL YES | ASTM V L'FAST | RATING ★

BRILLIANT GREEN 1 915

SCHMINCKE

A disastrous substance which becomes a dark grey - green when subjected to light. Short lived brilliance. The PG1 causes the damage.

HORADAM FINEST ARTISTS' WATER COLOURS

PG1 BRILLIANT GREEN WG V (259)
PY3 ARYLIDE YELLOW 10G ASTM II (37)

PIGMENT DETAIL ON LABEL YES | ASTM V | RATING ★

PERMANENT GREEN No.2 W267

HOLBEIN

Being fugitive, the PY14 will change the nature of the colour as it fades. Sample altered dramatically. Semi-opaque.

ARTISTS' WATER COLOUR

PY14 DIARYLIDE YELLOW OT WG IV (39)
PG7 PHTHALOCYANINE GREEN ASTM I (259)
PY53 NICKEL TITANATE YELLOW ASTM I (43)

PIGMENT DETAIL ON LABEL YES | WG IV L'FAST | RATING ★

PRUSSIAN GREEN 540 (037)

WINSOR & NEWTON

This could have been a reliable watercolour had an alternative yellow been used. PY1 failed ASTM testing. Semi-transparent.

ARTISTS' WATER COLOUR

PB27 PRUSSIAN BLUE ASTM I (214)
PY1 ARYLIDE YELLOW G ASTM V (37)

PIGMENT DETAIL ON LABEL YES | ASTM V L'FAST | RATING ★

SAP GREEN 1165

LUKAS

Another case of a mixed paint being let down by one of the ingredients, in this cases the PY1.

Colour change is serious on exposure. Semi-transparent.

ARTISTS' WATER COLOUR

PG7 PHTHALOCYANINE GREEN ASTM I (259)
PY1 ARYLIDE YELLOW G ASTM V (37)

PIGMENT DETAIL ON LABEL CHEMICAL MAKE UP ONLY | ASTM V L'FAST | RATING ★

Too often artist's rely on manufactured, pre-mixed greens which seem to inhibit any desire to mix a wider variety and add interest to the work. Bear in mind that many of these manufactured green mixes contain poor ingredients which fade or change in some other way and eventually spoil the colour.

One of the major advantages of understanding colour mixing is that you need only use a few, carefully chosen colours. Chosen not only for colour-type but also for lightfastness and other qualities.

The above examples are taken from '*The Wilcox Guide to The Finest Watercolour Paints*'. Similar problems exist with oil paints, acrylics and gouache.

Exercise 5
opaque orange-yellow + transparent violet-blue

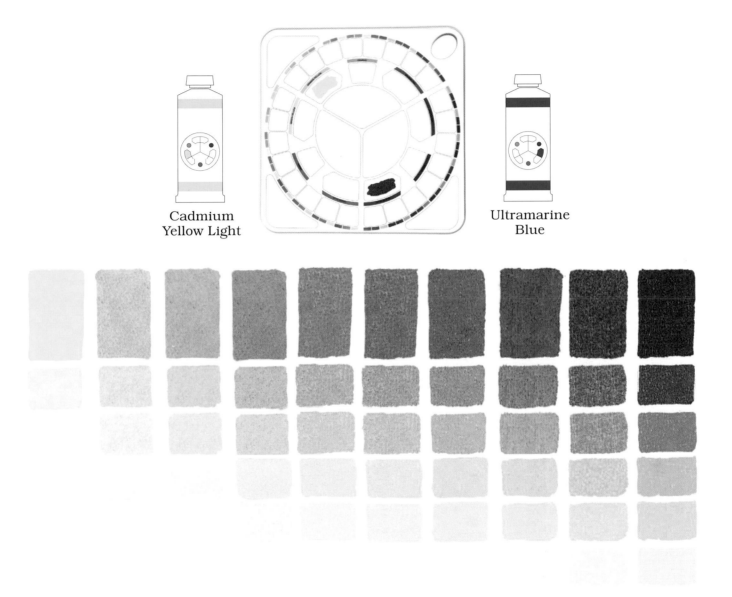

Cadmium
Yellow Light

Ultramarine
Blue

As shown on pages 24, orange-yellow and violet-blue both reflect only a small amount of green. When they are mixed in equal intensities, the yellow and blue will destroy each other, leaving only the very small amount of green that they both 'carry'.

Cadmium Yellow is a typical orange-yellow. When it is mixed with Ultramarine Blue (the only true violet-blue available) we can expect some especially greyed or neutralised greens.

Remember, the blue and yellow are only acting as carriers of the green. The 'blueness' and 'yellowness' will wipe each other out when the mix is even in intensity. The two colours will not somehow combine to form a new colour, green.

If you are actually producing these mixes, do not worry if your mid-greens start earlier or later in the series. As with all of the exercises, as long as you can see what is going on, that's all that matters.

Exercise 5
opaque orange-yellow + transparent violet-blue

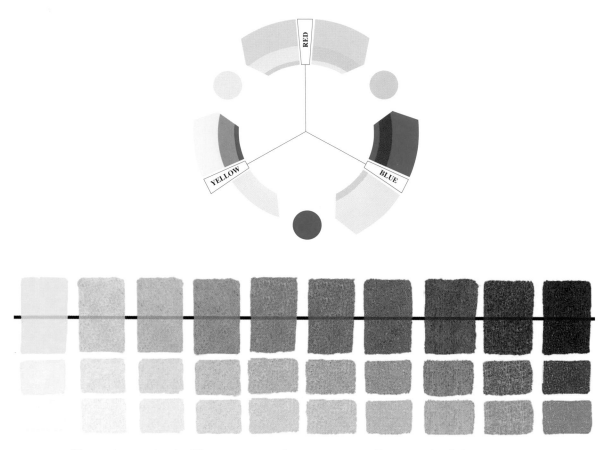

The mixes start off opaque at the orange-yellow end of the range and gradually become more transparent towards the blue.

A range of useful dull, darkened greens result when two *poor* carriers of green are mixed. Such dull greens often turn up when we wish to produce brighter hues, They are invaluable when we can mix them to order.

As shown in the 'Bias Wheel' above, the orange-yellow is a colour which reflects yellow very well, followed by orange. However, it only reflects a tiny amount of green, which is why it is being used for this exercise.

Likewise with the violet-blue. A very good reflector of blue, followed by violet, but a poor reflector of green. So we have started to make use of all the main colours reflected by the orange-yellow and the violet-blue.

At first sight it might seem a lot to remember, two reds, two yellows and two blues to work with instead of the traditional red, yellow and blue. And each of these is principally made up of three others.

But once you have used the violet-blue to produce both bright violets and dull greens a few times you will have come to terms with its properties.

Similarly, after you have employed orange yellow to give its small 'amount' of green or its generous 'helping' of orange a few times its use will fall into place.

Exercise 6
semi transparent green-yellow + transparent violet-blue

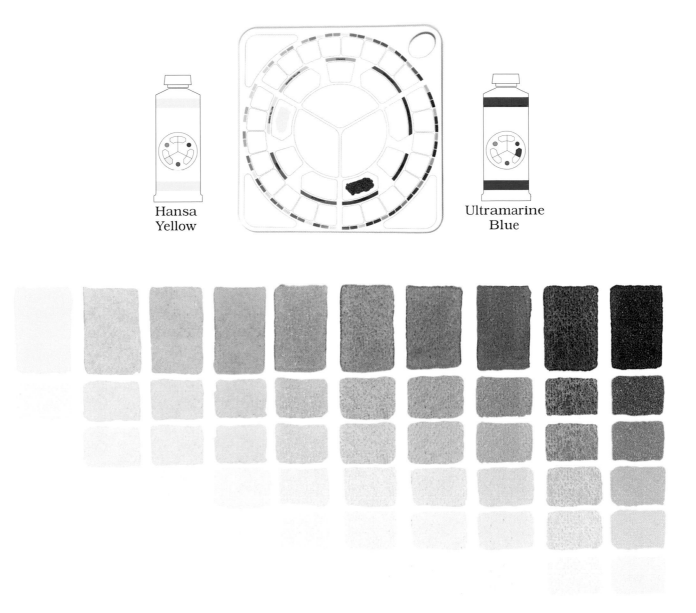

Hansa
Yellow

Ultramarine
Blue

We can use either the blue or the yellow to introduce green to the mix. For now we will stay with the same violet-blue used in exercise 5, (page 57) but use a green-yellow to 'step up' the amount of green reflected.

Although not as dull as the orange-yellow violet-blue mix, the greens will be soft and subdued as the yellow is the only colour carrying an appreciable amount of green.

A similar range can be produced from any green-yellow and violet-blue, in any medium; pastels, inks, gouache etc.

59

Exercise 6
semi transparent green-yellow + transparent violet-blue

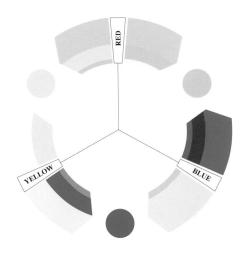

As many green-yellows (Lemon Yellows) are semi-transparent and the violet-blue (Ultramarine) is also transparent, the mixes from this exercise will be particularly clear.

Although they will be slightly more transparent towards the violet-blue end of the range, the> difference will be almost impossible to detect, particularly where the colour is applied thinly.

It pays to use a quality product to ensure such transparency. Any excess of filler, often found in student colours or low quality 'artists'' colours, will cloud thin applications.

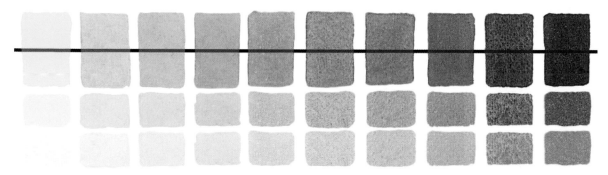

Semi-transparent green-yellow moving towards transparent violet-blue.

By now you will probably be able to forecast the result - a range of mid intensity hues ranging from yellow greens to blue greens.

In this exercise it seems as if we are mixing a blue and a yellow. In actual fact, because the blueness and the yellowness will disappear about the middle of the range, we are mixing the small amount of green in the violet-blue and the larger amount of green in the green-yellow.

We need to change our thinking, which is based on unworkable ideas from the past, if we are to master colour mixing once and for all.

Exercise 7
opaque orange-yellow + opaque green-blue

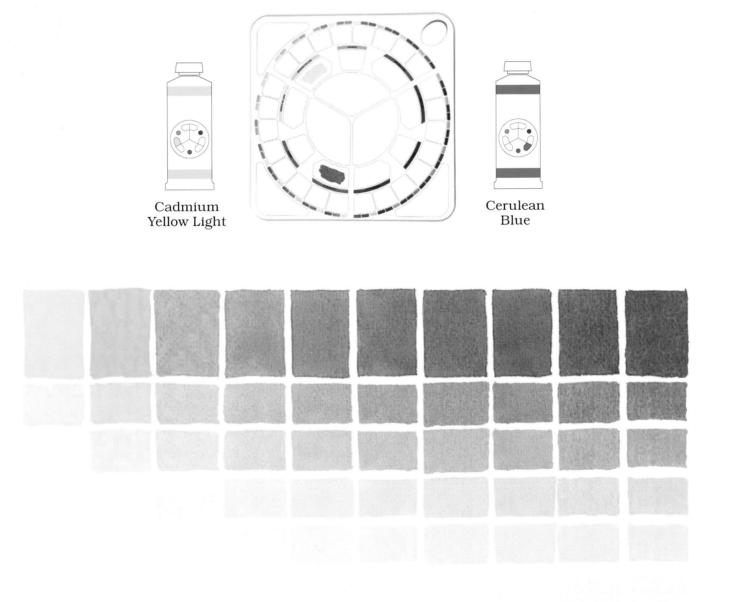

Cadmium
Yellow Light

Cerulean
Blue

In this exercise the blue will be the main carrier of the green, little will be added by the orange-yellow.

Again we can expect a series of mid-greens as only one of the contributing colours carries a significant amount of green. Slightly brasher mid-greens than the green-yellow/violet-blue combination, due to the differing characteristics of the colours involved.

Exercise 7
opaque orange-yellow + opaque green-blue

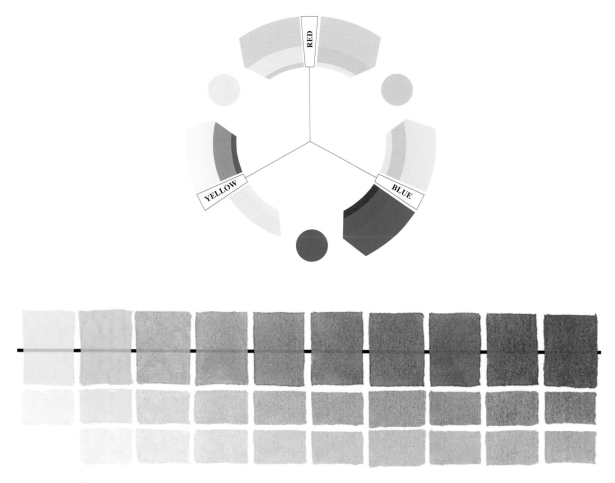

As both contributing colours are opaque the mixes will also cover well.

Orange-yellow and green-blue. One mixing arrow points *towards*, the green position on the palette and one *away*, the word green is only mentioned once - the result must be a range of *mid intensity* greens.

There will be differences between this range of mid greens and those mixed for exercise 6 (page 59), due to the characteristics of the actual pigments involved.

However, both ranges will be of *mid intensity*, neither particularly bright or dull.

By varying the contributing colours, for sound reasons, a wide range of predictable greens can be produced with ease. A few seconds of thinking, before mixing, will save the usual considerable waste of time and expensive paint.

Whereas the previous exercise featured a semi-transparent and a transparent colour, giving very clear washes in thin applications, these mixing partners are both opaque.

All of the mixes that you produce for this exercise will cover other colours well in heavier applications. If you compare this and the previous exercise you will see a noticeable difference between them in colour range (due to the nature of the pigments) and in opacity. Such differences are invaluable in all forms of work.

Let us stop for a moment and consider just why the yellow is needed at all for exercise 7 (page 61). The Cerulean Blue, we know, carries a lot of green. Let's say that it has all of the green that we need, that we do not require the small amount of green carried by the Cadmium Yellow. Why add the yellow at all?

If you think about the processes taking place within the paint film when these particular colours are mixed, the answer will be obvious, but contrary to all we have been led to believe.

The yellow is added to the green-blue in order to destroy the blueness and release the green that it carries.

Unless colour mixing can become a thinking process, based on a knowledge of what actually happens when colours are blended, controlled colour mixing over a wide range will never be possible.

As you mix them, visualise the in-fighting taking place in the innocent looking paints in front of you.

Exercise 8
semi transparent green-yellow + opaque green-blue

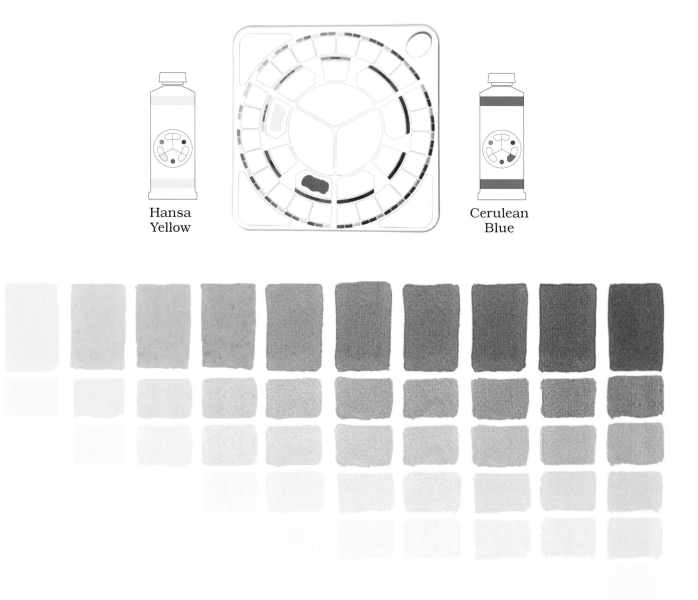

Hansa Yellow

Cerulean Blue

This time we will deliberately choose a yellow and a blue that are both *good* carriers of green. The greens that emerge are brighter than the previous mixes simply because more green is available.

This will be more noticeable in your own mixes than the above example as colour printing can never quite match up to mixed paints.

You will notice that the arrows on the Colour Bias Wheel point towards the green position.

In exercise 5 (page 57), dull greens emerged when the arrows both pointed *away*.

When mid-greens were created one arrow pointed *away* from the green and the other pointed *towards it*. For bright greens, both point *towards*.

Exercise 8
semi transparent green-yellow + opaque green-blue

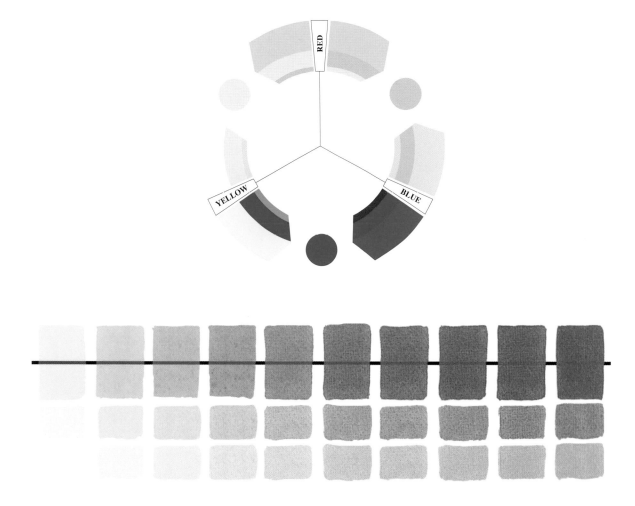

From semi-transparent yellows the mixes will become more opaque as you move towards the blue end of the range.

Our eyes are particularly sensitive to greens and we can recognise a very wide range as well as small changes between one and another.

Playing such an important part in many forms of painting we need to be able to mix the exact green required without hesitation.

The most common problem encountered when it comes to colour mixing lies in this area.

As you will see over the coming pages, this need not be one of *your* problems as a vast range of greens can be created with absolute ease.

Exercise 9
semi transparent green-yellow + transparent green-blue

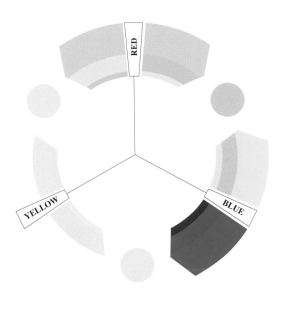

The main colours reflected by Cerulean Blue.

The main colours reflected by Phthalocyanine Blue.

The make up of each of the six principal mixing colours is shown in the 'Colour Bias Wheel' in diagram form to give an indication of the colours that each reflects. Naturally the actual make up of artists colours will vary one to another.

In the diagram above, the three main colours reflected by Cerulean Blue are shown. A large amount of blue followed by green with a smaller amount of violet. This is not intended to be a scientific diagram but a general guide.

Cerulean Blue is definitely a green-blue, green being the second colour to be reflected following the blue.

Phthalocyanine Blue is also a green-blue but it reflects a greater proportion of green than does Cerulean Blue. The additional green is largely at the expense of the violet.

This 'extra' green can be put to good use as you will find in the following exercise. This approach to colour mixing will enable you to 'fine tune' the results.

66

Exercise 9
semi transparent green-yellow + transparent green-blue

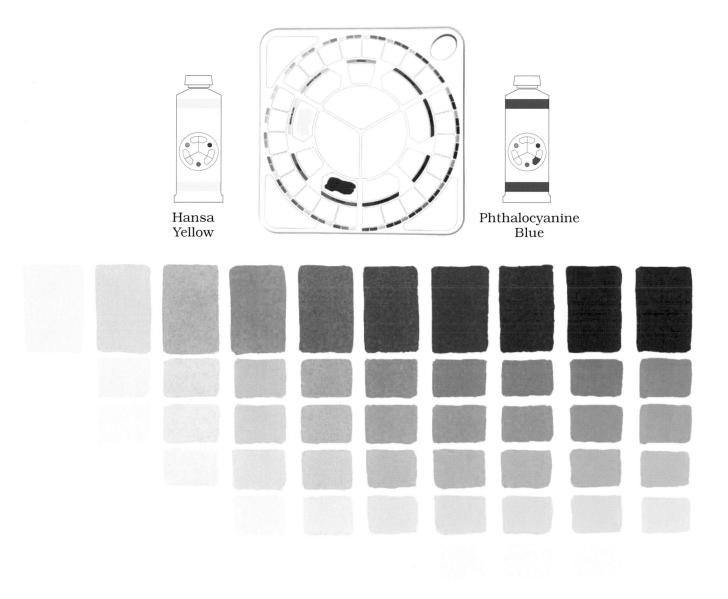

Hansa
Yellow

Phthalocyanine
Blue

When, for exercise 8 (page 64), you mixed the green-yellow with the green-blue, Cerulean Blue, a range of relatively bright greens emerged. This, of course, is because both the yellow and the blue carried large 'amounts' of green to the mix. Cerulean Blue is a definite green blue as is Phthalocyanine Blue. But the latter carries *even more* green.

As you mix the two colours above you will produce a range of extremely bright greens, varying from yellow greens to blue greens.

It is a case of knowing that this blue carries *extra green* when selecting.

When you know what is going on you control colour mixing, not the other way round.

Exercise 9
semi transparent green-yellow + transparent green-blue

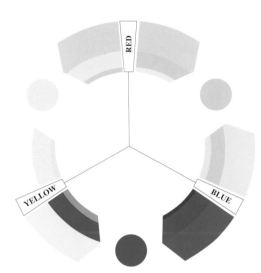

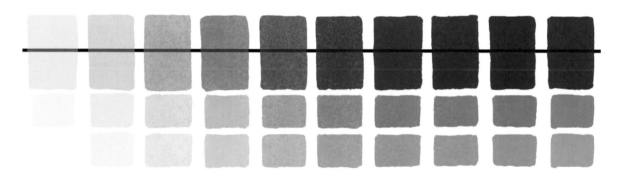

From semi-transparent yellow the mixes will become slightly more transparent as you move towards the blue end of the range. I say 'slightly' because the changes will hardly be noticeable. We can treat the greens and the blue greens as being fully transparent.

This approach to colour mixing is based on a quite different way of thinking to that suggested by the established 'Three Primary System'.

Once you adopt this way of working you will soon be able to visually analyse any colour that you wish to reproduce *before* mixing.

Exercise 10
semi transparent green-yellow + transparent violet-red

Practical work

Materials required: Quinacridone Violet, Cadmium Yellow Light, Cadmium Red Light, Hansa (Lemon) Yellow. A clean brush and dilutant.

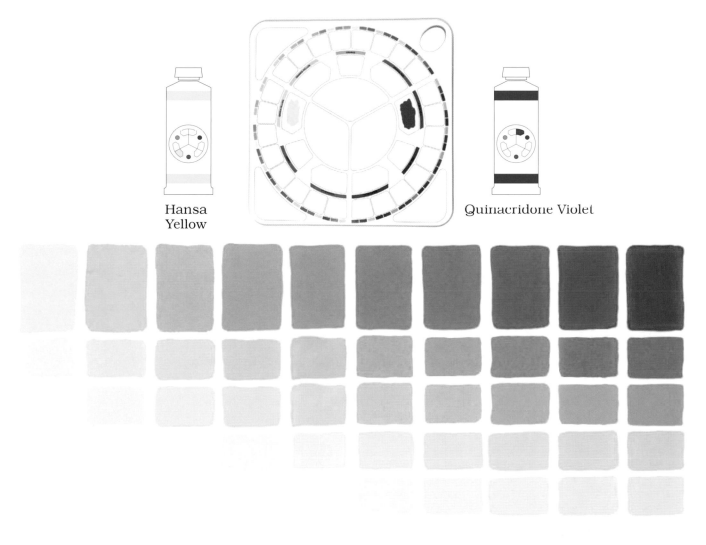

Hansa
Yellow

Quinacridone Violet

Orange is often a rather neglected colour, poorly mixed and applied. As you will discover later, it can be a particularly valuable hue.

The various oranges that can be mixed come into their own when offset against a range of complementary blues. When so used, it is essential to be able to produce a wide range of results.

Applied with skill, oranges can add tremendous vitality to a piece of work.

Since neither violet-red nor green-yellow reflect much orange, they can be expected to produce subdued hues. Again you will notice that for dull, greyed oranges both 'arrows' on the Bias Wheel point *away* from the orange position.

Exercise 10
semi transparent green-yellow + transparent violet-red

From the semi-transparent yellows /yellow oranges, the mixes will become a little more transparent as you move towards the violet-red end of the range.

1. In this exercise the 'colour-type' names green-yellow and violet-red *do not even mention the word orange.*

2. Neither the green-yellow or violet-red 'arrows' on the Colour Bias Wheel point towards the orange position.

The fact that they *both point away* from the orange indicates the result.

3. The 'Colour Bias Wheel' will show the actual make up of the colours and indicate the result.

Exercise 11
opaque orange-yellow + transparent violet-red

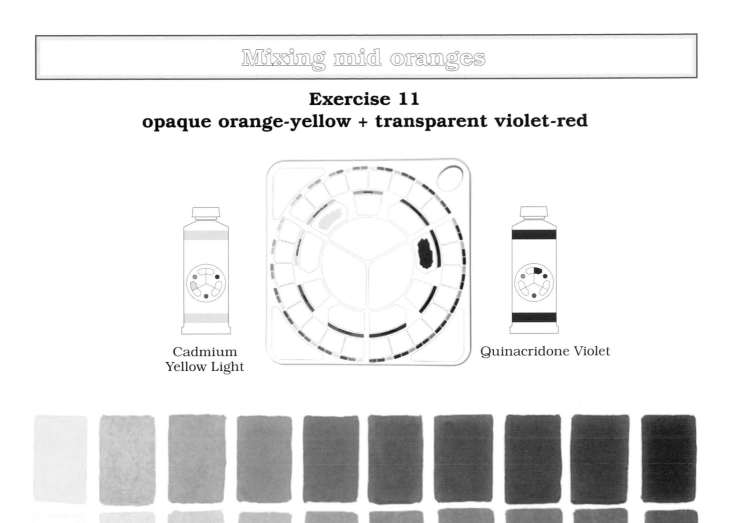

Cadmium
Yellow Light

Quinacridone Violet

The painter can produce quite strong, 'brassy' colours with a mix of orange-yellow and violet-red.

In this range the yellow is providing most of the orange. The main task of the red is to destroy the yellowness in order to reveal the orange.

As the two colours are mixed, the first few blends will lean towards yellow. Around the middle of the range the yellowness and redness will cancel each other out leaving behind the large amount of orange in the yellow and the small amount in the red.

The differences between the various oranges mixed using the two reds and the two yellows are not as marked as those between the various mixed violets and greens.

However, they are still significant when it comes to selecting colours for use in a piece of work.

71

Exercise 11
opaque orange-yellow + transparent violet-red

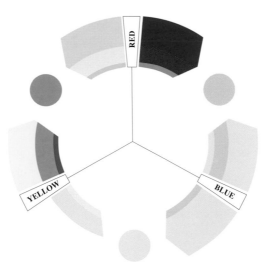

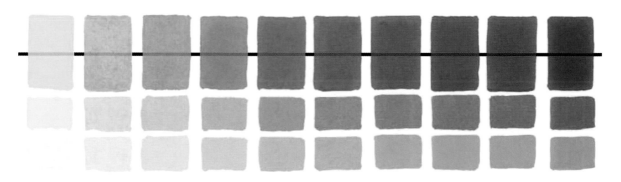

By changing the yellow from a semi-transparent green-yellow to an opaque orange-yellow several major changes are introduced.

Firstly the oranges will be rather brighter than the previous exercise as the orange content of the yellow is released. Secondly the opacity of the yellow will give a range varying from opaque at the yellow end, to semi opaque oranges and on to semi transparent red oranges.

As the tinting strength of the violet-red (Quinacridone Violet) is rather high, you will only require small touches of the colour when mixing for this exercise.

One of the advantages of using a limited palette in your work is that you quickly come to terms with the characteristics of the individual colours.

Exercise 12
semi transparent green-yellow + opaque orange-red

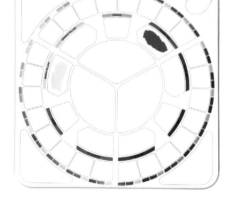

Hansa
Yellow

Cadmium
Red Light

Soft, warmer oranges emerge from a combination of green-yellow and orange-red.

Again, only one colour is providing a significant amount of orange, the red.

As only a limited amount of orange is available the colour can never be particularly bright.

As with the mid-violets and mid-greens that you mixed earlier, one 'arrow' on the Bias Wheel points *towards* the orange position and the other points *away*.

Exercise 12
semi transparent green-yellow + opaque orange-red

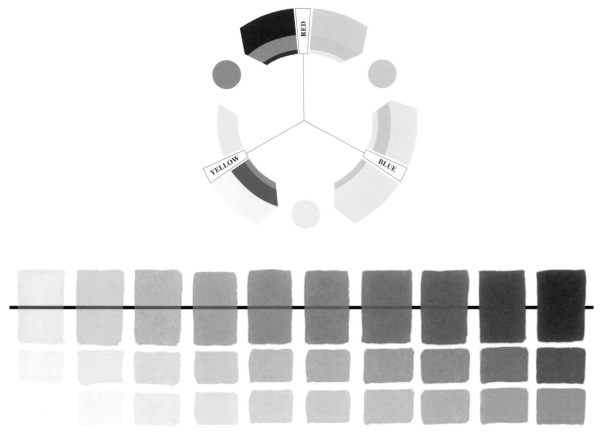

A range of semi-opaque to opaque oranges emerge from this mixing pair when compared to the previous exercise. This is particularly so at the red-orange end of the range where the opaque Cadmium Red Light has a major influence.

The printers 'primary' colours can only ever give dulled oranges.

Use the colour illustrations shown throughout the book as no more than a general guide as there *will* be differences between the colours that you mix and those printed here.

Conventional colour printing is severely limited, particularly in the area of orange.

This is because the red used in printing is a violet red (magenta). As the 'colour-type' name suggests, a violet-red carries a small amount of orange. Only mid oranges can result when it is mixed with a yellow.

If the yellow used by the printer happens to be a *green*-yellow the oranges will be even duller than if an orange-yellow had been employed.

Exercise 13
opaque orange-yellow + opaque orange-red

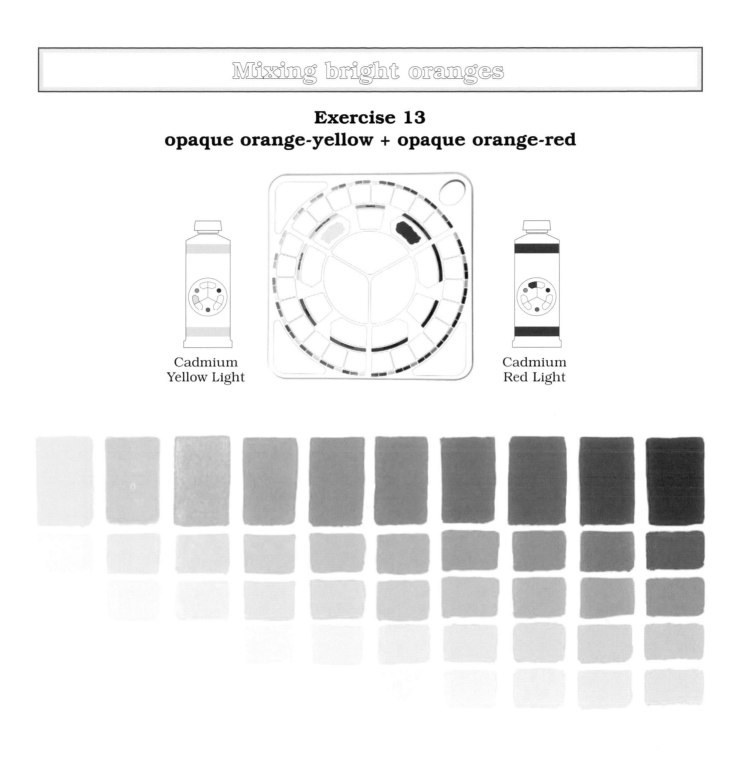

Cadmium
Yellow Light

Cadmium
Red Light

When using the Colour Bias Wheel as a guide, the two main indicators to use are the 'colour-type' names and the arrow shaped mixing wells.

In exercise 4 (page 53), a mix of *violet*-red and *violet*-blue produced a *bright* violet. The arrow shaped mixing wells both pointed *towards* the violet mixing well.

In exercise 8 (page 64), a mix of *green*-yellow and *green*-blue produced a *bright* green.

Again the arrow shaped indicators both pointed *towards* the green mixing well.

In this exercise *orange*-yellow and *orange*-red are used (the word orange is mentioned twice, indicating that the result will be a bright orange). A further indicator is the fact that both arrow shaped 'colours' point *towards* the orange position. The combination of 'colour-type' and the Bias Wheel will guide you in these initial exercises.

75

Exercise 13
opaque orange-yellow + opaque orange-red

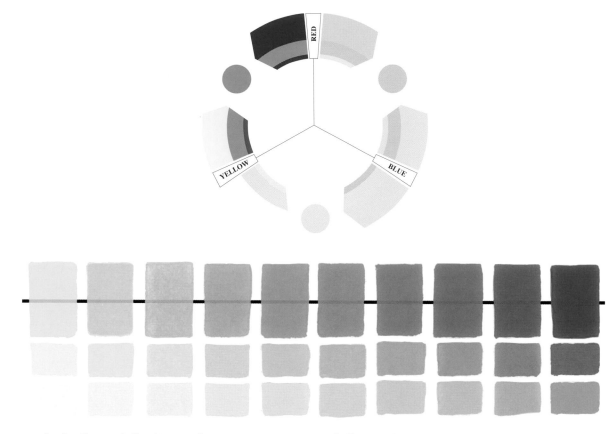

As both contributing colours are opaque it follows that their mixes will also cover well. You will notice that the tints are reasonably transparent (if you are thinning with dilutent rather than adding white), particularly as they become paler. Well made Cadmium colours have the strength to enable this characteristic. Paints choked with filler (as too many still are) tend to 'break up' and become grainy in the thinner applications.

By choosing contributing colours which both 'carry' large amount of orange, we can be certain of producing bright orange every time.

Again, use the illustration above as a very general guide as conventional colour printing is particularly limited when it comes to reproducing orange. Bright oranges are impossible to print using the conventional printing colours; magenta, cyan (green blue) a yellow and black.

This situation tends to be the cause of frequent concern. A common sequence is that a client will take an idea to a graphic artist. The latter will prepare artwork using bright markers and/or gouache.

After acceptance by the client, this work is then presented to the printer. It is scanned and printed. The finished print displays many shortcomings, particularly in the area of the oranges.

The printer is blamed for not producing the required result. But at the end of the day the graphic artist is at fault for not understanding why conventional colour printing is so limited.

Rather than the graphic artist, I should blame the three primary system and the methods of training which still largely prevail.

The blue is swamped by the red.

Point of equilibrium.

Now it is the turn of the red to become swamped.

The mixes around the middle of the range that we have been studying involved two colours which were present in approximately equal intensity.

We achieved a clear violet, for example, when the red and the blue were present in equal intensities. The red and blue lightwaves were all absorbed, leaving only the violet.

When the proportions of the two pigments are varied, we can expect quite different reactions to take place. If the amount of red pigment in the mix is increased, there will be insufficient blue pigment present to entirely destroy the reflected red and orange light. The result will be a red with a slight leaning towards violet. You can see this in the first few boxes of the exercises on page 53.

As the blue content in that range of mixes is increased, it is able to destroy more and more of the light being reflected by the red. About the centre of the range, a point of equilibrium is reached where all reflected light is destroyed, apart from the violet.

The mix moves towards blue as more of that colour is added. Now it is the red's turn to be swamped. More of the blue and green light reflected by the blue pigment is able to escape and mingle with the violet light. There were simply not enough particles of red pigment in the mix to physically cope with the large amounts of blue light.

A similar situation will exist where two (or more) colours are combined in unequal proportions. A green mixed from a combination of blue and yellow, for example, will become a blue-green if more blue paint is added, simply because the yellow, pigment will not be able to destroy all of the blue light.

Equilibrium - green.

Moving towards blue - green.

More blue is added.

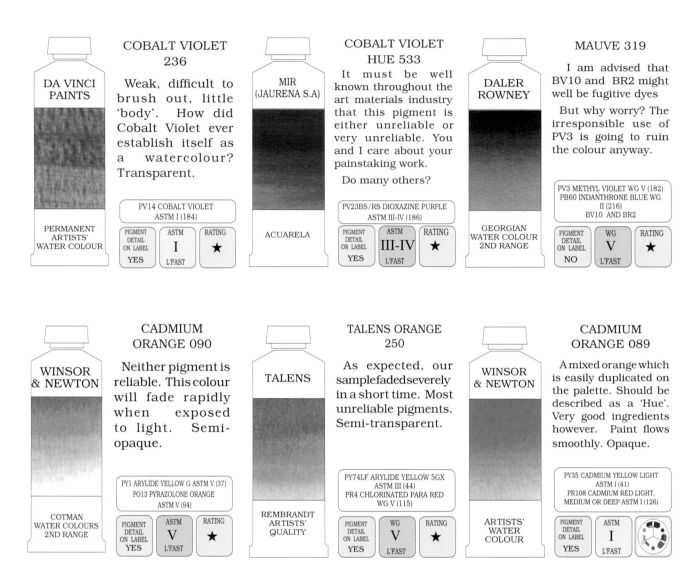

COBALT VIOLET 236

DA VINCI PAINTS

Weak, difficult to brush out, little 'body'. How did Cobalt Violet ever establish itself as a watercolour? Transparent.

PERMANENT ARTISTS' WATER COLOUR

PV14 COBALT VIOLET ASTM I (184)		
PIGMENT DETAIL ON LABEL YES	ASTM I L'FAST	RATING ★

COBALT VIOLET HUE 533

MIR (JAURENA S.A)

It must be well known throughout the art materials industry that this pigment is either unreliable or very unreliable. You and I care about your painstaking work.

Do many others?

ACUARELA

PV23BS/RS DIOXAZINE PURPLE ASTM III-IV (186)		
PIGMENT DETAIL ON LABEL YES	ASTM III-IV L'FAST	RATING ★

MAUVE 319

DALER ROWNEY

I am advised that BV10 and BR2 might well be fugitive dyes

But why worry? The irresponsible use of PV3 is going to ruin the colour anyway.

GEORGIAN WATER COLOUR 2ND RANGE

PV3 METHYL VIOLET WG V (182) PB60 INDANTHRONE BLUE WG II (216) BV10 AND BR2		
PIGMENT DETAIL ON LABEL NO	WG V L'FAST	RATING ★

CADMIUM ORANGE 090

WINSOR & NEWTON

Neither pigment is reliable. This colour will fade rapidly when exposed to light. Semi-opaque.

COTMAN WATER COLOURS 2ND RANGE

PY1 ARYLIDE YELLOW G ASTM V (37) PO13 PYRAZOLONE ORANGE ASTM V (94)		
PIGMENT DETAIL ON LABEL YES	ASTM V L'FAST	RATING ★

TALENS ORANGE 250

TALENS

As expected, our sample faded severely in a short time. Most unreliable pigments. Semi-transparent.

REMBRANDT ARTISTS' QUALITY

PY74LF ARYLIDE YELLOW 5GX ASTM III (44) PR4 CHLORINATED PARA RED WG V (115)		
PIGMENT DETAIL ON LABEL YES	WG V L'FAST	RATING ★

CADMIUM ORANGE 089

WINSOR & NEWTON

A mixed orange which is easily duplicated on the palette. Should be described as a 'Hue'. Very good ingredients however. Paint flows smoothly. Opaque.

ARTISTS' WATER COLOUR

PY35 CADMIUM YELLOW LIGHT ASTM I (41) PR108 CADMIUM RED LIGHT, MEDIUM OR DEEP ASTM I (126)		
PIGMENT DETAIL ON LABEL YES	ASTM I L'FAST	

Reproduced from the 'Wilcox Guide to the Finest (Best in USA) Watercolour Paints.

With careful selection, we can create clear, bright colours and a wide range of valuable, neutralised hues.

There are of course prepared violets available straight from the tube or pan: Cobalt Violet, for example, is widely used, but it is a weak hue which makes into a very poor paint, especially as a watercolour. *Beware of selecting particularly bright violets as many tend to darken.* When it comes to oranges, a well made Cadmium Orange can be very slightly brighter than a mixed bright orange.

Having said that, most Cadmium Oranges are not what they claim to be but are mixtures of Cadmium Yellow and Cadmium Red. Easily blended on the palette.

These and other alternatives can certainly have a place. However, the colours which are obtainable from our limited palette will probably be brighter than you will ever require and will either have to be applied in very small touches or desaturated slightly.

The benefits of looking for brighter versions are limited and can carry a lightfast penalty.

Judging by the appearance of most paint boxes that I come across, greys and neutral colours seem to be all the rage. But such dulled colours can quickly dominate a painting. It is only when they are deliberately produced and perhaps balanced against brighter colours that subtlety can be introduced and skill employed.

A popular pastime amongst artists seems to be the creation of what is usually described as 'mud'. Watercolourists in particular complain about the amount produced, but we are all capable of mixing it.

When bright, clear hues are mixed and they suddenly turn into a greyish sludge, a common reaction is to hurl the palette onto the floor, shout at the cat and swear never to paint again.

Although you might have the patience to calmly clean the brush and try again, I feel sure that you are in a minority. Many experience such frustrations for the simple reason that the 'mud' turned up uninvited.

At first sight it would seem that the mixture represents a waste of materials and time, but this need not be the case.

Once mixing is under complete control such colours can be seen in an entirely different light. The 'mud' becomes a series of subtle, often delicate neutrals and coloured greys.

Practical work

Materials required : Violet-red, orange-red, orange-yellow, green-yellow,
A clean brush and dilutant.

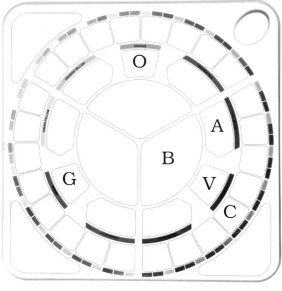

Fig. 1

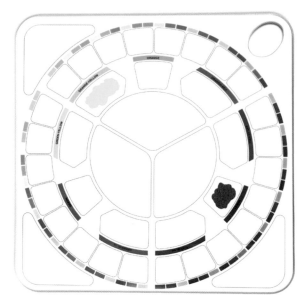

Fig. 2

The following is intended for those artists using our Colour Coded Mixing palette:

The use of the 'arrow' wells (A) for the six colour types will by now be obvious. (Please, see fig. 1)

The inner wells (B) are intended for mid and greyed hues produced from any two of the six basic colour-types. For example, a dull green mixed from violet-blue and orange-yellow.

The wells (V, G & O) are for bright violets, greens and oranges. The 'violet' well, (V), for example, would be used for a blend of violet-red and violet-blue.

The outer wells (C) have been designed to take the colours which result when complementaries are mixed.

If, for example, you wished to mix an orange-yellow and a bright violet, Place the orange-yellow into the orange-yellow arrow shaped well. (Fig 2).

Then mix the violet and place it into the 'violet' well. (Fig 2). As the yellow is added to the violet the resulting dark colours should be placed into the outer wells. Darkened yellows into the outer well behind the orange-yellow arrow shaped well and darkened violets behind

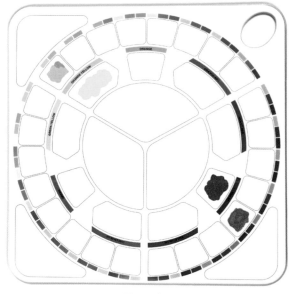

Fig. 3

one or other of the two wells behind the 'violet' position. (Please see fig 3).

The three corner wells are intended for large mixes or white.

These are just suggestions. At the end of the day it is really up to you how the mixing wells are employed. Work in a way that you find convenient.

Exercise 14
opaque orange-yellow + transparent mixed bright violet

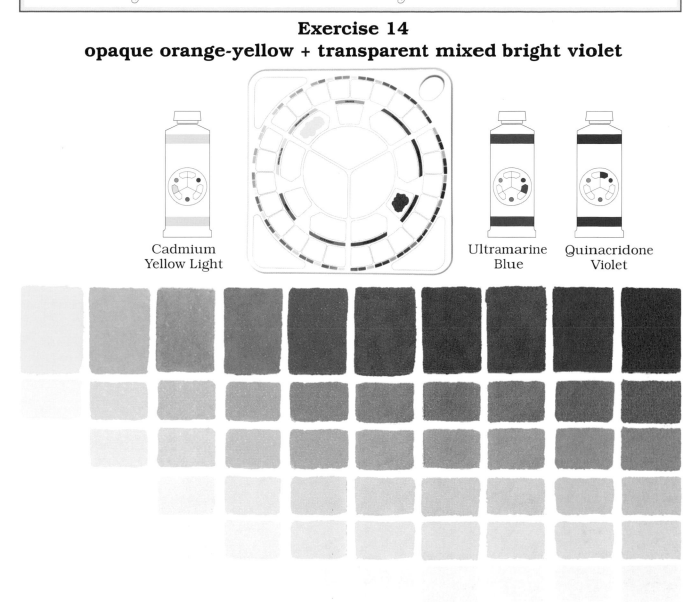

Cadmium
Yellow Light

Ultramarine
Blue

Quinacridone
Violet

Opaque orange yellows moving to semi opaque deep neutral yellows, semi transparent violets through to transparent violet. A wide range of neutrals, coloured greys, bright contributors and transparencies.

Yellow and violet, a complementary mixing pair, will destroy each other very efficiently when blended. Add small amounts of a pre-mixed bright violet (from violet-red and violet-blue of course) to the yellow.

As the violet is added progressively to the yellow it will absorb that colour. Violet is particularly efficient at destroying yellow.

As it is added it removes more and more of the reflected yellow light. This can be seen in practice over the first 4-5 mixes as the yellow becomes darker and darker.

Then, as more of the violet is added to less and less yellow, the opposite happens, the yellow dulls the violet. These two colours are very efficient at 'soaking up' each other's light.

At the left of the series you will mix what are known as *neutral* yellows, to the right are *neutral* violets. Around the centre of the range you will produce what are known as *coloured greys*.

These are particularly dark because most of the light is destroyed, the *two* colours attacking each other with a vengeance.

*Orange-yellow reflects very
little violet, absorbing the rest.*

*Violet reflects very little
yellow, absorbing the rest.*

As you know, orange-yellow is a very good reflector of yellow, a reasonable reflector of orange and will also reflect a useful amount of green.

But, and this is an important 'but', orange-yellow reflects only a small part of the blue, even less of the red and only a tiny portion of the violet.

If only a tiny portion of violet is reflected it follows that the rest is being absorbed. Orange-yellow therefore is a good absorber of violet. >

If one of the reasons that orange-yellow pigment looks that colour is because it efficiently absorbs violet, it follows that in a mix, any violet light reflected from violet pigment or a mixed violet, which runs into yellow pigment will mainly be absorbed.

Similarly, violet only looks that colour because it reflects violet well followed by the other colours in succession. But at the bottom of the list is yellow, which the violet is very good at absorbing.

To return to the diagram on page 28, the surface of the paint appeared green because the blue and the yellow pigments absorbed each others light and only the green (common to both) escaped from the mix.

In the case of an equal (in intensity) mix of yellow and violet, they will absorb each others light very efficiently. As there is *not* a common

colour that they both reflect, the result will be a lack of light at the surface and it will appear dark. I have shown a violet pigment here, the result will be the same from a mixed violet but even more complicated to illustrate.

I realise that these diagrams might look a little like a pig's breakfast, but it is a difficult concept to illustrate in any other way.

Try to imagine the violet acting almost as a dimmer switch on the yellow light and vice versa.

When the complementaries are mixed they immediately set about absorbing each other.

As soon as the violet is added to the yellow, even in very small amounts, it starts to absorb it.

The best way to think of this is to imagine the violet acting almost like a dimmer switch on the yellow. In fact this is a close analogy as the yellow paint only appears that colour because it reflects, or we could say 'sends out' yellow light. A yellow light bulb, in essence, does much the same.

As the violet is added, imagine it turning down the dimmer switch, reducing the amount of yellow light that can be reflected, causing the colour to become gradually more subdued.

In turn the yellow paint reduces the violet light (again like a dimmer switch) as it gradually absorbs it.

Around the middle of the range they do, in effect, turn both dimmer switches fully and almost all of the once reflected light is absorbed. The light almost goes out.

Exercise 15
semi transparent green-yellow + transparent mixed bright violet

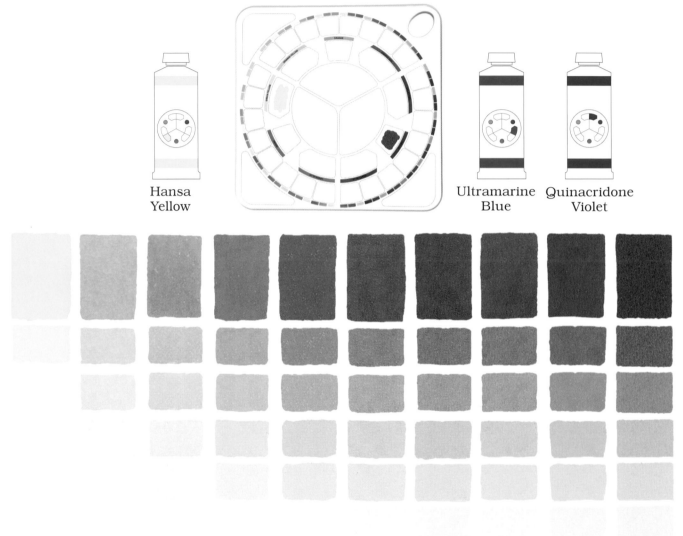

Hansa
Yellow

Ultramarine
Blue

Quinacridone
Violet

Use a pre-mixed bright violet as in the previous exercise, and place it into the violet mixing well.

This time the yellow is changed from an opaque orange-yellow to a semi transparent green-yellow.

Notice the difference between this and the previous exercise. Just by changing the yellow from one 'colour-type' to another a different range will emerge. The differences in transparency are also noticeable.

With a little practice you will be able to introduce such subtle changes to your own work.

As has been mentioned, this approach to colour mixing is based on the use of just two colours at a time to create any of a vast range of mixes. Because a colour such as a bright violet can be reproduced at any time and used as one of the mixing pair, you can re-create any colour with ease at a future date, perhaps to complete a piece of work or to use a favoured colour.

In the traditional way of working, via trial and error, some 6-8 or more colours might find their way into any mix produced on the palette.

Such complex arrangements cannot be reproduced unless by pure chance.

84

Exercise 15
semi transparent green-yellow + transparent mixed bright violet

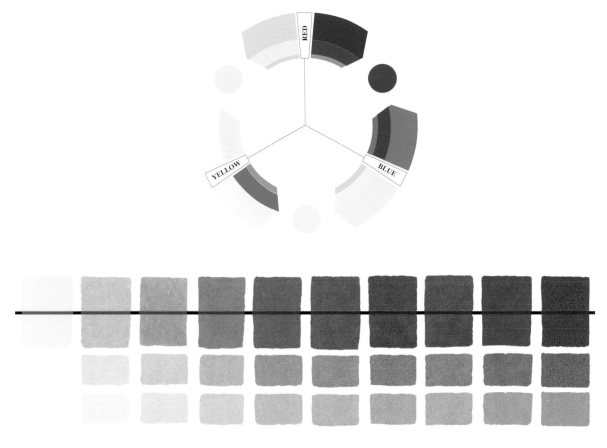

The transparency of the yellow in use here compared to the opaque orange-yellow of the previous exercise brings about further change. It is not just colour-type that we need to be aware of.

Neutrals are dulled or darkened hues, such as the darkened yellows and violets shown above. *Coloured greys* appear about the middle of the range where the two contributing colours are absorbing each others light.

When colours described as mixing complementaries are blended they start to absorb each others light as soon as one is added to the other. Such pairings are usually also visual complementaries.

For this reason they give both neutralised (or dulled) colours as well as the coloured greys. This exercise calls for the prior blending of one of the mixing colours, the bright violet (leaning neither towards the red or the blue).

Although it appears that three colours are being used, in practice only two are ever involved in this approach to colour mixing.

Once the violet has been mixed it is used as a single colour. It is easily reproduced at a future date if the same range is required.

Further amounts of red or blue are not normally added during use as this would remove control. One minute you would be working with a blue violet, the next with a red violet.

With experience this constraint can be removed as you will be able to guide any colour in any direction that you wish.

Practical work

Materials required: Violet-red, orange-red, violet-blue, green-blue, green-yellow, orange-yellow, white. A clean brush and dilutant.

Red Violet from
V-Red + V-Blue

V-Red + G-Blue
+ White

O-Red + G-Blue
+ White

V-Blue + O-Red
+ O-Yellow + White

O-Yellow + Grey
Violet from O-Red
+ B-Green

G-Yellow + Violet
from V-Red + V-Blue

Now we will start to loosen up. The exercises are necessarily rather formal so that you can build up a reference of mixes and note the gradual changes that take place.

Few people actually work this way however and it is important to also take a freer approach.

As you prepare and apply colours at random, you will quickly come to realise that you do in fact have control.

The realisation that you can blend any hue that you wish gives an enormous boost to confidence.

It is also important to get a 'feel' for colour mixing so that you can guide a colour in any direction that you wish.

Mix various violets from any of the previous exercises. They can be dull, mid or bright. Vary them from blue-violet to red-violet.

When you feel ready, try adding a touch of either type of yellow to such mixes in order to create neutral violets or greys.

Then perhaps add a violet to a yellow to create neutral yellows. The important thing is to relax and enjoy your colour mixing. Make notes with each mix if you wish or simply just get a feel for the possibilities.

Thin an area of the mixes to create tints or add a little white for tints of a different character, (more on this later). Typical mixes are shown above, they are not necessarily suggestions.

One of the main complaints as far as colour mixing is concerned is the ease with which muddy colours can be produced. They invariably turn up uninvited and cause a waste of expensive material, as well as frustration.

Painters who complain about the amount of 'mud' that they mix are really experiencing problems with the brighter, more saturated colours.

Once such colours are blended with ease, the duller, neutralised colours can come into their own.

A painting employing only bright, 'clean' hues can look rather garish unless handled well. Where only neutrals and greys are used, a piece of work can look dull and heavy.

Many successful paintings employ a combination of the two approaches.

Usually neutrals and greys offset smaller areas of bright, clear colours.

In exercise 14 (page 81), orange-yellow was mixed with the general complementary - mid violet.

In exercise 15 (page 84), green-yellow was mixed with the general complementary - mid violet.

Exercises 14 (page 81) and 15 (page 84), called for either type of yellow to be mixed with a *bright* violet, leaning neither towards red or blue.

Although yellow and violet are a general complementary pair we need to go a little further if seeking a close pairing. Which type of yellow with which type of violet?

In the next exercise a *green*-yellow will be blended with its close mixing complementary.

We could describe green-yellow another way; by reading the colour description *downwards*:

green

yellow

This description can be broken down into the complementary pairs by now reading left to right again, adding the complementary colour of each component. As you will discover later, green and red are complementaries as also, of course, are yellow and violet.

green > red
yellow > violet

The complementary of green-yellow is therefore a red-violet.

The close complementary of green-yellow is red-violet.

In general terms we can say that the green content of the yellow will attack the 'redness' of the red-violet and the yellow will absorb the 'violetness' of the red-violet.

You might need to read this several times. Do not worry if it is not quite clear just yet, as we will be returning to this approach later.

Once you are familiar with it you will find this method to be a quick and easy way to visualise colour pairings.

The closer a pair of colours are to being complementary, the more efficiently they will absorb each other. However, the transparency of the colours will play a definite role in the final colour. More on this later.

Practical work

Materials required: Orange-yellow, orange-red, green-yellow, violet-blue and violet-red. Clean brush and dilutant.

Exercise 16
semi transparent green-yellow + mixed, transparent bright red-violet

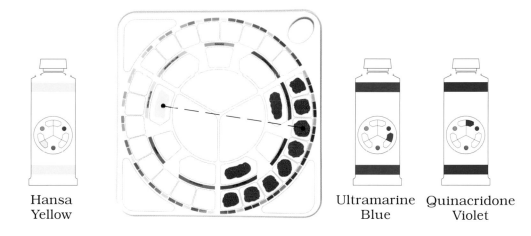

Hansa
Yellow

Ultramarine
Blue

Quinacridone
Violet

Before commencing the actual exercise take a few minutes to decide on the red-violet that you will use. Remember, you are looking for colours which are close to being true complementaries.

You will therefore need a violet which gives a dark colour when blended with the yellow.

Mix a red-violet from violet-red and violet-blue. When you have a violet which definitely leans towards red, add the green-yellow. Experiment until you find a red-violet which becomes quite dark when the yellow is added.

Mix up a quantity of this red-violet and complete exercise 16 in the usual manner.

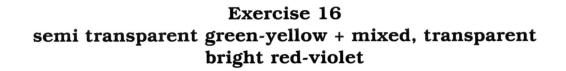

Exercise 16
semi transparent green-yellow + mixed, transparent bright red-violet

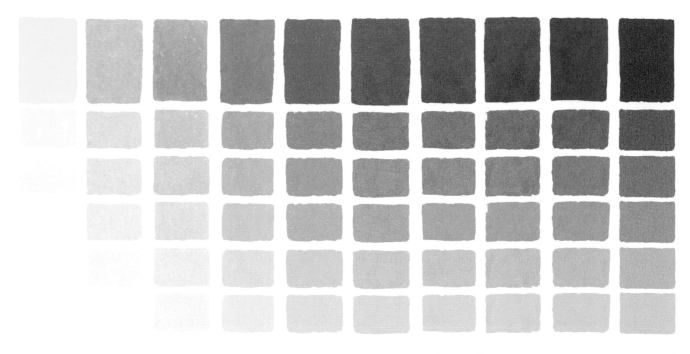

This range can be regarded as transparent. The fact that the yellow is semi-transparent will have little effect past the initial few mixes. Even then, a well produced green-yellow will have enough strength to give reasonably clear tints when thinned. It is only when excessive filler has been used that such colours give poor tints.

As mentioned earlier, do not worry in the slightest if your mixes are 'all over the place', in a muddled sequence. All that is important is that you can see what is happening as the two colours are mixed.

The 'coloured greys' which emerge will be fairly dark. This of course is due to the fact that little light is left because the colours are efficient at absorbing each other.

You will also notice that the darkened green-yellows and violet-reds retain their original characters reasonably well.

This is because, for example, when the red-violet is added to the green-yellow, the greenness and the yellowness in the green-yellow are both slowly absorbed by the redness and the violetness in the red-violet. Therefore the colour as a whole is 'dimmed down'.

If we had used, say, a mid-violet, the violet would have absorbed the yellowness but not all of the greenness which would remain to change the character of the darkened yellow.

If this all seems to be in another language, do not worry. It will become clearer later when we come on to other examples.

I wanted to introduce the concept at this stage so that it will gradually become familiar.

So, have a nice cup of tea, close your eyes and work it out slowly in your mind.

Exercise 17
semi transparent green-yellow + mixed, transparent bright blue-violet

Hansa Yellow

Ultramarine Blue

Quinacridone Violet

In this exercise the same green-yellow as used in the previous range will be mixed with violet, this time a *blue*-violet.

Mix a blue-violet from your violet-red and violet-blue.

At the left end of the range the yellows will lean towards green. This is because there is a lack of red in the blue-violet to cancel out the green in the yellow-green. This 'redness' was present in the red-violet used in exercise 16 previous page, (red and green remember are also complementaries).

The small green content of the blue-violet

will join in also. The results from the present exercises will take some thinking about and it might be a little confusing at first.

Do not let this worry you in the slightest. Colour mixing will become a thinking process for you as you work through the book.

If the reasons for the colours that you are mixing at the moment are not quite clear, you will soon be able to return to this section with all of the answers.

In time you will be able to look at any colour and quickly decide on its make-up.

Exercise 17
semi transparent green-yellow + mixed, transparent bright blue-violet

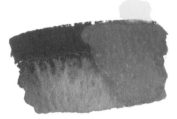

Mix a blue violet from the violet-blue and the violet-red similar to this for the exercise. Alter the mix until it darkens with a touch of the green-yellow.

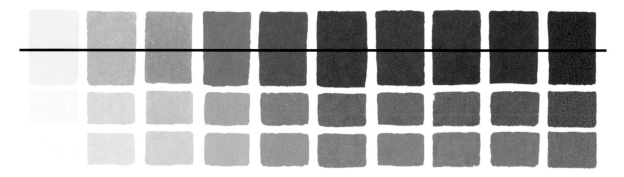

The semi transparency of the yellow will combine with the transparency of the blue violet to give very clear mixes. The very slight opacity of the yellow will have little influence.

As this and exercise 16 (page 90), will show, a mixing pair need to be fairly close to a true complementary relationship if the colours are to retain their individuality on darkening.

You might not always wish to do this of course.

In fact, additional interest can often be added by altering one or other of the complementary mixing pair. The same yellow, for example, with two types of violet will give a wide range of colours to work with which are still basically complementaries.

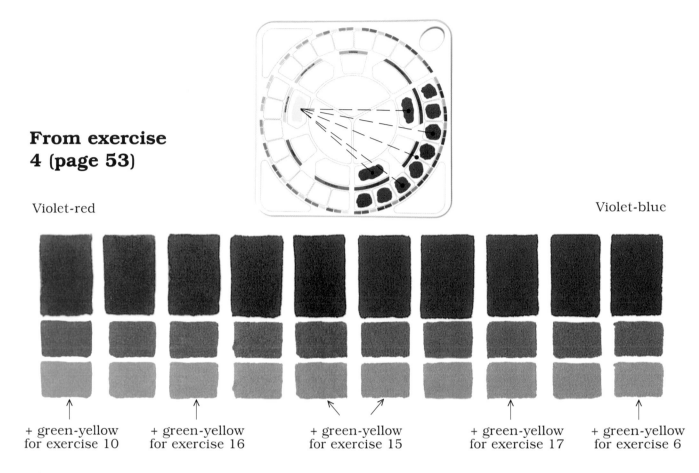

From exercise 4 (page 53)

Violet-red

Violet-blue

+ green-yellow for exercise 10 + green-yellow for exercise 16 + green-yellow for exercise 15 + green-yellow for exercise 17 + green-yellow for exercise 6

The six colour types that you have been using give a vast range of possible mixes. As you work through this book it might seem that there are too many possible blends to come to terms with. You will discover, however, that this is not the case at all, as the colours inter-relate. Take for example the range of bright violets mixed in exercise 4 (page 53), and shown above. We will use the exercise as a base reference for the following observations:

In exercise 10 (page 69), green-yellow was added to the violet-red to produce greyed oranges. It was selected *because it is a poor carrier of orange*.

The same green-yellow was mixed into the red-violet in exercise 16 (page 89), as the two colours were *a close complementary pair*.

The same yellow again was added to the mid-violet in exercise 15 (page 84). Both colours in this case being *general complementaries*.

In the exercise just studied 17 (page 91) the green-yellow was blended into the blue-violet as both were *loose complementaries*.

Finally the same green-yellow was added to the violet-blue to produce the mid-greens in exercise 6 *(page 59), as it is a good carrier of green*.

In each case the two colours were combined for specific reasons and the results were easy to forecast.

It would be useful to go back to the exercises in question to remind yourself how the characteristics of the green-yellow were employed in each case.

Do not worry about trying to take everything in at this stage. It will take a little time, some unhurried thinking and a little practice. Although a vast range of colours will be available to you, each can be found with ease once you understand the processes of colour mixing.

Exercise 18

A little experimenting will soon identify the true mixing partner.

In this exercise we will change from a green yellow to an orange-yellow. As with exercise 17 (page 91), it will be blended with a blue-violet.

The green-yellow used in exercise 17 had a very loose complementary relationship with the blue-violet. This became obvious as both colours began to lose their identity.

Orange-yellow on the other hand enjoys a close complementary relationship with blue-violet. We can ascertain the complementary of a particular colour with ease.

Describe the colour by type, one part above the other. Orange-yellow for example becomes:

<div align="center">

orange
yellow

</div>

Then simply decide on the complementaries of the two parts of the colour. As you will discover, orange is the complementary of blue. Therefore, on the top line, we have:

<div align="center">

orange > blue

</div>

As you already know, violet is the mixing partner of yellow. The bottom line is therefore:

<div align="center">

yellow > violet

</div>

The final arrangement identifies the complementary.

<div align="center">

orange > blue
yellow > violet

Orange-yellow is the complementary
of blue-violet.

</div>

The orange portion of the orange-yellow will absorb the blue (and vice versa). The yellow and the violet will also absorb each other.

The mixing partners can be found opposite each other on the palette.

We can therefore expect this type of yellow and the blue-violet to remain reasonably true to character as they darken each other.

Around the centre of the range, where the two colours almost completely absorb each other, reasonably dark greys should emerge.

To prepare the blue-violet, mix violet-red and violet-blue to produce a bright blue-violet.

Add blue or red to this colour until it gives a reasonably dark coloured grey with the yellow, as above.

What you will be doing in fact is adjusting the blue-violet until it becomes a close mixing partner to the yellow.

Exercise 18
opaque orange-yellow + mixed, transparent bright blue violet

Cadmium
Yellow Light

Ultramarine
Blue

Quinacridone
Violet

As the blue-violet is added to the orange-yellow the two colours will start to 'turn down' each other's light.

Being a close complementary mixing pair they will absorb each other efficiently, leading to a fairly dark coloured grey as they reach equal intensity. Such greys, together with their tints are the ideal accompaniment to the brighter colours from the rest of the range.

The most common 'mistake' when seeking harmony is to introduce other, unrelated dark colours rather than make use of those which are available from the complementary pair.

I write 'mistake' this way because there is no such thing as an *incorrect* colour combination. But we can say that certain approaches find favour with many people.

95

Exercise 19
opaque orange-yellow + transparent bright red violet

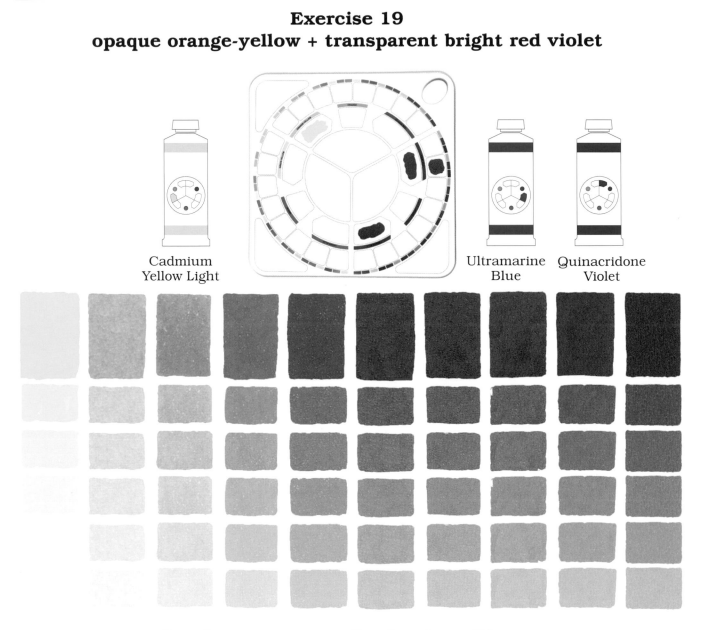

Cadmium Yellow Light

Ultramarine Blue

Quinacridone Violet

From the opaque orange-yellow the mixes will become progressively more transparent towards the red-violet.

In this exercise the same orange-yellow will be used but the type of violet will be changed from a blue to a red-violet.

The complementary relationship in this range will be loose so we can expect a loss of character in the two colours whilst they are at the neutral stage and greys which will not be particularly dark.

They are, never the less, interesting and useful colours. The secret is knowing where they are when you require them.

Although more to do with colour harmony, many very successful paintings have been produced using a particular colour together with variations of its complementary.

An orange-yellow, for example, with both blue and red violets in the one piece of work.

If this approach is to be successful the artist or craft-worker must have full control of colour mixing as well as a knowledge of the way colours inter-relate.

**From exercise 4
(page 53)**

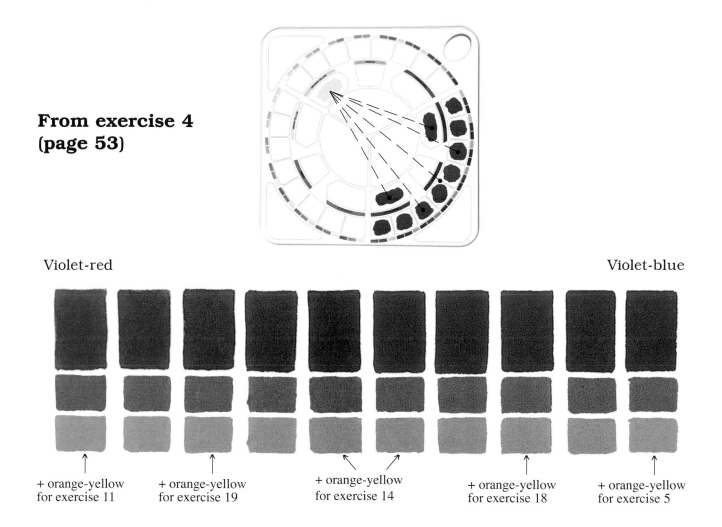

Violet-red

Violet-blue

↑
+ orange-yellow
for exercise 11

↑
+ orange-yellow
for exercise 19

↑
+ orange-yellow
for exercise 14

↑
+ orange-yellow
for exercise 18

↑
+ orange-yellow
for exercise 5

As already outlined on page 93, we can easily visualise the potential range of mixes. We added orange-yellow to the range of violets for a variety of reasons.

With the violet-red we were mixing for mid-oranges. (Exercise 11 page 71). The orange-yellow *carrying a generous amount of orange* to the violet-red's minimal contribution.

In exercise 19 (page 96), the two colours made a *very loose complementary pair.*

Exercise 14 (page 81), showed the range available from a *general complementary pair.*

The yellow was added to blue-violet in exercise 18 (page 94), as both were *close mixing partners.*

It was blended into violet-blue in exercise 5 (page 57), to produce greyed-greens as, like the blue, *it carried only a small 'amount' of green.*

Can you see how it all starts to take shape?

I have used exercise 4 (bright violets) as a starting point. We could also use exercises 1, 2 or 3 (grey and mid-violets) to mix into.
The final results would be related and many of them would be very similar. This of course is due to the fact that we would be neutralising already slightly or very dulled colours.

Can you see how important it is to understand colour-type and colour absorption? To say that violet and yellow are mixing complementaries is too vague. Which yellow and which violet?

Red Violet +
G-Yellow

Blue Violet +
O-Yellow + White

O-Yellow +
Red Violet

Green Yellow +
Blue Violet + White

Red Violet +
O-Yellow

Orange Yellow +
Blue Violet

If you are actually mixing the colours as you work through the book (it is certainly not essential to do so), take any of the colours that you mixed from exercises 14 to 19 and re-mix them at random, in a loose fashion. It would be a good idea to make notes on the mixes as each is completed.

It will be good practice to thin out the blends in order to create tints or to mix white with some of them to produce a different range of tints.

The above is intended as a guide rather than suggestions of possible mixes. Working in a loose, relaxed fashion like this is vital practice for the time when you will be applying your knowledge in earnest.

Coloured greys

It will be useful to study the painting *Miss Eliza Wedgewood and Miss Sargent sketching*, by John Singer Sargent, as the artist employed a series of neutralised and greyed violets to good effect.

The range varied from red-violets through to blue-violets and from slightly neutralised hues through to greys.

Yellow, the complementary of violet, has been introduced to add contrast as well as harmony.

Coloured greys

We will look first of all at the very dark greyed violets used to add a light/dark contrast.

A good example is the dark area on the back of the painting that the woman on the left is working on. (The top right hand corner of the back of the piece).

V

This same dark is used elsewhere on the clothing and in the hat. Where yellow and violet are being used together as visual complementaries, if colour harmony is sought the same two colours should ideally be mixed to give the darks.

Such dark greyed colours, of course, can be produced by mixing the complementaries until both are close in intensity and destroying each other on an even basis.

The coloured greys, the darks used in this

painting appear to have been produced from the same yellow and violet as used in the rest of the painting. The important factor here is that the darks, however nondescript, reflect a tiny amount of violet or yellow.

Why be so concerned that the dark colours also reflect traces of violet or yellow?

Many painters would simply reach for a naturally dark colour such as Burnt Umber or Payne's Grey.

Although such colours will provide a dark, they will add little or nothing to the harmony of the arrangement. At worse they can lead towards colour discord and certainly to a lessening of colour interest.

The introduction of 'outside' colours, such as Payne's Grey, can cause an imbalance. Many paintings become discordant because a wide array of unrelated colours are used.

With this in mind darks have been chosen by the artist which also reflects touches of violet or yellow, however subtly.

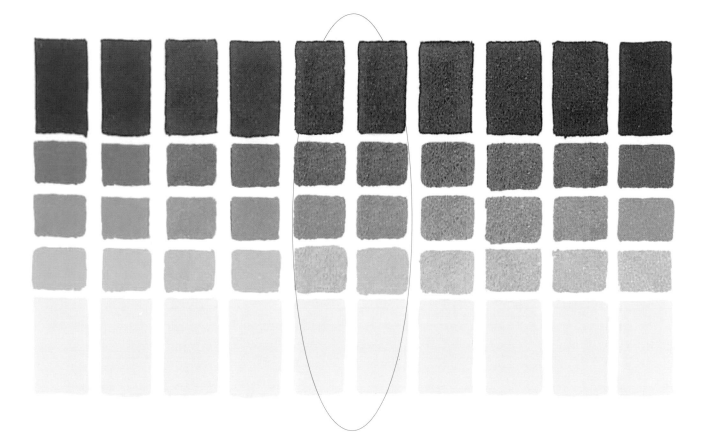

This diagram is based on exercise 4 (page 53), a mixed bright violet with the same orange-yellow added to each of the mixes in that particular range.

The yellow can be added to dull the bright violets (around the middle of the range, circled above) but care should be taken when adding the yellow to the particularly blue or red violets as the mixes will move towards either green or orange. Valuable colours, but they will be harder to harmonise with the rest, unless in small touches.

If the intention is to show areas of *bright* violet, even very small touches, the violet selected will *have* to be mixed from the two efficient carriers of violet, violet-blue and violet-red. No other combination will give *bright* violets.

This will give a very wide range to work with, a range that can be harmonised readily.

However, it will not give the range of blue violets (or red if these were required) that the approach outlined on the next page will.

101

Neutral yellows and violets

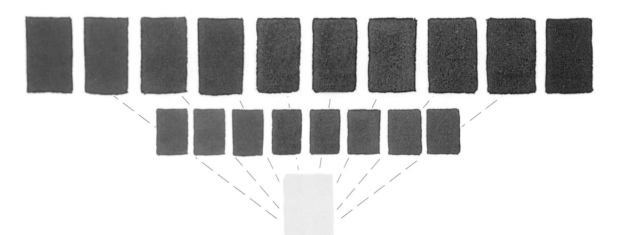

A mid-intensity violet produced from orange-red and violet-blue. Exercise 2 (page 48).

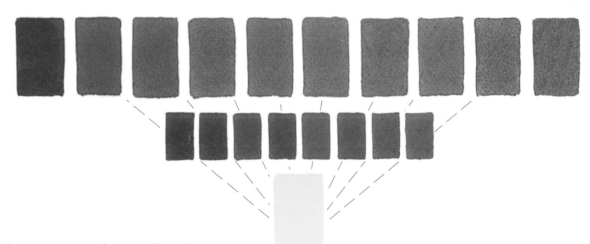

A mid-intensity violet produced from violet-red and green-blue. Exercise 3 (page 51).

Throughout the painting only the one type of yellow seems to have been employed, an orange-yellow. This appears to have been used with two types of mid violet.

If working this way, the yellow can be added to dull the mid violets but care should be taken when adding to the very blue or very red violets as the mix could move towards either green or orange. Such additional colours will be a little more difficult to harmonise.

The painting that we are studying contains a range of neutralised, or dulled, yellows and violets. The violets moving between blue, mid and red violets.

If colour harmony is an important consideration, the violets can be produced in several ways: That outlined on page 101, where bright violets are required, or; If only mid intensity violets (not bright) are ever needed they can be produced from either orange-red and violet-blue or violet-red and green-blue, as shown on the previous page.

The mid violet can then be taken either towards red by adding red or towards blue by adding more blue.

As bright violets do not appear in the painting, this approach appears to have been taken.

To add visual interest *both types of blue* appear to have been used, violet-blue as well as green-blue. These have been allowed to show clearly. Although I cannot be certain, both types of red might be in there somewhere. If so this would be a useful approach to colour harmony. The general approach being to use a complementary pair, in this case yellow and violet. The yellow then being worked into a variety of violets.

This might all take a little re-reading and thinking about, but it could be worth it! Balancing colours to achieve colour harmony is not always an easy matter, however, if you start to look closely at the work of others (with a knowledge of colour mixing under your belt) you can learn a great deal.

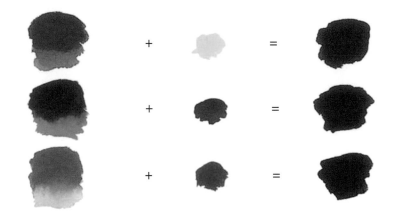

On page 17 we looked at the process involved in mixing a near black from the 'primaries'. We found that if a mix was not quite dark enough we could add another colour to darken it. If it was rather orange we could add a little blue, if violet, some yellow, and if it was on the green side, a little red would darken it.

As you have found, a colour will progressively absorb its complementary partner. We can use this fact to produce subtle neutrals and greys.

The traditional approach to mixing is to put a wide range of colours on to the palette and hope for the best. Many painters have to rely on using colours that 'turn up' while blundering from one mix to another.

Not only are colours employed in the work which are not those intended, but many very subtle colours escape the attention of the painter because they cannot be mixed with ease.

They remain hidden from sight and usually only emerge by accident.

Such colours, soft darkened hues and gentle greys, can be mixed from the complementaries with ease.

Once again let us differentiate between greys and neutral colours.

Greys are dark or nondescript colours that do not have a strong leaning towards any particular hue. When mixed from the complementaries they are often called *coloured* greys.

Neutrals are darkened or dulled hues, such as darkened red or green.

As covered on pages 17-18, when red, yellow and blue, (traditionally thought of as the artists primaries), are combined, the subtractive process destroys almost all of the light and the mix moves towards black.

The process is known as 'subtractive' because light is always subtracted, or removed.

If the intensities of the three hues are all equally balanced, they blend into a very dark grey, approaching black.

The balance, remember, refers to *intensity* and not the actual *quantities* of paint. Intensity varies from one paint to another.

The 'colour wavelengths' reflected from a green blue.

The 'colour wavelengths' reflected from a violet-blue.

If the blue column shown above represents all of the portion of blue light reflected, we can draw an imaginary box to show the amount of orange light which will also have arrived at the surface.

As the diagrams illustrates, most of the orange is absorbed from either type of blue, with very little being reflected.
We can say therefore that either type of blue is very efficient at absorbing orange.

Following the illustration on the previous page, let's look at the second example, adding blue to orange. We now know that there is no such thing as a pure blue paint. The blues that we use also reflect other colours, most importantly green and violet.

Sufficient blue, green and violet is reflected by any blue to make them important factors to consider when mixing.

But remember the other colours that are also involved: the red, orange and yellow.

Tiny amounts of these colours are reflected while the rest is absorbed. The blue is particularly good at absorbing orange light.

This is why the orange paint was made so much darker when the blue was added. The blue simply destroyed the orange light before it was able to escape.

For the same reasons, orange paint added to blue destroys the blue light. The orange will reflect a tiny amount of the blue, but absorb the remainder. Blue and orange, therefore, are mutually destructive.

These two colours appear opposite each other on our Colour Bias Wheel and on the mixing palette. Such colour combinations are known as mixing complementaries because they mix towards a dark grey. They are also close or exact visual complementaries and will enhance each other when juxtaposed in a piece of work.

We can use the fact that a colour will set about destroying its complementary partner to produce some very subtle effects.

Practical work

Materials required:
Green-blue, orange-red, violet-blue, orange yellow. A clean brush and dilutant.

Exercise 20

opaque mixed bright orange + transparent violet blue

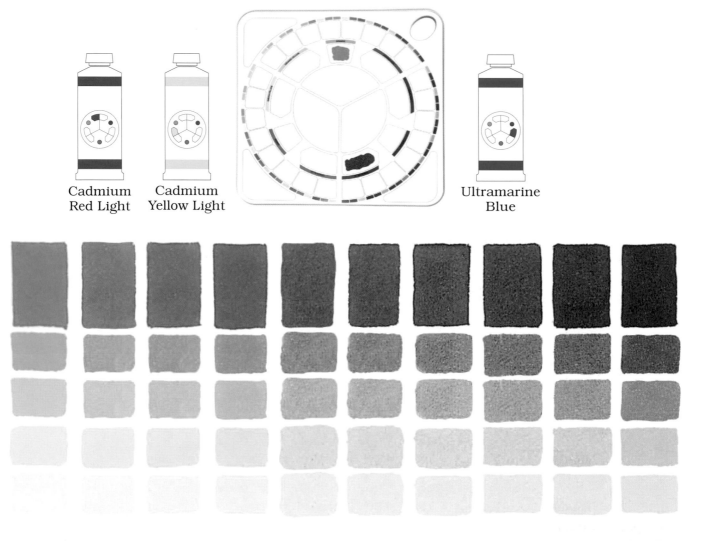

Cadmium Red Light Cadmium Yellow Light Ultramarine Blue

In this exercise, violet-blue is added progressively to a mixed orange.

If you are actually carrying out the exercises, prepare the orange from a blend of orange-red and orange-yellow. As you would expect, the orange will be bright as both contributing colours carry a lot of orange.

As the blue is added, it will gradually darken the orange until the colours approach equal intensities. A coloured grey will then emerge. As with many other 'coloured greys', do not expect this to look like a black/white mix.

Working from the other end we find that small additions of the orange will gradually darken the blue. We could say that it is almost as if the two colours were acting as dimmer switches on each other, turning down the available light.

They do in fact reduce each others reflected light. The important thing is that the light is turned down in a natural way. The nature of the colour is not destroyed, as it would be if black were to be added.

Exercise 20
opaque mixed bright orange + transparent violet blue

If the orange is on the yellow side the mix will lean towards green. The orange will then need to be adjusted.

Too red and the result will be more of a dull violet.
The additional red will have removed the greenness.

A mid orange and violet blue will give a coloured grey. Your mixes will probably look slightly different to these printed examples.

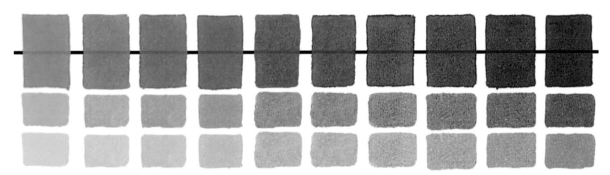

Opaque oranges moving to semi opaque coloured greys and onto transparent violet-blues.

As with yellow and violet, blue and orange are also known as mixing complementaries.

If you wish to try the exercise, pre-mix a bright orange as in exercise 13 (page 75). Make sure that the mix does not lean too far towards the yellow and become a yellow-orange or towards the red and turn into a red orange.

Vary the yellow and orange with care to produce an unbiased orange.

Although this approach to colour mixing is based on the use of only two colours, it could again be argued that three have been used here, the orange having been pre-mixed.

However, mixed hues such as this are always easy to come back to at another time. Therefore they can be treated as individual colours once mixed.

Colours found opposite each other on the palette are not only mixing partners but also visual complementaries.

Although this is not the place to go into detail, visual complementaries can enhance each other when used in a piece of work. They were the basis for the work of the Impressionists.

Exercise 21
opaque mixed bright orange + opaque green-blue

Cadmium Yellow Light Cadmium Red Light Cerulean Blue

The blue is changed from violet-blue to green blue in this exercise. The differences between this and the previous range, although slight at the orange end of the scale, are definitely apparent. Where the orange is used to darken the blue the differences are far more pronounced.

As expected, the green-blue adds a certain amount of green, while the violet-blue in exercise 20 (page 106), exerted a violet influence.

Note the very subtle, soft neutral hues that result when the mixes are made into tints. The colours that have emerged in these two exercises are typical of the vast range of hues that are usually completely hidden. Such dulled hues and coloured greys play a vital role in colour use.

With an understanding of paint mixing, they can be quickly revealed in a very predictable way and used to great effect.

108

Exercise 21
opaque mixed bright orange + opaque green-blue

As both contributing colours are opaque it follows that their mixes will also be opaque. When thinned to give tints, the strength of the orange-yellow (Cadmium Yellow Light) will ensure reasonably clear layers, the green-blue (Cerulean Blue) is less flexible as it makes into a weaker paint and does not stand up well to very thin applications.

It will be worth making a note of the differences between this and the previous exercise.

By changing from one type of blue to another the results are markedly different. To state that blue and orange are mixing partners is too general. The transparency of the colours will also come into play. In both exercises the orange has been mixed from two opaque colours. The Ultramarine Blue (violet-blue) used in the previous exercise is transparent. This transparency can best be seen towards the blue end of the range.

The Cerulean Blue (green-blue) used here is opaque and lacks the strength to brush out very thinly. The differences in colour and opacity are worth noting.

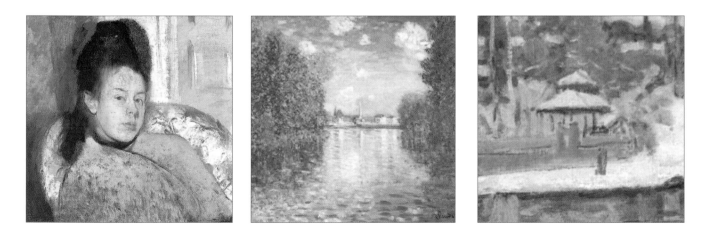

Of all colour combinations, orange and blue have, (by my own observation only) been the most popular since painting and the decorative arts began.

Examples of their use from all ages have been found world wide.

As one example, a glance through a book of Impressionist paintings will show their popularity with that particular group of artists. Not only can the two hues depict many everyday subjects but the wide range of coloured greys they give are invaluable.

109

Orange +
V-Blue + White

G-Blue + a touch
of Orange

V-Blue + Orange
+ White

Orange + a touch
of G-Blue + White

Orange + V-Blue

G-Blue + Orange
+ White

If you are working through the exercises it will be useful practice to produce a few of the orange/blue mixes from the previous two exercises. Mix and apply the colours in a loose, random fashion.

The idea is to experiment with the possibilities in a relaxed way in order to get a feel for the way the colours can be made to work together. Create tints by thinning the paint or add white to some or all of the mixes.

You might find it useful to make brief notes as you work. Treat the above as a general guide only. The mixes shown are not suggestions.

Exercise 22
opaque mixed yellow-orange + transparent violet blue

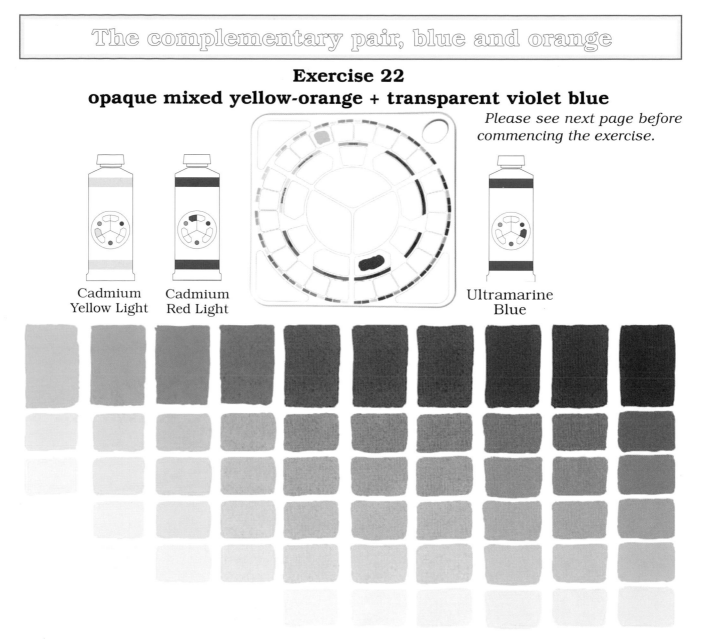

Please see next page before commencing the exercise.

Cadmium
Yellow Light

Cadmium
Red Light

Ultramarine
Blue

In exercises 20 (page 106) and 21 (page 108), a mid-orange was mixed, first with one blue and then the other. In either case, the complementary relationship could only be described as 'general'.

Blue and orange make a general mixing pair.

If we wish to keep the neutral blues and oranges close to their original character and also produce dark coloured greys, we have to choose a blue and orange which are 'close' complementaries rather than 'general'.

In both exercises referred to above the blue was clearly defined but not the orange, it was simply a 'mid-orange'. Once again we can decide on the close complementary of a colour by describing its components, or make up.

If we decide to work with say, a violet-blue we have first to decide on its mixing partner.

Violet-blue, of course, can be described as:

violet

blue

As you know, the complementary of violet is yellow. The top line therefore becomes:

violet > yellow

As the mixing partner of blue is orange, the lower line becomes

blue > orange

Put them together and we have:

violet + yellow
blue orange

The close mixing complementary of a violet blue is therefore a yellow-orange.

111

Exercise 22 continued

After you have mixed your yellow orange, add a touch of violet-blue. If the mix moves too far toward green, add a little red to the yellow orange. The extra red will absorb the

greenness and give a yellow orange which will move towards a coloured grey with the violet-blue. Do not expect a grey which is similar to a mix of black and white.

If you wish to try this exercise, prepare a yellow orange from orange-red and orange-yellow. This, of course, will be a bright orange due to the nature of the contributing colours. Once you have a definite *yellow*-orange, mix some with a little violet-blue.

Adjust the colour until you have a yellow-orange which gives a neutral coloured grey with the blue. If the colour leans towards green add a little red to the orange. (Please see above).

This will be a very valuable colour mixing exercise: Red being the complementary of green (more on this later), the additional touch of red will remove the green from the orange/blue mix. This approach is a means of finely tuning any colour.

Mix this colour with the violet-blue and complete exercise 22 in the usual way.

Do not worry about neatness or gradual change in colour over the range. The aim is to mix the colours and observe the changes taking place.

The greys which emerge will be quite dark. Coloured greys are not necessarily *very* dark. As long as the colour does not lean towards one contributing colour or the other, it can be classed as a coloured grey.

In the case of this exercise (22) it might be found that the greys are not quite as dark as those produced in exercise 21 (page 108), due to the nature of the pigments involved. Mainly their particular transparency.

However, if you observe carefully, you will see that this exercise will produce greys which are

devoid of 'life', as the contributing colours have been destroyed.

As you will know, the reason for this is that the two colours, being close complementaries, will absorb each other very efficiently.

Notice also that the darkened yellow oranges and the blues will retain their individual characters fairly well.

They become darker as their light is dimmed and they do change in character a certain amount. However, they do not take off dramatically in other directions.

Compare this range of colours with those produced from a *mid*-orange and violet-blue, (exercise 20 page 106).

We can describe this earlier mix as:

> violet >
> blue > orange

The violet portion is left largely untouched and remains to influence the neutral blues.

Exercise 22 is quite different and (as outlined on the previous page), can be described as:

> violet > yellow
> blue > orange

The violet content in the violet-blue has been absorbed by the yellow in the yellow-orange. It takes a little thinking about but will be worth the effort.

The differences might be subtle but they are definitely there. To describe blue and orange as a mixing pair is too vague.

Exercise 23
opaque mixed red-orange + transparent violet blue

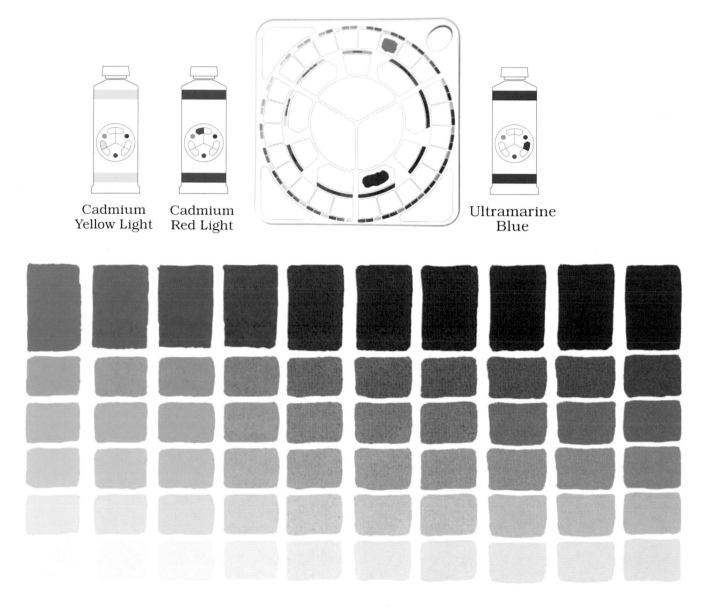

Cadmium
Yellow Light

Cadmium
Red Light

Ultramarine
Blue

In order to increase the possible range, a very 'loose' complementary pair can be blended.

Produce a definite *red*-orange and combine it with the same violet-blue as in exercise 22 (page 111).

By using the one blue with various types of orange, a full and controlled range can be employed. Earlier artists, most particularly the Impressionists, made great use of a base colour such as violet-blue together with several different oranges. The final work had harmony and vitality. This came about not by accident, but by a combination of prior planning and colour knowledge.

113

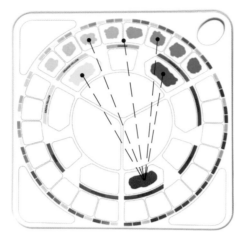

From exercise 13 (page 75)

Orange-yellow Orange-red

↑ + violet-blue for exercise 5 ↑ + violet-blue for exercise 22 ↖ ↗ + violet-blue for exercise 20 ↑ + violet-blue for exercise 23 ↑ + violet-blue for exercise 2

In order to gain an overall picture of the possible range from our six colour types, we can carry out a similar exercise to those shown earlier. The ideal reference to begin with as far as the oranges are concerned is exercise 13 (page 75), bright oranges. We could, of course, select either the greyed or the mid-oranges to work from.

The colours that would emerge would be similar but more subdued.

Violet-blue was added to orange-yellow to produce greyed-greens (exercise 5 page 57) *as neither carried very much green*.

The same violet-blue was blended into yellow-orange in exercise 22 (page 111), as the two colours *are close complementaries*.

Violet-blue was mixed with a mid-orange in exercise 20 (page 106), as they made a *general mixing pair*.

Red-orange was used in exercise 23 (page 113), because it made *a loose complementary to the blue*.

Violet-blue and orange-red were mixed in exercise 2 (page 48) to give a range of mid violets as *only the blue carried an appreciable amount of violet*.

Once you start to use specific colours for a reason, full control over colour mixing will soon follow.

114

Exercise 24
opaque mixed red orange + opaque green blue

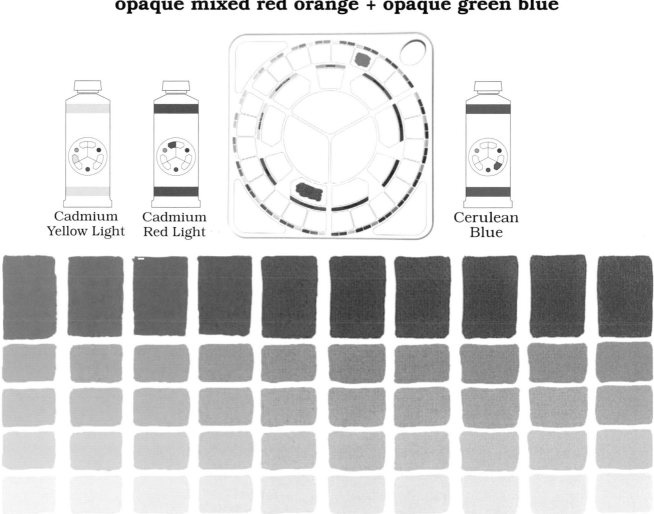

Cadmium Yellow Light Cadmium Red Light Cerulean Blue

The blue will now be changed from a violet blue to a green-blue and mixed with the same red-orange.

In this exercise the close complementary will have been selected to give a range of red-oranges and green-blues which will remain close to their original character as they darken. The greys will also be quite dark.

Follow the usual method to decide on the close complementary of the green-blue. i.e. break the colour down into its main components.
Green-blue becomes:

green
blue

As the complementary of green is red, the top line becomes: green > red

Orange, of course, is the partner of blue, therefore the lower line becomes:

blue > orange

The final line up therefore is:

green red
blue + orange

The more you use this method of determining the close complementary of a colour, the more familiar it will become.

When preparing the red-orange, mix a little with the green-blue. Adjust the red-orange until you arrive at a dark grey when the two colours are blended.

115

Exercise 25
opaque mixed yellow orange + opaque green-blue

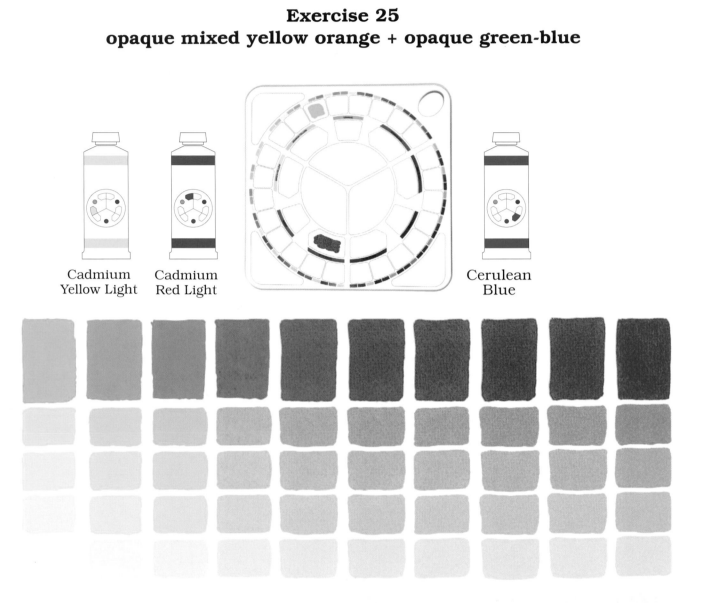

Cadmium
Yellow Light

Cadmium
Red Light

Cerulean
Blue

Mix a *yellow*-orange and complete the exercise by blending it with the same green-blue.

As you will see, these two colours form a very loose relationship. A certain amount of mutual absorption will take place because they do have a complementary relationship. The 'blueness' absorbing the 'orangeness' and vice versa.

However, another way to look at this mix is as an opaque orange-yellow/ opaque green-blue combination (leaving out the red for now).

As you will remember from exercise 7 (page 61), such a mix will give opaque mid intensity greens. The opaque orange-red which has been added to the yellow in order to create the yellow orange can now be considered.

As red and green are complementaries, the red element of the yellow-orange will remove some of the 'greenness' from the central mixes.

The result, as you will see when completing this exercise, will be greens which are even duller than those produced for exercise 7.

I have explained the mix in this way as it is a useful mind exercise when controlling any mix or when taking a colour in another direction; when 'fine tuning' it.

116

**From exercise 13
(page 75)**

Orange-yellow Orange-red

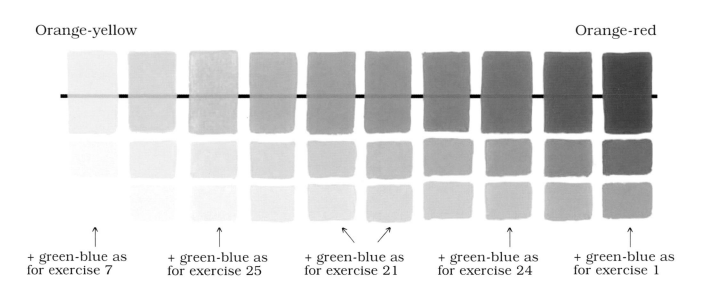

+ green-blue as + green-blue as + green-blue as + green-blue as + green-blue as
for exercise 7 for exercise 25 for exercise 21 for exercise 24 for exercise 1

Once more we can refer to an earlier exercise (ex.14 bright oranges) and work out just why the green-blue has been added to certain of the colours in subsequent exercises.

This will help you to visualise the potential range. It also emphasises the fact that when colours are chosen for a definite reason, the results can be predicted with ease.

It would be a useful exercise to think through the reasons for adding green-blue to:

1) orange-yellow, Ex 7 (page 61).
2) yellow-orange, Ex 25 (page 116).
3) mid-orange, Ex 21 (page 108).
4) red-orange, Ex 24 (page 115).
5) orange-red, Ex 1 (page 45).

Yellow Orange
+ V-Blue

Orange Yellow
+ G-Blue + White

Violet Blue +
Yellow Orange
+ White

Red Orange +
V-Blue + White

Green Blue +
Red Orange

Red Orange +
Green Blue

As in the above example, If you are working through the exercises it will be useful practice to mix various colours from exercises 20 to 25 in a loose, random fashion. Apply some of the mixes thinly onto a white background to create a tint, mix in white with others.

As with other, similar exercises, the idea is to get a feel for the way that the colours blend.

It would be a good idea to make notes on the various mixes as you proceed and to try and work in a loose, open fashion.

Not only do we have a need to be able to mix any desired colour quickly, accurately and without waste, we also have to give some thought to how those colours will be employed.

Careful planning is essential if we arc to use colour to its full potential.

Few artists, in fact, plan their combinations beforehand and rely on 'things working themselves out' as the painting progresses.

This is a little like leaving home for a trip to a distant town without having the first idea about the direction to take.

It is always worth examining well planned work, as much can be learnt.

Let us now study the colour use in the painting. *The Little Peasant* by Amadeo Modigliani.

The combination of hues is simple but very effective and has been used many times in successful works.

The entire painting is centred on the use of the complementary pair, blue and orange. Green-blue as well as violet-blue have been used, together with two types of orange, a red-orange and a yellow-orange.

Although here is not the place to explain further, these two colours will enhance each other visually.

Through after-image they will enliven and support each other and harmonise readily .

What is equally important is the fact that they are a *complementary mixing pair*, each will absorb the other very efficiently, allowing a wide range of neutrals and greys to be mixed.

Look around the painting with reference to colours that you have already mixed and you will discover that these two hues, together with white, have provided the entire range of colours.

119

The darker areas in the jacket are painted in both types of blue (violet and green) and neutralised with a little of the orange. White has then been added to the neutralised blues to give the lighter touches.

Such pale neutrals can be very effective and have a vital role to play in colour use.

(Alternatively the paint could have been applied thinly to allow the white background to create the tint).

Now look at the lapels, particularly the one on the right. Not only has the neutral blue tint been employed but touches of the orange have been worked in and allowed to show.

The orange has been further neutralised with the blue.

This same dull orange, made less intense by the blue and also made paler, has been used in the trousers.

Touches of neutral blue are placed alongside the dulled oranges much in the same way that the two colour types were used in the lapel.

Even the hat and chair appear to come from these same two colours. Wherever you look on the painting you will discover the use of blue and orange as the mixing partners.

Coloured greys, the darker colours, have been created and either used as full strength or desaturated with white.

Coloured greys, whether at full strength or desaturated with white, can also be very effective and as with the neutralised colours, have a vital role to play.

The complete painting appears to have been created using only blue, orange and white.

Yet look at the range of colours, from bright to neutrals to greys, all interacting beautifully (to my mind).

To add a little variety, touches of orange-red have been used in the cheeks and a little green blue has been used close by in the background. Again these are a complementary pair and will be found opposite each other on the palette.

The use of complementary colours to create both subtle contrast and harmony has been explored by many artists. The example given here is but one of countless similar approaches.

120

If you have completed some or all of the exercises so far you might find it a useful learning experience to make a general copy of this painting.

I must stress that this is an exercise in colour mixing, not in accurate copying.

Select colours from exercises 20 (page 106) and 21 (page 108). The aim is to mix and use the range of colours that can be produced from orange and both blues.

Use either the whiteness of the background to produce the tints or white paint as used in the original. Do not try and match the colours exactly; it will be almost impossible to do and quite pointless. Neatness is also unimportant.

Change the colour scheme if you wish. For example, you will gain as much experience if you make the hat blue and the background orange.

This is a colour mixing exercise only, please treat it as such.

SAP GREEN 599 (043)

WINSOR & NEWTON

Unsuitable for artistic expression where permanence is a consideration. Colour becomes paler and bluer. Both pigments are fugitive, as W&N know. Semi-

PG12 NAPHTHOL GREEN B ASTM IV (260)
PY100 TARTRAZINE LAKE ASTM V (46)

ARTISTS' WATER COLOUR

| PIGMENT DETAIL ON LABEL YES | ASTM V L'FAST | RATING ★ |

ALIZARIN CRIMSON 004

DANIEL SMITH

The use of this most unreliable pigment continues despite the fact that it has failed ASTM testing as a watercolour. Best avoided if you value your work.

PR83:1 ALIZARIN CRIMSON ASTM IV (122)

EXTRA-FINE WATERCOLOURS

| PIGMENT DETAIL ON LABEL YES | ASTM IV L'FAST | RATING ★ |

HELIO GENUINE GREEN LIGHT 1193

LUKAS

Pigment Yellow 1 is an unreliable colorant which is known to fade on exposure. It will cause damage to any mix. Semi-transparent.

PG7 PHTHALOCYANINE GREEN ASTM I (259)
PY1 ARYLIDE YELLOW G ASTM V (37)
PY3 ARYLIDE YELLOW 10G ASTM II (37)

ARTISTS' WATER COLOUR

| PIGMENT DETAIL ON LABEL CHEMICAL MAKE UP ONLY | ASTM V L'FAST | RATING ★ |

Reproduced from the book 'The Wilcox Guide to the Finest ('Best' in USA) Watercolour Paints'.

During research for 'The Wilcox Guide to the Finest ('Best' in USA) Watercolour Paints', I came to realise that very many of the greens available today are unsuitable for artistic use.

Many manufacturers use this area as a dumping ground for cheap and unreliable industrial colorants.

In some cases the yellow will fade, moving the green towards blue, or the blue might fade making the green a lot yellower. Sometimes the entire colour will simply fade or darken, often quite dramatically.

Very many paintings are eventually spoiled by the use of such colours. This is not scare mongering, but fact.

There are reliable greens on the market without a doubt, lightfast colours such as Phthalocyanine Green, Viridian and Chromium Oxide Green. These and a few other specialist green paints have a role to play.

That role is usually to provide greens that are either particularly bright, opaque, transparent or possess some other desirable quality. For most work, however, the artist will prepare the greens through mixing.

Because of the poor quality of many pre-mixed, manufactured greens, it is vital, as far as the caring artist if concerned, to be able to produce a wide range of greens from a few reliable colours.

Reds too are often quite unreliable. Many being unsuitable for artistic use.

When you work with a limited palette it is relatively easy to select reliable colours. There are other advantages too, such as the ease with which colours can be harmonised or contrasted.

In earlier exercises a wide range of greyed, mid and bright greens were mixed by carefully selecting the blue and yellow 'carriers'.

The range can be dramatically increased, and a series of subtle greys produced at the same time, by mixing the complementary pair red and green.

Practical work

Materials required
Orange-red, violet-red, green-blue,
green-yellow,
A clean brush and dilutant.

Exercise 26
opaque orange-red + mixed, semi opaque green

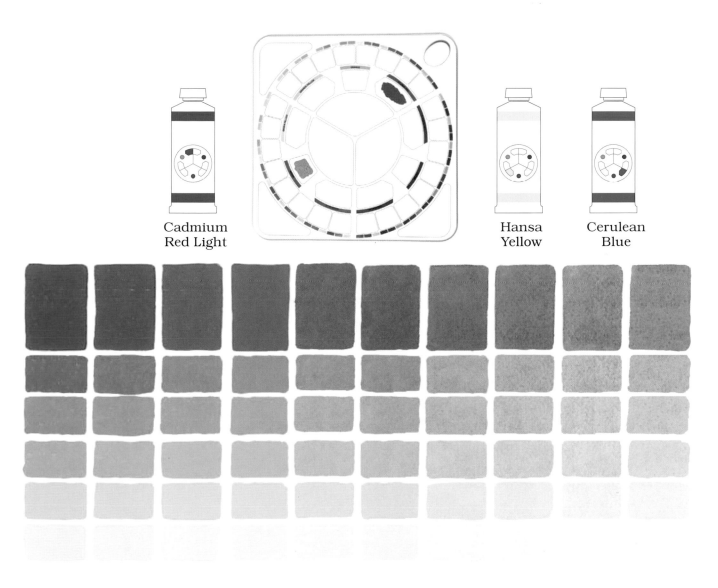

Cadmium
Red Light

Hansa
Yellow

Cerulean
Blue

Prepare a green from green-blue and green yellow. (The green should not lean either towards the blue or the yellow).

Add the green progressively to the orange red in the usual way. A range of neutral reds and greens will emerge, with coloured greys around the middle of the range.

Coloured greys are not necessarily very dark, much depends on the characteristics of the pigments used, particularly their opacity.

As long as the colour does not lean towards one contributor or the other it is classed as a coloured grey.

An orange-red and a mid-green will not produce particularly dark greys as they make a general complementary pair rather than a close one.

The greys will not be very dark for the simple reason that neither colour is capable of entirely absorbing the other.

123

Exercise 26 (continued)
opaque orange-red + mixed, semi opaque green

Empress (c1900) Victoria and Albert Museum.

This combination, used at full or close to full strength (or fully saturated) is, and has been for a long time, a great favourite with the Chinese. When so used, the two hues can contrast strongly and evoke a feeling of excitement in many.

When seeking colour harmony the approach would be for greater subtlety. As in the above example, the contrast has been muted somewhat by the areas of neutral colouring in the floor and to the top of the picture.

Practical work
Materials required
Orange-red, violet-red, green-blue, green-yellow,
A clean brush and dilutant.

Exercise 27
transparent violet-red + mixed, semi opaque green

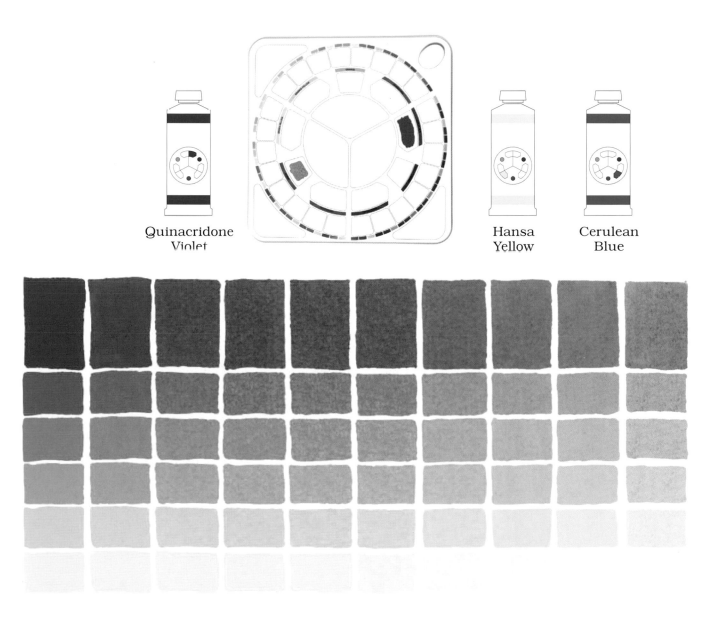

Quinacridone Violet

Hansa Yellow

Cerulean Blue

Now change reds and combine the same green with a *violet*-red. Again, a useful range of neutrals and coloured greys will emerge.

During the exercise the green will neutralise the red and vice versa. You can see the effect of this neutralising, or dulling, at either end of the range.

Around the middle of the range you will find the darker coloured greys. Notice the range of very soft, pale colours which emerge as the tints are produced. Such colours can add great subtlety to a piece of work, yet they are usually very hard to find or to reproduce.

Without an understanding of colour mixing, we come across them by chance, use them once and then they are gone.

When seeking mixing partners, do not worry about trying to find *exact* pairings.

For example, we are not worrying about finding the exact green for the violet-red, but, together with the previous exercise are using both types of red with the one green. Later in the book we will match up a specific type of green with a particular red. Yellow-green with a violet-red for example.

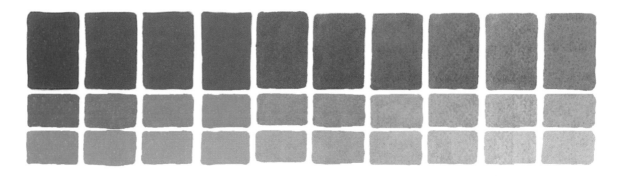

Exercise 26 (page 123)

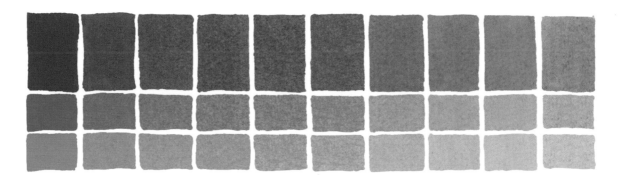

Exercise 27 (page 125)

The violet-red will give a rather different range to the previous exercise. Basically we can say that the redness and the greenness will absorb each other but the main differences will be at the *red* end of each range.

In exercise 26 the orange content of the red was noticeable, in *exercise* 27 the violet component will play a part.

Great versatility can be added to a piece of work by changing the relationship of the complementaries: two reds with the one green for example. The results of both exercises could well be used together in the one piece of work.

Exercise 28 opaque orange-red + mixed, semi opaque blue-green

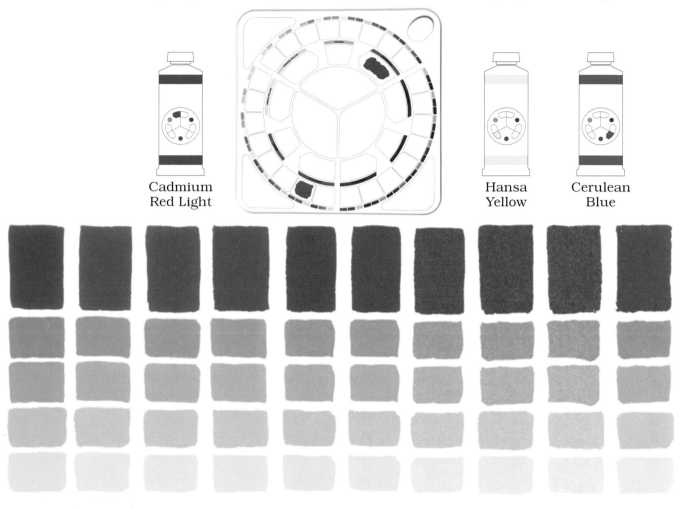

Cadmium
Red Light

Hansa
Yellow

Cerulean
Blue

In exercise 26 (page 123), orange-red was mixed with a mid-green. The two colours made a *general* complementary pair.

In order to keep the colours close to their original character they must be carefully matched; 'balanced' might be a better word.

Again we can find the true complementary of a particular colour by describing it in a different way: Orange-red becomes:

orange
red

The complementary of orange, of course, is blue, and that of red, green.

orange > blue
red > green

The close mixing partner of an orange red is therefore a blue-green. This approach becomes very easy once you have used it several times.

The type of blue-green can be decided upon by mixing a small quantity with the orange-red. When the resulting coloured grey is neutral and quite dark you will have a balanced pair.

As you blend these two colours in the exercise, note the way that they remain fairly close to their original nature.

The greys will be quite dark as each colour will make a thorough job of destroying the other as their intensities are equalised.

If you are putting the exercises into practice, please read the following two pages before proceeding.

127

Exercise 28 (continued) opaque orange-red + mixed, semi opaque blue-green

If using our Colour Coded Mixing Palette, do not worry about trying to match up a mixed paint exactly with the colour codes printed on the palette. Simply go to the nearest match. To cover all possible mixes via the colour indicators would require a palette several miles across.

Place the blue-green into the nearest matching colour coded outer well and look to the other side of the palette for the mixing partner. In this case it is an orange-red, not any red but an *orange*-red. As the blue-green is added very slowly to the orange-red it will neutralise the colour, giving a useful range of dulled orange reds, coloured greys and dulled green-blues.

When working with a complementary pair, one colour will absorb the others light and vice versa.

This particular type of red is very good at absorbing this type of green. As outlined earlier, think of the red acting like a dimmer switch on the blue green light, turning it down gradually.

When it is the turn of the red to be 'turned down' in intensity, this type of green will do the job very efficiently.

Where the two almost absorb each others light fully, the coloured greys will emerge.

128

Exercise 28 (continued)
opaque orange-red + mixed, semi opaque
blue-green

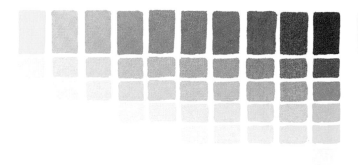

Violet-blue and orange-yellow (ex.5 page 57).

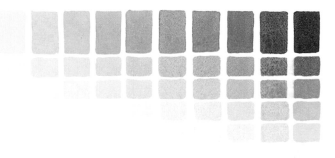

Green-yellow and violet-blue (ex. 6 page 59).

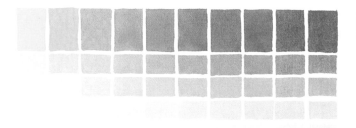

*Orange-yellow and green-blue
(ex. 7 page 61).*

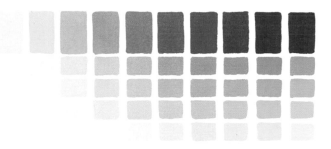

*Phthalocyanine Blue and green-yellow
(ex. 9 page 67).*

To produce the *blue*-green for this exercise, Cerulean Blue and Hansa Yellow were employed.

To work with the blue-green / orange-red combination you could of course mix any of the blue-greens that have appeared in previous exercises. It could be that you were already working with violet-blue and orange-yellow (exercise 5). In which case the blue-green would be rather dull.

Or the blue-green might be of mid-intensity and come from either a mix of green-yellow and violet-blue (exercise 6) or orange-yellow and green-blue (exercise 7).

However, if you decide on introducing touches of *bright* blue-green in a piece of work it will have to come from a mix of green-blue and green-yellow.

Rather than using Cerulean Blue as the green-blue you might well find that the transparent (and greener) Phthalocyanine Blue will fit your purposes better (exercise 9). It would be impractical to cover all possibilities in this book (and we are only working with 12 colours), this is why it is vital to gain an understanding of what happens when colours are mixed. An appreciation of the varying transparencies of your colours is also important.

Exercise 29
opaque orange-red + mixed, semi transparent
yellow-green

Cadmium
Red Light

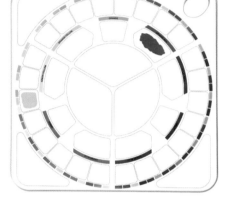

Hansa
Yellow

Cerulean
Blue

Now change the green from a blue-green to a *yellow*-green. As you will notice, these two are not directly opposite each other on the palette diagram above.

This indicates that they are a *loose* complementary pair. Each colour will change somewhat in character as it is darkened. The coloured greys will not be particularly dark.

Nevertheless they make an interesting combination. You can add versatility in a piece of work by varying the complementaries.

The same orange-red with yellow-green and blue-green will give a vast range of colours which can be harmonised with ease. Please see next page before commencing the exercise, if that is your intention.

**Exercise 29 (continued)
opaque orange-red + mixed, semi transparent
yellow-green**

For those using our Colour Coded Mixing Palette, the outer ring of wells on the palette are for colours that you wish to neutralise (make duller or darker). They are also used when you wish to produce coloured greys. In this exercise, a yellow-green is mixed from Cerulean Blue and Hansa Yellow.

When you are satisfied that you have a suitable yellow-green place it into the nearest matching outer well.

As has been mentioned, do not try to match up the paint mix with the colours printed on the palette, they are for guidance only.

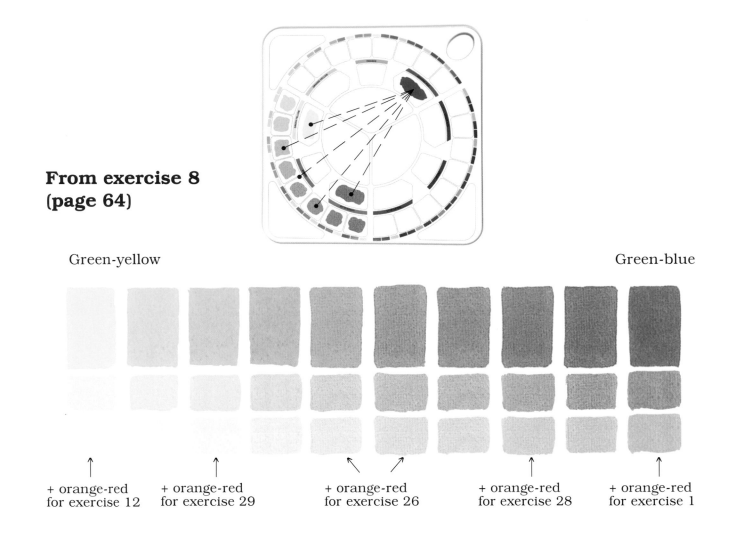

**From exercise 8
(page 64)**

Green-yellow Green-blue

+ orange-red + orange-red + orange-red + orange-red + orange-red
for exercise 12 for exercise 29 for exercise 26 for exercise 28 for exercise 1

Several ranges of greens were produced in the early part of the book. Greyed greens from violet-blue and orange-yellow, mid-greens and bright greens from other combinations.

In order to keep a mental picture of the potential scope, we will return to the range of bright greens (exercise 8), and remind ourselves of the reasons for adding the orange-red.

Orange-red was added to the green-yellow to give a series of mid-oranges in ex. 12 (page 73). These came about because the green yellow is a poor carrier of orange and required the *efficient carrier of that hue, the orange-red.*

Orange-red was added to a yellow-green in exercise 29 (page 130), as the two colours formed a *loose complementary relationship.*

The orange-red and mid-green (ex. 26 page 123)) were a *general complementary pair*, giving predictable results.

Orange-red and blue-green, a *close mixing pair*, gave dark greys and neutrals which remained relatively close to their original character. (Ex. 28 page 127).

Finally the orange-red was added to the green blue as both were *poor carriers of violet*, to produce greyed, dull violets in exercise 1 (page 46).

As soon as you start adding one colour to another for a specific reason, you will have accuracy. The 'three primary system' could never give such control. With practice, this control will give you absolute mastery.

Exercise 30

transparent violet-red + mixed, semi transparent yellow-green

Quinacridone
Violet

Hansa
Yellow

Cerulean
Blue

In exercise 29 (page 130), yellow-green was combined with orange-red. The red will now be changed from an *orange*-red to a *violet-red*.

Note the dramatic difference when the same type of green is mixed with a different red.

To describe red and green as a complementary pair is far too vague. Which red and which green?

Yellow-green and violet-red are a close complementary pair.

We can ascertain this by describing the make up of the two colours:

 yellow > violet
 green > red

The yellow content of the yellow-green will look after the violet of the red and the greenness and redness will absorb each other. It is important in colour mixing to be able to decide as to the close, general and loose complementary of any given colour. When you can do this with ease and also predict the results, you will have absolute control.

133

Exercise 31
transparent violet-red + mixed, semi opaque blue-green

Quinacridone Violet

Hansa Yellow

Cerulean Blue

Now change the green to a blue-green and blend it with the same violet-red.

As you will have discovered (ex. 28 page 127), blue-green is the close complementary of *orange*-red. When those two were combined they stayed close to their original nature.

In this exercise, where a *violet*-red is used, the result will be quite different as the relationship is very loose.

As you will see on the palette diagram above, blue-green and violet-red do not lie opposite each other, indicating that they are not a complementary pair when it comes to colour mixing.

However, they still represent the general mixing partners red and green. They will desaturate (darken) each other but the mixes will not stay in 'character'.

134

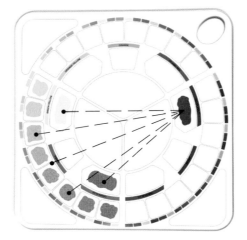

**From exercise 8
(page 64)**

Green-yellow Green-blue

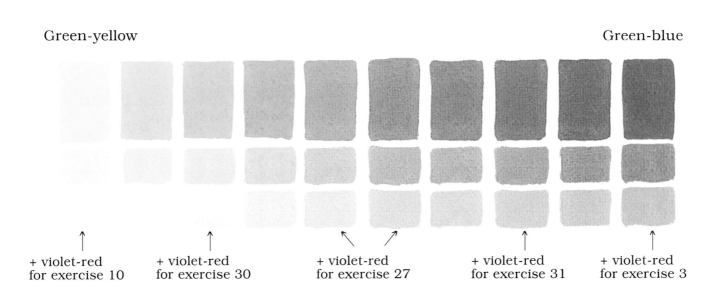

↑ ↑ ↖ ↗ ↑ ↑

+ violet-red + violet-red + violet-red + violet-red + violet-red
for exercise 10 for exercise 30 for exercise 27 for exercise 31 for exercise 3

Again it will be useful to remind yourself just why certain colours were used together in earlier lessons.

This exercise will also help you to form a picture of the basic structure of colour mixing.

It will be useful to think through the reasons why violet-red was blended into:

1) Green-yellow, Ex. 10 (page 69).
2) Yellow-green, Ex. 30 (page 133).
3) Mid-green, Ex. 27 (page 125).
4) Blue-green, Ex. 31 (page 134).
5) Green-blue, Ex. 3 (page 51).

Mid Green +
V-Red + White

Mixed Mid Green
+ O-Red

V-Red + Yellow Green

Blue Green +
O-Red + White

Yellow Green +
O-Red

Orange Red +
Blue Green

Practice piece 1

It you are working through the exercises it will be useful practice to select any of the mixes from the red/green exercises and apply them in a looser style.

The aim of this practice piece is to explore the range available in a more relaxed way, to get a 'feel' for the way the colours blend.

There will be various dusky pinks to work on, or the type of neutral green that you might find useful in your own work.

It pays to make notes as you work for future reference.

The illustration above is a general guide only.

Practice piece 2

Choose any of the red/green combinations.

Once you have decided on a particular exercise, create a small painting or design from the range chosen. Try to balance the colours used in the work.

The subject is immaterial, you might wish to paint realistically or apply patches of colour side by side in a general design.

Always bear in mind that this is colour mixing practice, it is not a test of your painting skills, and only you need ever see it.

Practice piece 3

Select another pair of colours from the same series of exercise for a second painting or design.

Use the same subject matter as practice piece 2. By producing a similar painting or design using a different red and green you will start to realise the enormous range at your finger tips.

Just two colours, particularly if they are complementaries, (even loose complementaries), can be made to harmonise very readily. *Many very successful paintings and designs have been produced using such combinations.*

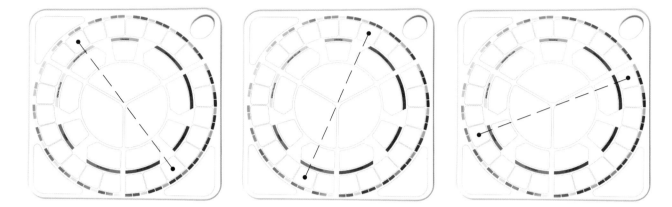

For those using our mixing palette; whatever colour you wish to neutralise, simply place it into the nearest colour coded mixing well and look across to the other side of the palette for its mixing partner. *(Which is also its close visual complementary).*

As already mentioned, do not worry about trying to match the colour exactly with the colours printed on the palette.

As long as the mix is fairly close to one of the three colours (light, medium and dark) printed alongside each well, you will obtain the correct results.

Although colour mixing should always be a thinking process it should not become a worry to you. The creative process will become stilted if you try to match up mixing partners exactly. After a short time you will become experienced enough to steer a mix in any direction that you wish.

An added bonus to this approach to colour mixing is that all of the colours in each of the exercises can be made to harmonise with ease, particularly if the two mixing partners are used in moderation when at full strength.

As, apart from the individual contributing colours, all of the mixes contain only the same two colours, it is relatively easy to make them harmonise for many people.

In addition, you have a wide range of colours to work with, particularly in the case of the complementary pairings where you also have the use of the coloured greys to provide your darks.

Two colours (one can be pre-mixed) on the palette at once can give you enough hues for a complete painting.

Three to four and you have a tremendous range at your finger tips. Five or more and most artists are completely out of control.

Yet many painters place 15-20 colours at a time onto the conventional palette and work on a trial and error basis.

Hopefully I have been able to provide sufficient guidance to allow you to overcome any difficulties that you might once have had. By thinking in a different way colour mixing can be fully mastered in a short time.

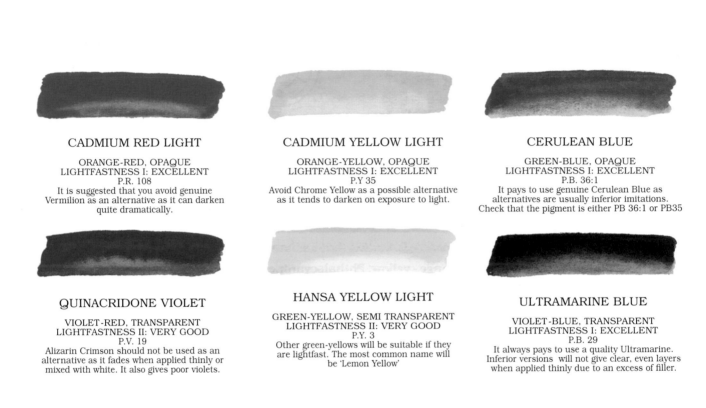

CADMIUM RED LIGHT

ORANGE-RED, OPAQUE
LIGHTFASTNESS I: EXCELLENT
P.R. 108
It is suggested that you avoid genuine
Vermilion as an alternative as it can darken
quite dramatically.

CADMIUM YELLOW LIGHT

ORANGE-YELLOW, OPAQUE
LIGHTFASTNESS I: EXCELLENT
P.Y 35
Avoid Chrome Yellow as a possible alternative
as it tends to darken on exposure to light.

CERULEAN BLUE

GREEN-BLUE, OPAQUE
LIGHTFASTNESS I: EXCELLENT
P.B. 36:1
It pays to use genuine Cerulean Blue as
alternatives are usually inferior imitations.
Check that the pigment is either PB 36:1 or PB35

QUINACRIDONE VIOLET

VIOLET-RED, TRANSPARENT
LIGHTFASTNESS II: VERY GOOD
P.V. 19
Alizarin Crimson should not be used as an
alternative as it fades when applied thinly or
mixed with white. It also gives poor violets.

HANSA YELLOW LIGHT

GREEN-YELLOW, SEMI TRANSPARENT
LIGHTFASTNESS II: VERY GOOD
P.Y. 3
Other green-yellows will be suitable if they
are lightfast. The most common name will
be 'Lemon Yellow'

ULTRAMARINE BLUE

VIOLET-BLUE, TRANSPARENT
LIGHTFASTNESS I: EXCELLENT
P.B. 29
It always pays to use a quality Ultramarine.
Inferior versions will not give clear, even layers
when applied thinly due to an excess of filler.

The exercises shown so far have been produced from the six principle colours central to this approach to colour mixing.

Two reds; orange-red and a violet-red.

Two yellows; orange-yellow and green-yellow.

And two blues; green-blue and violet-blue.

The same pigmented colours have been used throughout. The orange-yellow, for example has always been Cadmium Yellow Light.

The only exception to this rule has been in the area of green-blue. Two types of green blue have been employed, Cerulean Blue and Phthalocyanine Blue. The latter was employed in exercise 9 (page 67) because of the extra green that it carried.

At this stage it will be useful to examine each in more depth. In fact, once colour mixing is mastered, (or at least brought under some control in the early stages of practice), you will be in a better position to become familiar with whichever colours you decide to use.

Many artists, with large collections of colorants, have very little idea of the individual characteristics of all, if any, of their paints.

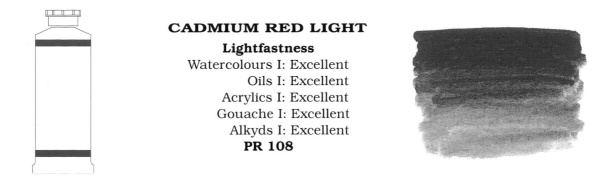

CADMIUM RED LIGHT
Lightfastness
Watercolours I: Excellent
Oils I: Excellent
Acrylics I: Excellent
Gouache I: Excellent
Alkyds I: Excellent
PR 108

A good quality Cadmium Red Light can be rather expensive, but it will be money well spent. Bright, strong, opaque and absolutely lightfast, it is a superb colour. When well produced the paint handles very positively in all media, giving smooth, even layers and washes.

An opaque colour which covers well and has the added strength to allow reasonably thin layers and washes. To my mind this is the ideal orange-red and it will be worth taking extra time to choose a suitable version.

If possible, try various makes held by fellow artists or quietly unscrew the paint caps in your art store to check for brightness.

Cadmium Red Light has largely replaced Vermilion, an orange-red with a troubled history. A superb all round orange-red, but the same cannot be said for imitations. Apart from the rare exception I would avoid all student quality versions.

These can normally be identified by the use of the word 'Hue' or 'Azo' following the name.

More than one Artists' quality 'Cadmium Red' on the market has not been near Cadmium Red pigment, so check the pigments carefully before making a purchase.

Recommended

Cadmium Barium Red PR 108:1 is usually slightly weaker and should be less expensive.

Mixing tips

Being an orange-red it darkens beautifully with the complementary blue-green. In these examples the blue-green has been mixed from Cerulean Blue and Hansa Yellow.

Technical information: *Common Name* - Cadmium Red Light. *Colour Index Name* - PR108. *Colour Index Number* 77202. *Chemical Class* - Concentrated Cadmium Seleno Sulphide (CC). *ASTM Lightfast rating* - In all media I: Excellent. *Transparency* - Opaque. *Staining power* - Slight. *Drying* -Dries very slowly forming a fairly strong film as an oil paint. Low to medium oil content.

This page has been reproduced from our book 'The Artist's Guide to Selecting Colours'.

QUINACRIDONE VIOLET

Lightfastness
Watercolours II: Very Good
Oils I: Excellent
Acrylics I: Excellent
Gouache I: Excellent

PV 19

QUINACRIDONE RED

Lightfastness
Watercolours II: Own test
Oils I: Excellent
Acrylics I: Excellent
Gouache I: Excellent

PV 19

One good violet-red and a suitable orange-red will be all that you will normally ever require. These two, together with two suitable blues and a pair of carefully selected yellows will give several million mixes.

The ideal all round violet-red, to my mind, is either Quinacridone Violet or Quinacridone Red. Both are very bright, extremely transparent and lightfast.

In every respect they out class Alizarin Crimson, a colour that either or both will hopefully replace on the average artist's palette.

They brush out more smoothly in all media, give violets which are far brighter when mixed with Ultramarine Blue and are lightfast.

For reasons of their own, manufacturers of artists' paint prefer to sell these closely related colours under a variety of fancy or trade names.

If they all used the correct name, artists would come to recognise their true value and purchase accordingly.

But it does not quite work that way.

Both are worth seeking out, even if it means checking the ingredients used in a wide variety of reds.

Sold under such names as 'Permanent Rose' 'Red Rose Deep' and 'Ruby Red'.

Recommended

Mixing tips

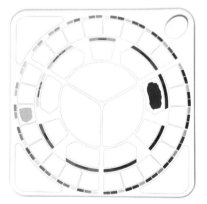

If you wish to darken either of these violet-reds, add their mixing partner, yellow-green.

Either version will darken and stay in character by the addition of small amounts of yellow-green.

Bright, transparent and lightfast violets are available by mixing with a good quality Ultramarine Blue.

Technical information: *Common Name* - Quinacridone Violet or Quinacridone Red. *Colour Index Name* - PV19. *Colour Index Number* 73900. *Chemical Class* - Quinacridone B & Y forms. *ASTM Lightfast rating* - Quinacridone Violet -Oils, alkyds, acrylics and gouache rated I: Excellent, in watercolours rated II: Very good. Quinacridone Red - Oils, acrylics and gouache rated I: Excellent. *Transparency* - Transparent. *Staining power* - high. *Drying* - Medium to slow drying as an oil paint.

This page has been reproduced from our book 'The Artist's Guide to Selecting Colours'.

CERULEAN BLUE

Lightfastness

Watercolours I: Excellent
Oils I: Excellent
Acrylics I: Excellent
Gouache I: Excellent
Alkyds not tested but will almost
certainly be lightfast.

PB 35

The name is derived from the Latin 'Caeruleum', meaning 'sky blue pigment'. Two spellings are in use nowadays, Cerulean and Coeruleum.

A definite green-blue much valued as an 'atmospheric' colour. It is opaque and covers very well, even in thin layers, but this does not prevent well produced versions brushing out quite thinly.

It is a rather heavy pigment which tends to settle into pockets in the paper when used as a watercolour. It will also separate from certain lighter pigments when applied as a very wet wash. The 'grainy' effect which results is much loved by watercolourists.

Check the texture before purchasing in any media as certain makes can be rather coarsely ground.

Although low in tinting strength it has a definite part to play in colour mixing, particularly when bright, opaque greens are sought.

Two versions are available, the Cerulean Blue PB 35 as described here and Cerulean Blue, Chromium PB 36.

Both possess similar characteristics (lightfast and opaque), but the latter is usually slightly brighter. An excellent, all round green-blue which is absolutely lightfast in all media.

Recommended

Mixing tips

Cerulean Blue can be a very versatile colour for mixing purposes. This is particularly the case after a certain amount of experimentation has taken place.

Mix it with the different reds and yellows and observe not only the resulting colour, but also the transparency of the hue. The more you know about your colours, the better they will serve you.

Being an opaque green-blue it will give opaque, very greyed

violets with Cadmium Red Light (also opaque).

Dull, semi-opaque to semi-transparent neutralised mid-violets with the transparent Quinacridone Violet.

Bright, semi-opaque greens with a green-yellow such as Hansa Yellow Light.

And opaque mid-greens with Cadmium Yellow Light.

Technical information: *Common Name* - Cerulean Blue. *Colour Index Name* - PB 35. *Colour Index Number* 77368. *Chemical Class* - Oxides of Cobalt and Tin. *ASTM Lightfast rating* - Watercolour, oils, acrylics and gouache tested I: Excellent. Not yet tested in Alkyds. *Transparency* - Opaque. *Staining power* - slight. *Drying* -Medium to slow drier forming a soft but non elastic film as an oil colour. High oil content.

This page has been reproduced from our book 'The Artist's Guide to Selecting Colours'.

ULTRAMARINE BLUE

Lightfastness
Watercolours I: Excellent
Oils I: Excellent
Gouache I: Excellent
Alkyds I: Excellent
Acrylics I: Excellent
PB 29

Genuine Ultramarine was produced from a semi precious stone. Its preparation was difficult and very time consuming. The inexpensive, modern version is almost identical in every way.

A well made Ultramarine Blue is essential if the full range from a limited palette is to be achieved. It is the only true violet-blue available and, as such, is the only blue able to contribute towards bright violets.

It will also play a very important part in colour mixing in general.

The pigment was originally produced from Lapis Lazuli, a semi-precious stone imported from Afghanistan.

Genuine Ultramarine was an exceedingly expensive pigment and, as such, was out of the reach of almost all artists who were not working on a commission (usually for the Church).

The invention of artificial Ultramarine by the Frenchman Monsieur J.B. Guimet in the early 1800s was a major breakthrough. We still owe much to him.

A bright, transparent violet blue with good tinting strength and absolutely lightfast.

Genuine Ultramarine is still manufactured, but on a tiny scale. Do not hanker after the pigment as it is almost identical in colour and chemical composition to the modern synthetic version. It is also very expensive.

Modern Ultramarine is available from light to dark and sold as Ultramarine or French Ultramarine.

Check the transparency (possibly of versions held by fellow painters) when deciding on a purchase. If the colour is not very clear in thin applications, choose again as it will probably contain an excess of filler. Fortunately this is not common. An indispensable and inexpensive colour for all - round application.

Recommended

Mixing tips

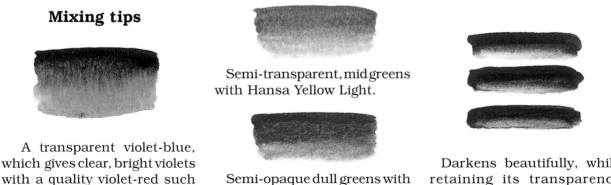

A transparent violet-blue, which gives clear, bright violets with a quality violet-red such as Quinacridone Violet.

Semi-transparent, mid greens with Hansa Yellow Light.

Semi-opaque dull greens with Cadmium Yellow Pale.

Darkens beautifully, whilst retaining its transparency, with Burnt Sienna.

Technical information: *Common Name* - Ultramarine Blue. *Colour Index Name* - PB 29. *Colour Index Number* 77007. *Chemical Class* - Complex Silicate of Sodium & Aluminium with Sulphur. *ASTM Lightfast rating* - Watercolour, oils, alkyds, gouache and acrylics I: Excellent. *Transparency* - Semi Transparent to transparent. *Staining power* - slight. *Drying* -Medium to slow drier forming a rather hard, brittle film as an oil paint. Medium to high oil content.

This page has been reproduced from our book 'The Artist's Guide to Selecting Colours'.

CADMIUM YELLOW LIGHT

Lightfastness
Watercolours I: Excellent
Oils I: Excellent
Acrylics I: Excellent
Gouache I: Excellent
Not yet tested in Alkyds but should prove to be equally lightfast.

PY 35

Genuine Cadmium Yellow Light (when well produced) is one of the most important, if not *the* most important light yellows of the palette.

A strong, bright, clean hue noted for its opacity. Although this latter quality allows for the covering of earlier work, its strength will allow you to produce reasonably clear washes and layers when applied thinly.

Although absolutely lightfast under normal conditions, dampness can cause the colour to fade. This can be a problem in areas of high humidity. Depending on the manufacturer, the colour will either be biased towards green or orange. Be wary of imitations, there are many on the market and most tend to fade. Look for the pigment description **PY35**.

Do not worry if a little PO 20 (Cadmium Orange) has been added or if a light version of PY37 (see next page), was used as all of the Cadmiums are from the same 'family'.

If a pigment number is not given I suggest that you do not purchase. Ask yourself why it is not given.

Recommended

Cadmium Barium Yellow Light is an equally reliable, close relation. It should be cheaper than the chemically pure version (PY35). Look for the Colour Index Name PY35:1.

As with Aureolin, the colour can be biased towards either green or orange.

Mixing tips

If biased towards green you will obtain bright greens with a green-blue such as Cerulean (another opaque colour), and dull oranges with any red.

If your version leans towards orange, expect bright oranges when mixed with Cadmium Red Light and dullish greens with Cerulean Blue.

A strong, bright, opaque yellow giving a useful range of values. Covers well but its strength will allow reasonably clear thin layers.

Technical information: *Common Name* - Cadmium Yellow Light. *Colour Index Name* - PY35. *Colour Index Number* 77205. *Chemical Class* - Concentrated Cadmium Zinc Sulphide. *ASTM Lightfast rating* - In oils, watercolour, acrylics and gouache I: Excellent (Not yet tested as an Alkyd but will almost certainly be found to be lightfast). *Transparency* - Opaque. *Staining power* - Slight. *Drying* - Dries slowly as an oil paint to a fairly strong film.

This page has been reproduced from our book 'The Artist's Guide to Selecting Colours'.

ARYLIDE YELLOW 10G
or HANSA YELLOW LIGHT

Lightfastness

Watercolours II: Very good
Oils II: Very good
Acrylics II: Very good
Gouache I: Excellent
Alkyds II: Very good

PY 3

In your search for suitable colours you will almost certainly have come across the simple pigment description 'Arylide'.

By itself the name is meaningless because it encompasses fugitive, worthless pigments such as **PY1** Arylide Yellow G as well as the superb **PY3** Arylide Yellow 10G. Unless the actual *Colour Index Name* is given on the tube (PY1, PY3 etc.), treat with extreme caution.

The manufacturer knows the actual variety of Arylide Yellow that you are being offered, so why are they not telling you?

The Common Name of this colour is Arylide Yellow or Hansa Yellow Light but it is often simply called Lemon Yellow. Reasonably transparent but this can vary depending on whether or not filler has been added.

Will cover well when applied even moderately heavy. Good tinting strength makes this a very useful colour when mixing. Dries quite well as an oil paint.

If you are looking for a lightfast green-yellow (Lemon Yellow), with good handling qualities, reasonable transparency and strength, this colour will stand you in good stead. It should also be less expensive than the alternative Cadmium Yellow Lemon.

Recommended

Mixing tips

This is a particularly useful yellow for colour mixing purposes. It possesses good tinting strength and holds its own in any mix.

The fact that it covers well when applied at all heavily, and at the same time will give reasonably transparent washes in thin applications, adds to its value.

Being a definite green-yellow it will give bright, clear greens (when applied thinly) with

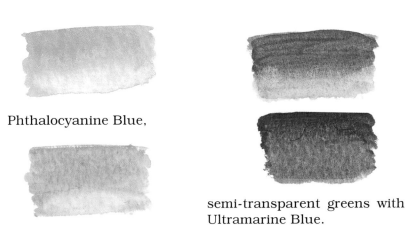

Phthalocyanine Blue, bright, semi-opaque greens with Cerulean Blue and dark semi-transparent greens with Ultramarine Blue.

Please see next page for the mixing complementary.

Technical information: *Common Name* - Arylide Yellow 10G or Hansa Yellow Light. *Colour Index Name* - PY3. *Colour Index Number* - 11710. *Chemical Class* - Arylide Yellow. *ASTM Lightfast rating* - In oils, watercolour, acrylics and alkyds II : Very Good, in Gouache I : Excellent. *Transparency* - Semi Transparent. *Drying* - Average drier as an oil paint.

This page has been reproduced from our book 'The Artist's Guide to Selecting Colours'.

YELLOW OCHRE

NEUTRALISED ORANGE-YELLOW,
SEMI-OPAQUE
LIGHTFASTNESS I: EXCELLENT
P.Y. 43
A good quality Yellow Ochre will cover well, (semi-opaque) but also give quite clear thinner layers.

BURNT SIENNA

NEUTRALISED ORANGE, TRANSPARENT
LIGHTFASTNESS I: EXCELLENT
P.Br. 7
As with all transparent colours it pays to use a
good quality as inferior versions often contain an
excess of filler.

PHTHALOCYANINE GREEN

MID-GREEN, TRANSPARENT
LIGHTFASTNESS I: EXCELLENT
P.G. 36
Viridian would be a suitable alternative as it is
similar in colour, transparency and strength to
Phthalocyanine Green.

RAW SIENNA

NEUTRALISED ORANGE-YELLOW,
SEMI-TRANSPARENT
LIGHTFASTNESS I: EXCELLENT
P.Br. 7
Look for the ingredients 'P.Br 7 Raw Sienna' as
this colour is often imitated.

PHTHALOCYANINE BLUE

GREEN-BLUE, TRANSPARENT
LIGHTFASTNESS II: VERY GOOD
P.B.15
Prussian Blue could be used as an alternative
to Phthalocyanine Blue as it is similar in hue,
transparency and strength.

WHITE, OPAQUE

TITANIUM WHITE
LIGHTFASTNESS I: EXCELLENT
P.W. 6.
Colour Index No. 77891. Titanium Dioxide,
carefully dispersed in the appropriate medium.
Non-metallic preservatives.

We will now start to explore the additional six colours that I would like to recommend as part of a limited palette.

There are many advantages to using a carefully selected, *deliberately* limited range of colours:

Colour mixing is easier to control, colour harmony is a great deal easier to achieve, the varying transparencies and other characteristics of the colours are easier to come to terms with and the cost of painting can be dramatically reduced.

In addition you can ensure that, through the careful selection of a limited number of colours, all of your paints are lightfast. A vital factor as far as the caring artist is concerned.

To obtain bright, 'clean' colours it is very important to use the finest quality that you can afford. If you need to make savings by using certain Student range paints, at least try to ensure that the *principal mixing colours*, the two yellows, two reds and two blues suggested, are of the highest quality. A student grade 'Cadmium Red' for example will never be as bright as a *well made* Artist Quality colour.

I emphasis the term *well made* as not all 'Artist Quality' paints are.

PHTHALOCYANINE GREEN

Lightfastness

Watercolours I: Excellent

Oils I: Excellent

Acrylics I: Excellent

Gouache I: Excellent

Alkyds I: Excellent

PG 7

It is most depressing to have to describe so many pre-mixed greens which are a disgrace to the profession of colour manufacturing.

So it is with some pleasure that I come to Phthalocyanine Green.

A 'clean' vibrant blue- green produced by the further processing of Phthalocyanine Blue.

Noted for its very high strength and purity of colour, it must be managed with some care as it can quickly dominate a painting. The fact that it is a powerful stainer must also be taken into account.

A well made version will be extremely transparent and of great value in washes and when mixing by glazing.

It closely resembles Viridian in colour, but is, if anything, even more intense. It is also often slightly darker.

This excellent pigment, which is resistant to light, is sold under a wide range of fancy but usually meaningless names. It would help if this practice were to cease, then the artist might be in a better position to choose. Apart from the sillier names, it is also sold as Monestial Green, Thalo Green, Phalo Green and Winsor Green.

You might come across the use of Phthalocyanine Green PG36. A member of the same family, it tends to be yellower in hue. It is as lightfast as PG7.

Recommended

Mixing tips

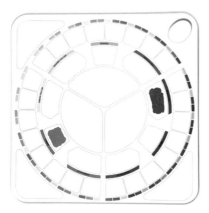

When choosing a mixing partner, the transparency of both colours should also be taken into account.

When a transparent complementary pair are mixed, the results remain transparent throughout and the coloured greys are very dark.

Quinacridone Violet makes an ideal mixing partner to Phthalocyanine Green, not only in hue but also in transparency.

Technical information: *Common Name* - Phthalocyanine Green. *Colour Index Name* - PG 36. *Colour Index Number* 74265. *Chemical Class* - Chlorinated & Brominated Phthalocyanine. *ASTM Lightfast rating* - Watercolour, oils, gouache, acrylics and alkyds I: Excellent. *Transparency* - Transparent. *Staining power* - high. *Drying* - Slow to medium drier when made up into an oil paint, forming a fairly hard, durable film. Average oil content.

This page has been reproduced from our book 'The Artist's Guide to Selecting Colours'.

Exercise 32
opaque green-blue + transparent mid green

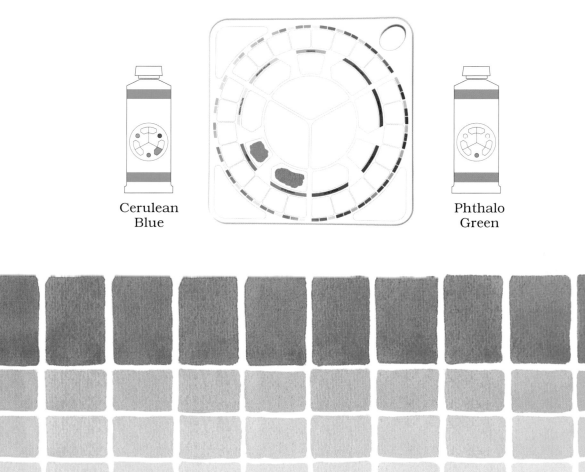

Cerulean
Blue

Phthalo
Green

In this first exercise, Phthalocyanine Green will be blended into Cerulean Blue. To describe the two colours by their common name will tell us very little about the results to expect.

It will be much better to say that we will mix a *transparent mid-green with an opaque green-blue*.

These descriptions indicate that we can expect the following:
1) A range of bright blue-greens.
2) The colours will gradually become more transparent as they move from the opaque blue end of the range to the transparent green end.

Exercise 33
transparent violet-blue + transparent mid green

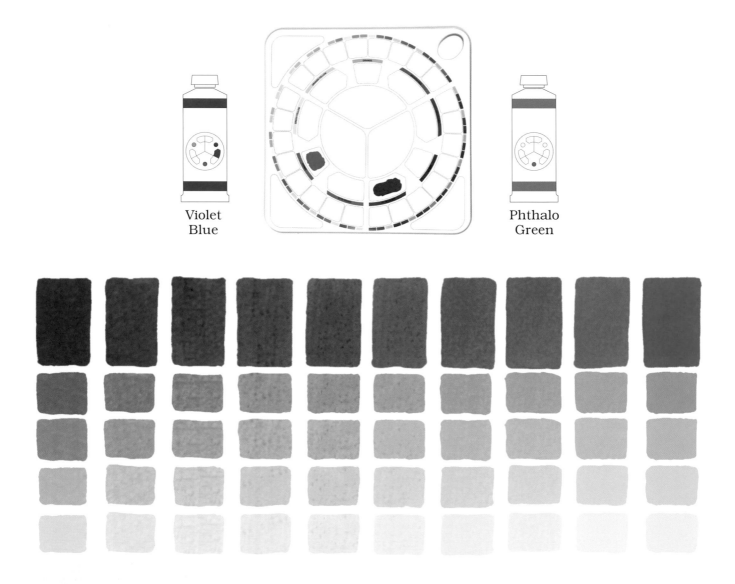

Violet
Blue

Phthalo
Green

If the blue is now changed to Ultramarine Blue, the mix can be described as a *transparent violet blue blended with a transparent mid-green.* As the blue is a poor carrier of green, we will get slightly duller blue-greens.

The differences between this exercise and the previous are very marked and illustrate the importance of choosing mixing colours with care and for good reasons.

Whereas the green-blue in exercise 32 (page 147), is opaque, the violet-blue used here is transparent. As both contributing colours are transparent it follows that all of the mixes will be particularly clear.

They will also be rather dark when applied at all heavily. More on this very important factor later.

Exercise 34
semi transparent green-yellow + transparent mid green

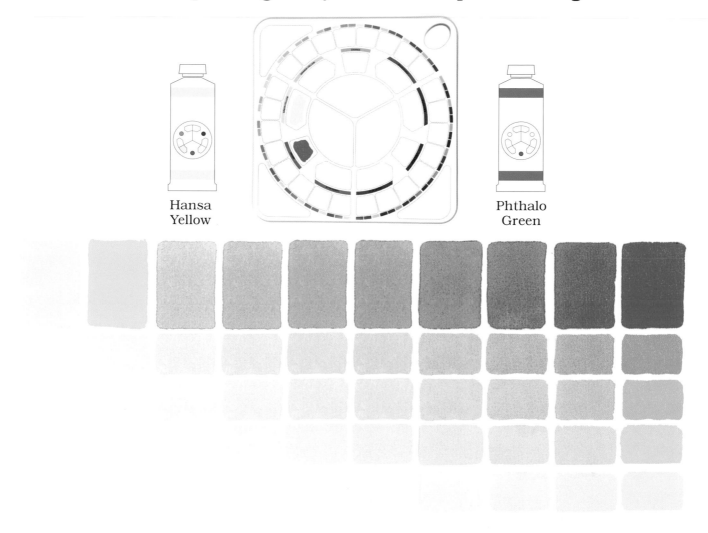

Hansa Yellow

Phthalo Green

A good quality Hansa (Lemon) Yellow will be reasonably transparent and Phthalocyanine Green is definitely very transparent.

To describe this exercise as a mix of Hansa (Lemon) Yellow and Phthalocyanine Green would tell us little or nothing about the results to expect.

If however, we describe the combination as a *semi-transparent green-yellow* and a *transparent mid-green* we will be able to forecast the results with ease.

This combination will give a series of clear yellow-greens as the green-yellow that we use is a semi-transparent colour.

It is important to use a quality green-yellow (often called Lemon Yellow), if you wish to achieve such clear semi-transparent mixes. Poorly made varieties can be very chalky due to an excess of filler. They can also fade or darken quite dramatically.

Towards the green end of the range the colours will be even more transparent due to the nature of the Phthalocyanine Green.

Once colour mixing is under full control the transparency of a colour can also be used to its full advantage.

149

Exercise 35
opaque orange-yellow + transparent mid green

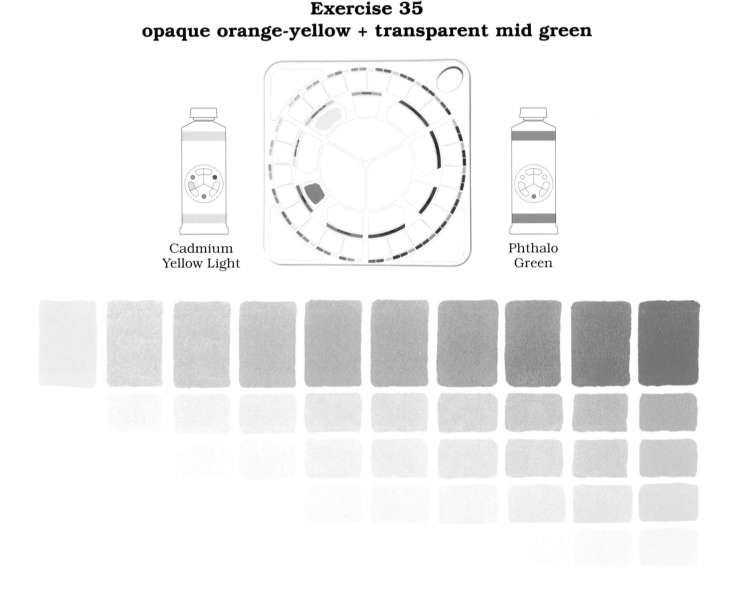

Cadmium
Yellow Light

Phthalo
Green

The yellow is now changed to Cadmium Yellow Light (opaque). Going from a semi-transparent green-yellow to an opaque orange-yellow will cause certain subtle but very definite changes, not only in colour but also in transparency. Such differences are worth observing as they teach us a lot about the characteristics of our chosen colours.

A good quality Cadmium Yellow Light, (the orange-yellow that I suggest), will be opaque, but due to its strength of colour will give reasonably clear washes when applied thinly.

A poorly made paint will give broken washes due to the excess of filler which is often added. It always pays to use the better qualities when mixing for clear bright colours.

Viridian Green is almost identical in both colour and transparency to Phthalocyanine Green and can be used for the exercises if you already have it.

I chose to use Phthalocyanine Green in our own paint range as it seems to be slightly more consistent between batches. This is not an important consideration.

PHTHALOCYANINE BLUE

Lightfastness
Watercolours II: Very Good
Oils I: Excellent
Acrylics I: Excellent
Gouache I: Excellent
Alkyds I: Excellent
PB 15

Phthalocyanine Blue, or Phthalo Blue as it is often called, is an extremely intense, very transparent, deep green-blue. Although very versatile when handled with care, it can quickly stamp its mark on a painting unless used in moderation.

A powerful colour, it will quickly influence others during mixing and will stain the paper as a watercolour. The main drawback to this factor is that mistakes cannot easily be rectified.

It will not only stain paper but may also gradually stain subsequent paint layers when used in any media.

Although it needs to be used with care, it is highly valued for its strength and transparency. This latter factor being very important to many painters, particularly watercolourists and those who prefer to mix by glazing.

When applied heavily it can take on a slight metallic sheen, although not to the same extent as Prussian Blue.

Marketed under various names, Phthalocyanine Blue. Phthalo Blue, Thalo Blue, Monestial Blue, Winsor Blue, Rembrandt Blue, Cyanin Blue-and the list goes on.

It is also to be found in very many mixed colours, where it is often let down with rather large amounts of filler. Such colours are easily avoided.

Various types are in use, PB15, PB15:1, PB15:2 etc. The main difference between them is a slight colour shift. All are equally lightfast.

You might also come across Phthalocyanine Blue PB 16. An reliable pigment which was given an ASTM rating of I: Excellent in both oils and acrylics.

Recommended

Mixing tips

With the addition of white the colour becomes very close to Cerulean Blue. Many imitation Cerulean Blues are, in fact, produced this way.

A range of very vivid greens will result when mixed with a green- yellow such as Hansa Yellow Light.

For extremely transparent, and often very subtle, blue greens, mix with either Phthalocyanine Green or Viridian.

Technical information: *Common Name* - Phthalocyanine Blue. *Colour Index Name* - PB 15 - 15:1 etc. *Colour Index Number* 74160 - 74160:1 etc. *Chemical Class* - Copper Phthalocyanine Blue. *ASTM Lightfast rating* - Watercolour, II: Very good, oils, alkyds, acrylics and gouache tested I: Excellent. *Transparency* - Transparent. *Staining power* - high. *Drying* -An average drier forming a hard, durable film as an oil paint. Average oil content.

This page has been reproduced from our book 'The Artist's Guide to Selecting Colours'.

Exercise 36
transparent mid green + transparent blue-green

Phthalo
Green

Phthalo
Blue

In this exercise the blue is changed yet again to Phthalocyanine, or Phthalo Blue. It is a rather strong colour which must be used with some care.

The characteristics of Phthalo Blue are frequently overlooked and it is often used in a careless manner. If thought of as a particularly transparent green-blue, and used accordingly, it can be of great value.

When the two colours, transparent green-blue and transparent mid-green are combined, the results can be forecast with ease.

A range of very transparent, bright blue-greens will emerge.

This transparency can be used in two ways:

1) Thin washes will give very clear colours.
Being transparent (and strong), the mixes can be applied very thinly. This will allow for very pale tints.

2) When applied heavily the colours will be quite dark.

Exercise 36 (continued)
transparent mid green + transparent blue-green with the addition of violet-red to each mix

Like Phthalocyanine Green, its cousin, Phthalocyanine Blue is a strong colour which needs to be used with a little caution.

It really comes into its own when transparent blue-greens arc required. Such mixtures are invaluable in areas such as seascape painting.

By mixing the two Phthalocyanine colours together a wide range of extremely transparent blue-greens emerge which cannot be mixed any other way.

(A mix of Prussian Blue and Viridian will be close but the Prussian Blue might bring a metallic sheen with it).

As shown above, try adding a little violet-red to any of the mixes in this exercise (ex.36). The violet-red will desaturate the mixes at the green end of the range very well, at the same time preserving their transparency. The greens will darken and stay in character as you will be working with the general complementary pair, red and green.

They will remain particularly clear, of course, because the green, blue and red are all very transparent colours.

As you move towards the blue end of the range the mix will become closer to a green blue/violet-red combination. As with exercise 3 (page 51), they will give a series of mid intensity violets. They will, of course be very transparent, as opposed to the semi-opaque versions from exercise 3.

Again, it is a case of working with a limited palette and, most importantly, getting to know the characteristics of your colours.

If, in a piece of work you needed a mid intensity violet but the violet-red/Cerulean Blue combination (ex 3), was a little too opaque, a quick change of direction can be achieved simply by switching green-blues.

As you start to work with this approach it will all quickly fall into place.

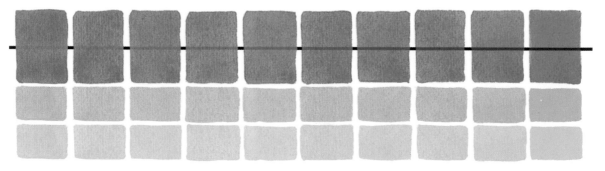

Exercise 32 (page 147) - Opaque green blue to transparent mid green.

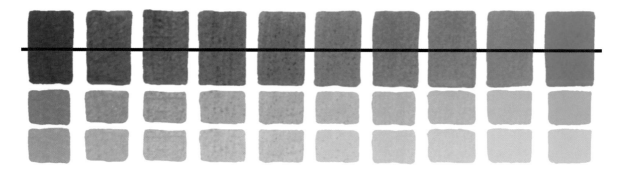

Exercise 33 (page 148) - Transparent violet-blue to transparent mid green.

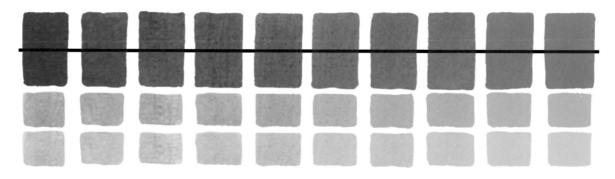

Exercise 36 (page 152) - Transparent green-blue to transparent mid green.

It will be worth comparing the recent 'blue + Phthalo Green exercises side by side.

Exercise 32 called for the use of opaque green blue (Cerulean Blue) with the Phthalocyanine Green. The clarity of the mixes improving only at the extreme green end of the range.

In exercise 33 the blue is changed to a violet-blue which is as transparent as the green. Note the differences between the two exercises as the violet content is exchanged for a green element and the transparency is dramatically altered.

Now compare the final range (exercise 36) to the previous two and decide upon the differences.

Once you know what is actually happening you will be able to forecast the result of any mix with ease. Any colour mixing problems that you once had will disappear.

Whenever I give a demonstration of colour mixing I ask my audience to outline their main concern. The answer is always the same, 'mixing greens'.

As I hope you will have discovered, a vast range of predictable greens can be mixed with ease. They will vary from the bright transparent greens found in the previous exercise to dull, heavy opaque colours elsewhere.

When you understand and employ the varying colour types and transparencies, you can extract virtually any green possible in paint form from the very limited range that I would like to suggest.

155

Practical work

Materials required
All paints except white. Clean brush and dilutant.

Exercise 37

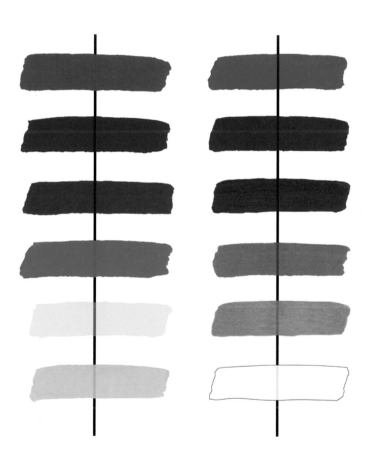

It will be a useful exercise to carry out the transparency test described above.

Apply a reasonably thin layer of each colour over a black line and try and make the paint layers approximately the same thickness.

You should find that your Cadmium Red Light and Cerulean Blue are *opaque*.

Cadmium Yellow is generally considered *opaque* yet is strong enough to appear semi-opaque when applied in thin layers.

Hansa (Lemon) Yellow is *semi-transparent*, although this will depend to a certain extent on the make.

Quinacridone Violet, Ultramarine Blue, Burnt Sienna, Phthalocyanine Blue and Phthalocyanine Green are all particularly *transparent*. This is only noticeable when they are applied thinly. When they are at all heavy they take on a particularly dark appearance.

It is vital to take the transparency of a colour into account when mixing.

White light enters a single piece of coloured glass (A). The red, yellow, orange and green is then mainly absorbed. The violet blue (in this case) travels through the glass (B), or a thin paint layer (C), reflects from the background and leaves almost intact, giving a bright blue appearance.

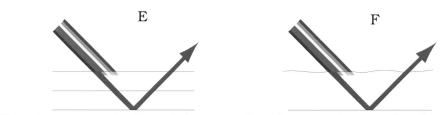

When two pieces of coloured glass are placed one on the other (D), the light enters the glass, is reflected from the base and leaves a lot weaker (E), giving a darker appearance. For the same reason, a thicker layer of transparent paint (F) will appear darker than a thin layer.

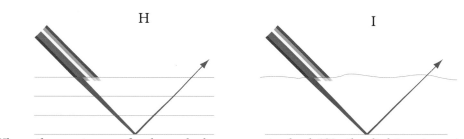

When three pieces of coloured glass are stacked (G), the light enters, is reflected from the base and struggles to leave at the surface (H), For exactly the same reason, a thick layer of transparent paint (I), takes on a very dark appearance.

Transparent paint acts in a similar way to coloured glass. A piece of thin, blue coloured glass, placed onto a white background, will appear as a very bright, clear blue. The light will sink effortlessly into the glass, reflect from the white background and emerge from the surface. Nearly all of the light will be reflected, which is why the colour is so bright.

The same circumstances apply to a film of transparent blue paint, with the same results.

When paints or inks etc. are applied very thinly, the light arriving at the surface loses little energy as it enters and then leaves the paint film. This type of mixing is known as simple *subtractive* mixing.

To return to the blue glass, if we were to pile on, say, two or three pieces of the glass, the colour would appear much darker at the overlap. Being transparent, the glass will allow the light to sink in deeply. So deeply, in fact, that little of it would even reach the white background.

Any light which did manage to get that far would then have to turn around and try to struggle back to the surface.

As little of the light which enters the glass is able to leave, the colour appears very dark.

For exactly the same reason, thickly applied transparent paint also takes on a very dark appearance.

Exercise 38

1.

2.

3.

4.

A valuable exercise would be to mix a small amount of Cadmium Yellow Light (opaque) and Cerulean Blue (also opaque) to produce a mid green. Apply this colour, *thinly*, as in illustration 1 above.

Now paint out the colour quite *thickly* as per illustration 2 above.

Although there is an obvious difference between the two paint layers, the colour does not become particularly dark when applied heavily.

Although less light is lost when opaque paints are mixed as opposed to transparent, a layer of any opacity loses even less when applied very thinly as the light will find its way through or around the pigment particles to the painting surface and back. When opaque paints are mixed the result is known as *complex subtractive mixing*.

Thin a little Phthalocyanine Green (transparent) and apply a *light* layer as per illustration 3 above.

Then paint out the same colour *heavily* as in 4 above.

As you can see, when transparent paint is applied thickly the light will sink in deeply causing the paint to take on a comparatively dark appearance. This factor is of vital importance in colour mixing.

Opaque paints remain the same colour no matter how thickly they are applied (after the 'thinned out' stage has been passed).

Transparent paints become progressively darker until a certain stage is reached. Semi opaque and semi-transparent paints fall in between these two extremes.

Exercise 39
transparent violet-red + transparent mid green

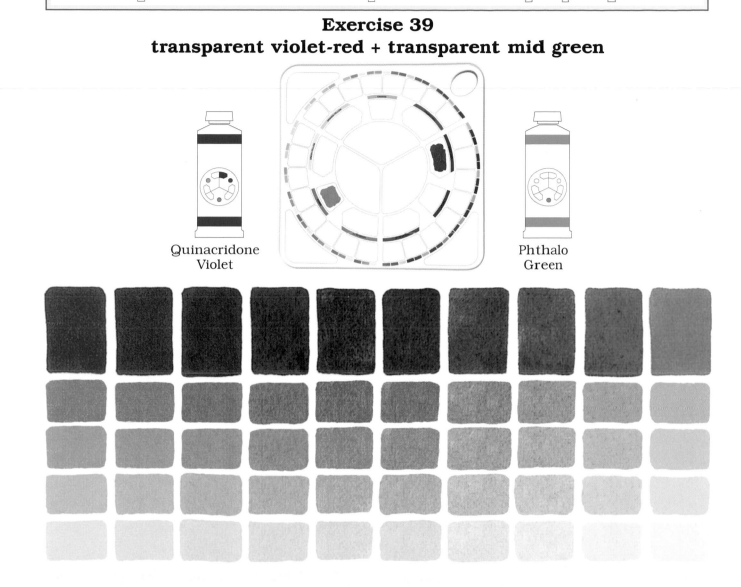

Quinacridone
Violet

Phthalo
Green

Quinacridone Violet (violet-red) and Phthalo Green are quite close complementaries. If the green were slightly yellower they would be even closer.

They make an ideal mixing pair as both are particularly transparent. If you decide to carry out this exercise, notice how dark the mid-greys become when they are applied at all heavily. You can also see this above.

 This, of course, is due to two factors.

1) Being complementaries, the red and green will absorb each other efficiently when near equal in intensity.

2) Both colours being transparent, the light will sink deeply into the paint film.

Other transparent violet-reds, such as the unreliable Alizarin Crimson, will give similar results. Unfortunately, as the Alizarin Crimson fades (as it will in all thin applications or when mixed with white), the colour will move gradually back to the lightfast green.

Although Phthalocyanine Green is a powerful, staining colour, there is no need to be over cautious about using it. Many artists try the colour, find it too dominating in a painting and discard it.

As you will have seen, when mixed with certain well chosen colours it will give a surprising range of valuable greens. Hues which cannot be mixed without it.

159

Exercise 40
opaque orange-red + transparent mid green

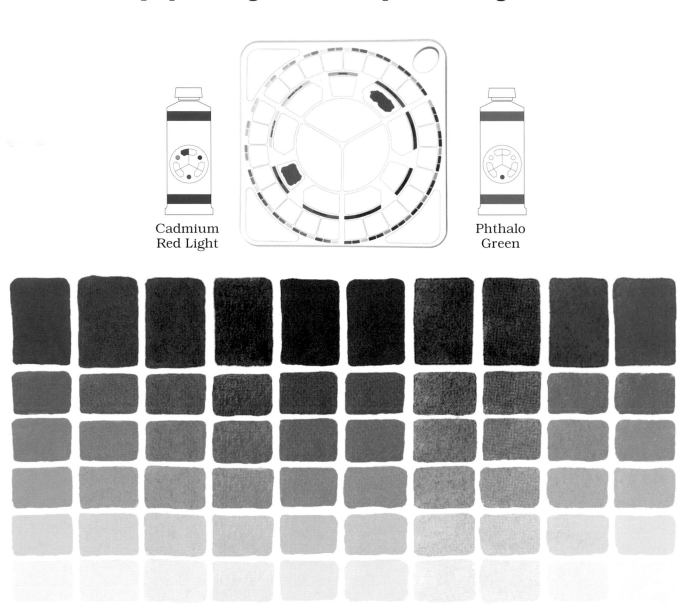

Cadmium
Red Light

Phthalo
Green

Now change the red to an orange-red. In this case the orange-red will be Cadmium Red Light, an opaque colour.

After you have completed the exercise, you will learn a great deal by noting the differences between this and the previous exercise; where the red was a *transparent violet*-red. It is important to understand the actual reasons for these differences.

I have chosen the colour combinations for this book that I believe will convey the most information applicable to the needs of the artist and craft-worker.

Obviously there are many more that could be selected. You might wish to add to the range based on your particular requirements.

160

BURNT SIENNA

Lightfastness

Watercolours I: Excellent
Oils I: Excellent
Acrylics I: Excellent
Alkyds I: Excellent
Gouache I: Excellent

PBr 7

We have inherited a variety of pigments from earlier artists and colour manufacturers, some dating back to antiquity. Many of these are quite worthless and should have been replaced long ago.

Certain of our inherited colours, however, are superb. Chief amongst these must surely be Burnt Sienna, a pigment long valued for its clean colour and transparency.

This latter factor is too often ignored by modern painters, who, rather than exploit the clarity of the colour to its fullest, often plaster it on in heavy layers, thinking of it as no more than a type of brown. A moment's experimenting will show that thin applications will give a glowing neutral orange. It was discovered long ago that Raw Sienna could be roasted to produce Burnt Sienna - a warm, rich colour which varies from a slightly yellow neutral orange to a reddish brown.

It should be borne in mind that this is an earth colour and as such will vary in hue and transparency. Not only will the base Raw Sienna vary but the degree of roasting will also affect the final colour. For these reasons I suggest that you try every make which comes your way. Perhaps fellow artists have several varieties between them, if so ask for a tiny amount from each.

A quick wash will soon reveal the make with the greatest clarity and the colour which suits your work. It can be a mistake to simply accept the full colour range from any one particular manufacturer. The only limitation here is when choosing acrylics, different makes should not be mixed as their formulations are rather complex.

Burnt Sienna does tend to darken over time in oils. **Recommended**

Mixing tips

Exploit the clarity of this colour by selecting, where possible, other transparent colours as mixing partners.

Burnt Sienna neutralises particularly well with transparent Ultramarine Blue (please see page 73). They will darken each other efficiently and produce some valuable darks, approaching black.

It can be taken towards clear neutral red - oranges by mixing with Quinacridone Violet.

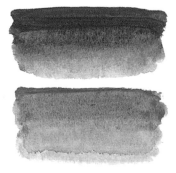

And semi-transparent, neutral yellow-oranges with a green-yellow such as Hansa Yellow.

Technical information: *Common Name* - Burnt Sienna. *Colour Index Name* - PBr 7. *Colour Index Number* 77492. *Chemical Class* - calcined Natural Iron Oxide. ASTM *Lightfast rating* - watercolour, oils, gouache, acrylics and alkyds I: Excellent. *Transparency* - Transparent. *Staining power* - medium. *Drying* - A fast to average drier forming a hard, fairly strong, durable film as an oil paint. Medium to high oil content.

This page has been reproduced from our book 'The Artist's Guide to Selecting Colours'.

Exercise 41
semi transparent green-yellow + transparent neutralised orange

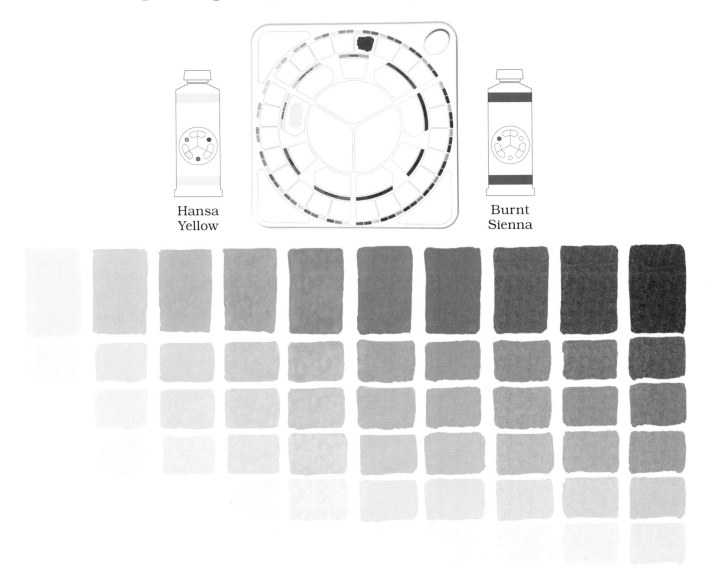

Hansa
Yellow

Burnt
Sienna

Another very important colour to consider is Burnt Sienna. When *well made* it is a particularly transparent, fiery, neutral orange.

Instead of being considered as a clear, neutral orange, it is too often treated as a general brown and used quite roughly. When the transparency of the colour is taken into account, it can be an invaluable addition to any paint range.

It certainly comes into its own when blended with other transparent colours.

In this exercise, Hansa (Lemon) Yellow and Burnt Sienna, or more correctly, *semi-transparent green-yellow will be blended with a transparent neutralised orange.*

As you will know, green-yellow only 'carries' a tiny amount of orange.

When this is added to an already neutralised orange, the blends can never be particularly bright.

A useful range of subdued yellow-oranges will emerge. With a quality Hansa (Lemon) Yellow these will all be reasonably transparent, vibrant colours when applied thinly.

Exercise 42
transparent violet-red + transparent neutralised orange

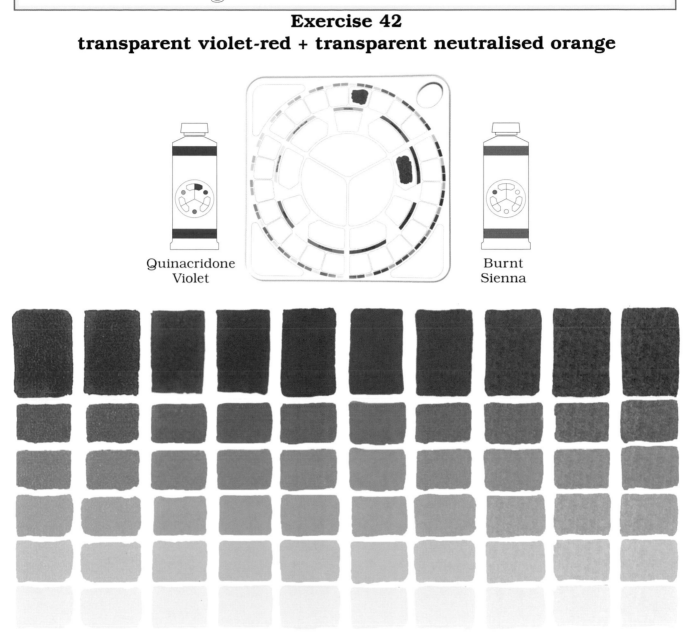

Quinacridone
Violet

Burnt
Sienna

Transparent violet-red (Quinacridone Violet) plus transparent neutral orange (Burnt Sienna). It is easy to forecast the results of this combination.

The violet-red will not add a great deal of orange as it is a poor carrier of that colour, therefore we can expect a range of transparent neutral red-oranges.

Exercise 43
transparent violet-blue + transparent neutralised orange

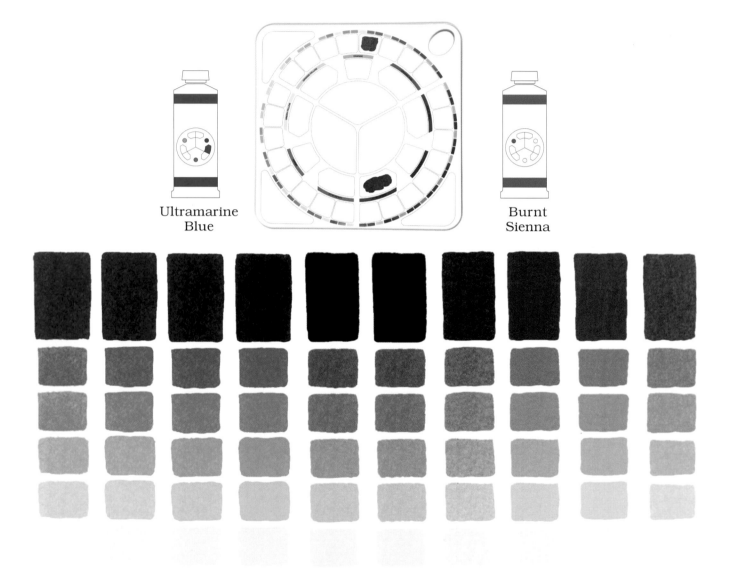

Ultramarine
Blue

Burnt
Sienna

If you are using our Colour Coded Mixing Palette, place the Burnt Sienna in the outer well to the red side of the orange mixing well. This is appropriate as it is a 'neutralised, (slightly red) orange' as far as 'colour type' is concerned. Burnt Sienna has long been valued for its transparency, revealing its true beauty only in thin applications.

Being transparent it will give clear darks, approaching black, when mixed with the equally transparent Ultramarine Blue (violet blue).

The colour becomes very dark when applied heavily because any light left over after the two complementaries (blue and orange) have cancelled each other out sinks into the transparent paint layer. Such soft velvety darks are the ideal replacement for black, which can have a deadening effect in a piece of work.

164

Exercise 44
transparent green-blue + transparent neutralised orange

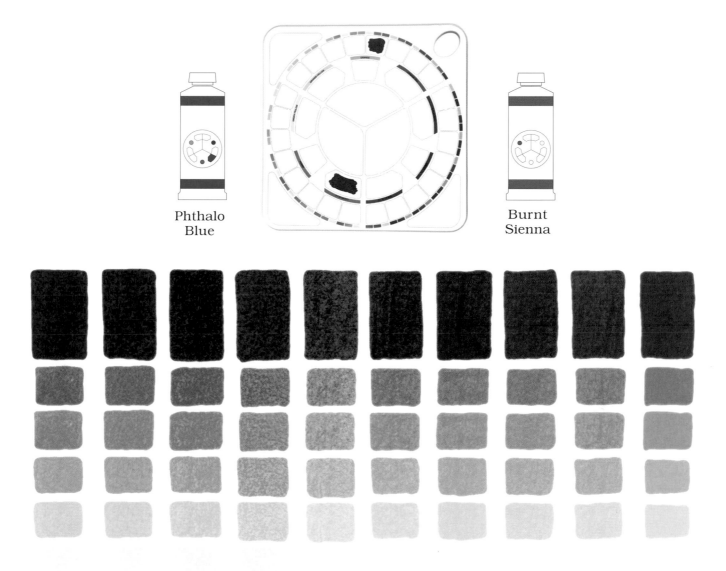

Phthalo
Blue

Burnt
Sienna

Transparent green-blue (Phthalocyanine Blue) blended with transparent neutral orange (Burnt Sienna).

When purchasing Burnt Sienna it pays to check that the paint is not clouded by filler. If the colour is rather light and lacks 'life' when applied heavily it indicates an excess of filler or that a low quality pigment has been used.

Another indication, with this as with all transparent colours, is to brush the paint out thinly or create a wash.

If the paint layer becomes grainy when very thin it suggests an overuse of filler.

As the name suggests, 'filler' fills tubes. It costs a fraction of the price of coloured pigments.

Exercise 45
opaque green-blue + transparent neutralised orange

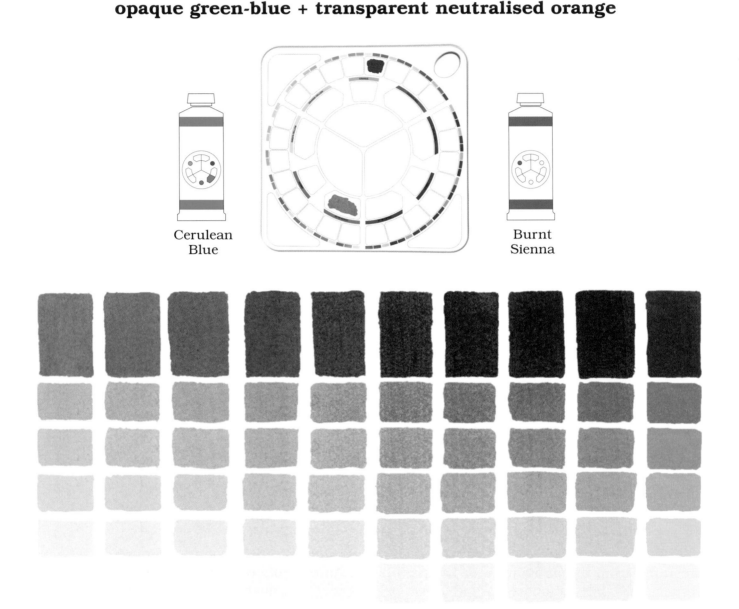

Cerulean
Blue

Burnt
Sienna

Cerulean Blue has been used as the green-blue in this exercise, rather than the Phthalocyanine Blue of the previous. This exercise has been included to complete the series of 'transparent neutralised orange' (Burnt Sienna) and blue.

When purchasing Cerulean Blue it pays to check the ingredients as many imitations are on the market, in both the Student and Artist Quality ranges.

The most common imitations are mixes of Phthalocyanine Blue and White and Ultramarine Blue and White.

Genuine Cerulean Blue should have the description PB 35 or PB 36 on the label.

It also pays to ensure that the pigment is not coarsely ground, making it rather gritty.

The traditional way to check the fineness of grind is to place a tiny amount of paint onto a thumbnail and rub this with the other thumbnail. Any grittiness will be apparent.

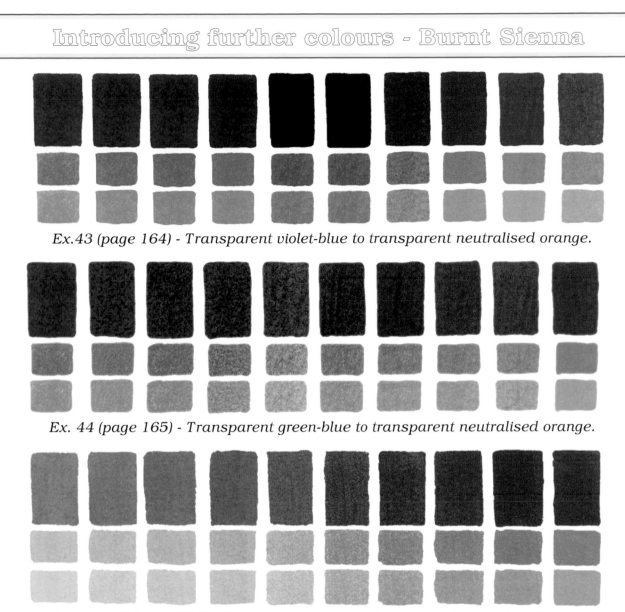

Ex.43 (page 164) - Transparent violet-blue to transparent neutralised orange.

Ex. 44 (page 165) - Transparent green-blue to transparent neutralised orange.

Exercise 45 (page 166) - Opaque green-blue to transparent neutralised orange.

The differences between the mixes which resulted from a combination of the various blues and the transparent neutral orange will indicate the importance of choosing your colours carefully and for sound reasons.

The transparency of the Phthalocyanine Blue will lead to dark coloured greys and the extra greenness from this type of blue will have a marked effect.

Compare all three exercises for differences: By moving from a transparent violet-blue to a transparent green-blue, certain changes can be expected. The change of bias from violet to green have a noticeable effect.

In the final mix the opacity of the Cerulean Blue will cause obvious differences.

As the coloured greys in the centre of the range are semi-opaque (a combination of the opaque green-blue and the transparent neutral orange), less light will be absorbed than in the previous (all transparent) mixes and the coloured greys will be slightly lighter.

Incidently, Payne's Grey is a mixture of Ultramarine Blue and black. To avoid the deadening effect of black, and have a *range* of 'Payne's Greys' to work with, the ideal replacement can be found at the Ultramarine Blue end of the first exercise in this section. The Burnt Sienna will darken the blue in a more natural way than black ever could.

YELLOW OCHRE

Lightfastness
Watercolours I: Excellent
Oils I: Excellent
Acrylics I: Excellent
Alkyds I: Excellent
Gouache I: Excellent

PY 43

Pigment Yellow 43, Yellow Ochre, has been in constant use since the days of the cave painter, although they probably had a different name for it.

It is absolutely lightfast. The many examples of coloured earths in the landscape are proof that pigments produced from them do not fade under the harshest of light and weather conditions, over endless years. Yellow Ochre is a carefully selected and processed natural coloured earth.

A soft, dulled golden yellow which brushes and mixes well over a full range of values. The better grades can be fairly transparent in thin washes but will cover well when applied at all heavily. Tinting strength varies but is usually strong enough to play its part in colour mixing.

Considered by many artists to be a softer, less brash colour than its artificial counterpart, Mars Yellow.

You will come across many examples of Mars Yellow (PY42) on sale as Yellow Ochre, and Yellow Ochre (PY43) being offered as Mars Yellow.

In fact, the majority of 'Yellow Ochre' watercolours on the market are produced using Mars Yellow. Makes you wonder what its all about, doesn't it? Could Mars Yellow pigment be any cheaper than a well produced Yellow Ochre?

Check ingredients if you wish to select the characteristics of one over the other.

Recommended

For mixing purposes treat as a low intensity, neutralised, opaque orange-yellow.

Mixing tips

It will therefore behave in a similar way to Naples Yellow and Mars Yellow.

The mixing complementary is violet-blue. These two colours will darken each other without destroying the character of either, as black certainly would.

They will also produce some very subtle greys when mixed in near equal intensities, particularly when these are made lighter.

Technical information: *Common Name* - Yellow Ochre. *Colour Index Name* - PY43. *Colour Index Number* - 77492. Chemical *Class* - Natural Hydrated Iron Oxide. *ASTM Lightfast rating* - In all media I: Excellent. *Transparency* Semi-Opaque but reasonably transparent in thin applications. Staining *power* - Slight. *Drying* -Dries medium to slowly forming a fairly strong film as an oil paint. Medium oil content.

This page has been reproduced from our book 'The Artist's Guide to Selecting Colours'.

Exercise 46
semi opaque neutralised orange-yellow + opaque orange-red

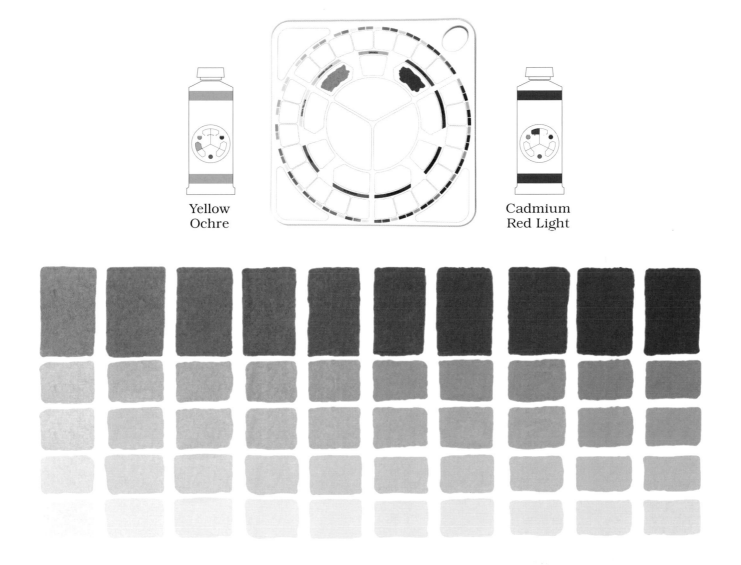

Yellow
Ochre

Cadmium
Red Light

Yellow Ochre is best thought of as a 'neutralised orange-yellow'. Although it is semi-opaque and covers well, Yellow Ochre will also give fairly transparent washes when applied in thin layers. It offers a useful range of values and transparencies.

A soft golden yellow which leans towards orange, Yellow Ochre brings a certain calm to other colours in mixes, as this exercise will,

I believe, show. Here it is blended with the orange-red, Cadmium Red Light. As the latter is opaque we can expect the mixes to also be rather opaque.

However, if both colours have been well produced, without an excess of filler (particularly in the case of the red), the washes will be reasonably clear.

169

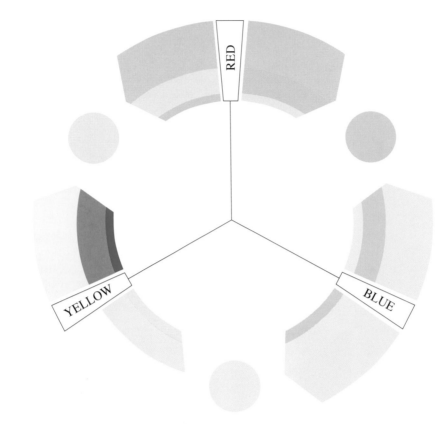

Fig. 1 *The make up of Cadmium Yellow Light, a bright orange-yellow.*

Fig. 2 *The make up of Yellow Ochre, a neutralised, or dulled orange-yellow.*

Let us look at Yellow Ochre another way. To describe it as a *neutralised* orange-yellow means in effect that it is a *dulled* colour.

This can certainly be seen when it is compared to the other orange-yellow that we have been using, Cadmium Yellow Light.

As the colour itself is *dull* we can say that it will only reflect *small* 'amounts' of yellow, orange and green.

If the make up of the orange-yellow in fig. 1, above, represented the 'amounts' of the various colours reflected by Cadmium Yellow Light, fig. 2 would represent the proportional make up of Yellow Ochre.

170

Exercise 47
semi opaque neutralised orange-yellow + transparent violet-blue

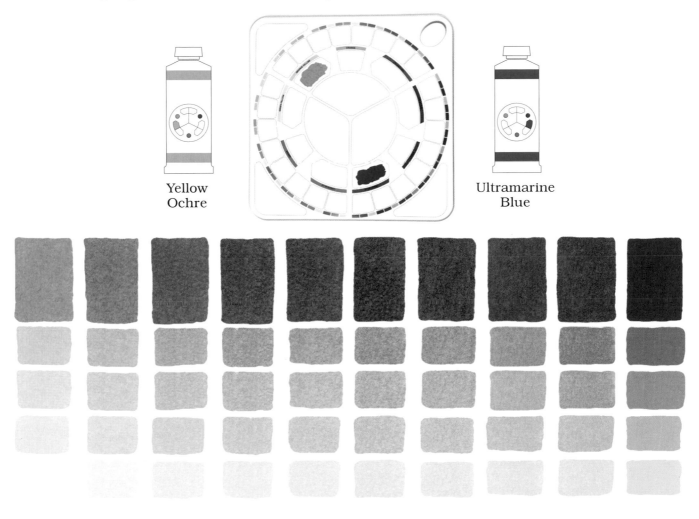

Yellow
Ochre

Ultramarine
Blue

We can use our knowledge concerning the make up of Yellow Ochre when mixing. In the above exercise the *very small* amount of green in the Yellow Ochre is mixed with the *small* amount in the violet-blue.

After the yellow and blue, as such, have cancelled each other out we are left with a *very small* and a *small* amount of green, hence the extremely dull greens above.

After a while you will be able to look at any colour and decide on its general make up. I say 'general' because the last thing required for practical work is a concern for scientific accuracy. When colour mixing becomes a thinking process it can be brought under full control. The essence of successful mixing lies, I believe: in the following:

1. A knowledge of how to produce a wide range of violets, greens and oranges from the 'six principal mixing colours'.

2. The ability to desaturate (darken, dull) a colour with its mixing complementary.

3. An understanding of why a complementary pair will give a series of coloured greys.

4. An ability to add or remove certain colours to fine tune a mix. The additional green in Phthalocyanine Blue as opposed to Cerulean Blue. The diminished green content in Yellow Ochre when compared to Cadmium Yellow Light etc.

RAW SIENNA

Lightfastness
Watercolours I: Excellent
Oils I: Excellent
Acrylics I: Excellent
Alkyds I: Excellent
Gouache I: Excellent

PBr 7

Like the other natural earth colours, Raw Sienna is absolutely lightfast. The crude Raw Sienna smeared on the cave wall by the first artists will not have changed in colour to this day. Whatever binder was used might have altered, but not the pigment.

Valued for its transparency, Raw Sienna has a place on many a palette in all media. It generally lies somewhere between Yellow Ochre and Burnt Sienna in colour. I say generally because several rather dark versions are on the market.

Raw Sienna, named after a particularly fine variety once produced at Sienna, Tuscany, has been in use since painting began.

It has long been valued as a glazing colour, giving warm, semi-transparent golden tans when applied thinly. Such glowing tans are particularly appreciated by the watercolourist.

Although it has good covering power, which can be useful, the colour can look rather 'heavy' when thickly applied.

Due to its rather high oil content it does tend to darken with age, it is the binder which darkens, not the pigment.

Although very similar in make up to Yellow Ochre, Raw Sienna is darker due to its higher silica content. Despite this it has become common practice to sell Yellow Ochre as Raw Sienna. I have been able to find very few cases where the colour was described as an Imitation.

If there were not clear differences between the two colours they would long ago have merged under the one name.

It is worth being aware of this practice, look for the pigment description PBr 7 Raw Sienna rather than PY43 Yellow Ochre. Otherwise you might end up with two almost identical colours.

Select the genuine article with care and you will have a first class colour. I suggest that you try as many samples as you can first.

Recommended

Mixing tips

A close imitation of the colour can be mixed from a good quality Yellow Ochre and a well made Burnt Sienna.

I emphasise the quality aspect because both must be reasonably transparent, not clogged with dulling filler.

For mixing purposes it can be considered as a neutral or dulled orange - yellow.

With a little experimentation you will find the mixing complementary, a violet with a leaning towards blue.

Technical information: *Common Name* - Raw Sienna. *Colour Index Name* - PBr 7. *Colour Index Number* 77492. *Chemical Class* - Natural Iron Oxide. *ASTM Lightfast rating* - watercolour, oils, acrylics, gouache and alkyds I: Excellent. *Transparency* - Semi-transparent to transparent. *Staining power* - Medium. *Drying* - Medium to fast drier forming a tough, reasonably strong film in oils. Medium to high oil content.

This page has been reproduced from our book 'The Artist's Guide to Selecting Colours'.

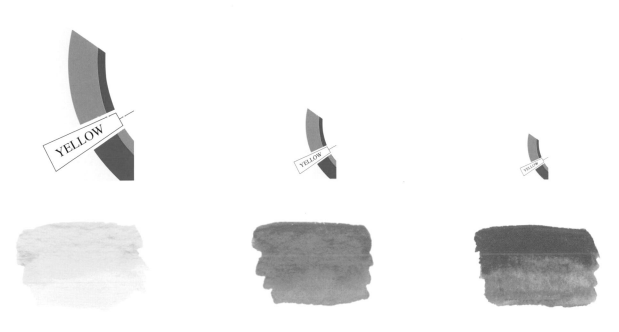

Fig. 1 The make up of Cadmium Yellow Light, a bright orange-yellow.

Fig. 2 The make up of Yellow Ochre, a neutralised, or dulled orange-yellow.

Fig. 3 The make up of Raw Sienna, a neutralised, or dulled orange-yellow.

Raw Sienna is a transparent to semi transparent, soft, neutral orange-yellow. I have included it in our limited palette due to its transparency and limited green content.

It makes up the trio of orange-yellows in our range:

1. Cadmium Yellow Light for a bright, opaque orange-yellow carrying a small 'amount' of green.

2. Yellow Ochre as a neutralised, semi-opaque orange-yellow carrying a *very* small amount of green.

3. Raw Sienna as a neutralised, semi transparent orange-yellow.

It is darker than the Yellow Ochre, therefore reflecting *even less* yellow, orange and, most importantly, green.

You might have to read these descriptions several times and go back over recent mixes.

By describing your colours according to 'colour-type' and transparency, you have the information at your finger tips before commencing to mix.

I have also described these colours in some depth to give the reasons for their inclusion in this limited range. Limited in the number of colours that you need to purchase but not in your final results.

Exercise 48
semi opaque neutralised orange-yellow + transparent violet-blue

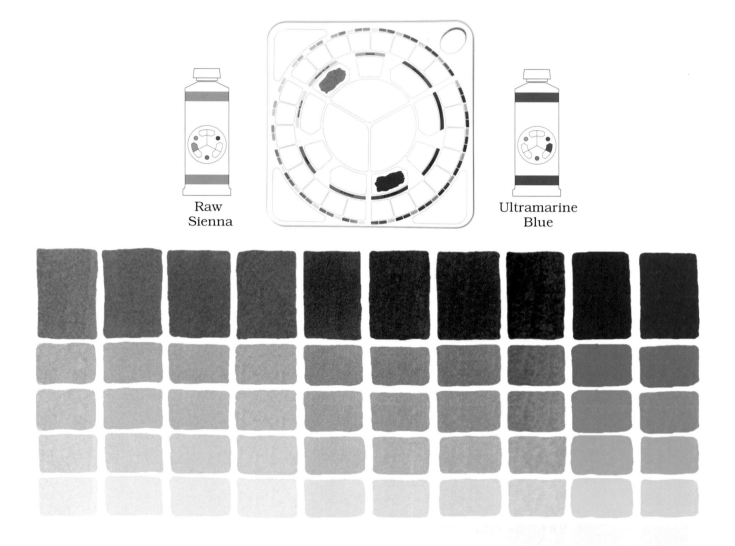

Raw
Sienna

Ultramarine
Blue

As you will see in the above mix, by using an orange-yellow with even less green content than the Yellow Ochre and combining it with the same violet-blue as the previous exercise, the mixes become even darker, extending the range.

The coloured greys are darker than the previous mix due to two factors.

1. Raw Sienna moves rather more towards orange than Yellow Ochre. This takes the blend closer to an orange/blue complementary mix.

2. Being more transparent than Yellow Ochre, (although there is little difference when both are thinned), the mixes above will be clearer. The extra transparency means that more light will sink into the mix when it is heavily applied.

Colour-type and transparency; when these two factors are taken into consideration and are fully understood, controlled colour mixing becomes straight forward.

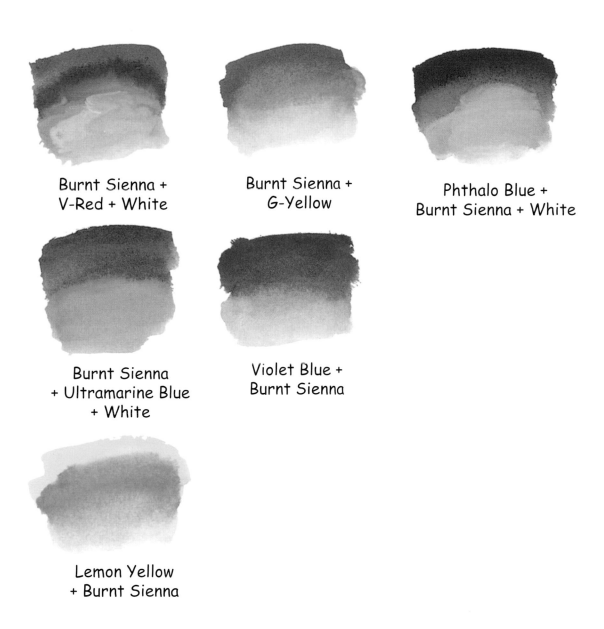

Burnt Sienna +
V-Red + White

Burnt Sienna +
G-Yellow

Phthalo Blue +
Burnt Sienna + White

Burnt Sienna
+ Ultramarine Blue
+ White

Violet Blue +
Burnt Sienna

Lemon Yellow
+ Burnt Sienna

It will be invaluable experience to practice any of the mixes from exercises 41 to 48. Work in a loose fashion and further explore those blends which are of interest to you.

It would be particularly valuable to investigate the Burnt Sienna/Ultramarine Blue range.

As already mentioned, the very dark coloured greys from this combination can be a useful replacement for black.

Such dark, velvety, coloured greys can also be invaluable when harmony is sought. When thinned down, or mixed with white, soft neutral greys will emerge.

The mixes above are examples only. Create colours as you see fit. By working in a very loose way, you will quickly gain confidence. Colour mixing should be a thinking process which gradually becomes second nature.

Exercise 49 - adding white

Base colour
(Cadmium Red Light)

Base colour
(Ultramarine Blue)

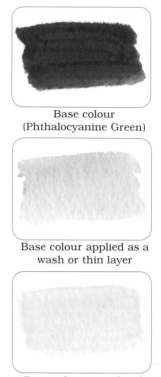

Base colour
(Phthalocyanine Green)

Base colour applied as a
wash or thin layer

Base colour applied as a
wash or thin layer

Base colour applied as a
wash or thin layer

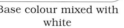

Base colour mixed with
white

Base colour mixed with
white

Base colour mixed with
white

Tints can be produced by either:
1) Allowing a white (or very lightly coloured) background to influence thinly applied paint or, 2) By adding white paint.

It is vitally important to realise that the brilliance of a colour is damaged by adding white paint. It will also make otherwise transparent colours more opaque and add a certain 'coolness' to many mixes.

This is particularly noticeable in watercolour painting, which relies heavily on clean, transparent tints for much of its effect.

The first method, allowing the white background to create the tints, gives the clearest, brightest colours.

The purist would usually say that there should be little or no call for using a white in watercolour painting because the paper itself provides the whites and tints.

However, by automatically excluding the use of white, half of the available tints are discarded as there are many colours which simply cannot be mixed without the use of white.

The tint produced by thinning the Cadmium Red Light above (for example), is certainly brighter, warmer and more transparent than that produced with the addition of white. But the latter colour could not be produced any other way.

If, as a watercolourist, it is a colour that you require for your work, you will search for it in vain if you automatically discard white.

This will apply particularly to botanical illustrators and those who paint floral arrangements.

A subtle, subdued pink or a dulled pale yellow might *only* be available if white is called in.

176

Cadmium
Yellow Light + White

Modern Naples Yellow is a mixture of White and Cadmium Yellow, with perhaps a touch of ochre or similar. Many prepared colours contain white as this is the only way to mix them.

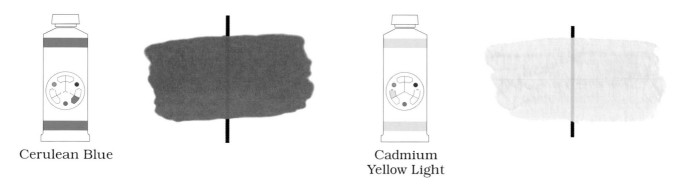

Cerulean Blue

Cadmium
Yellow Light

Colours such as Cerulean Blue, Cadmium Yellow and Cadmium Red are opaque but make a valuable addition to many a watercolour palette.

I realise that I have, in the past, upset many a watercolour 'purist' with this approach. The common response is 'I would never use white in a watercolour painting'.

I can usually then find colours such as Naples Yellow in their paint box, which is basically a mixture of Cadmium Yellow and white. (A convenience colour which cannot be produced any other way). There are many other examples of commercially produced paints which employ white in their make up.

So many watercolour purists are making use of white, if indirectly. When this is pointed out the common response to say that white makes colours more opaque.

This it certainly does with the more transparent colours.

But the use of Cerulean Blue and Cadmium Yellow, both opaque colours, does not seem to cause a problem in watercolours.

Just as opaque colours can be applied with care, so to can a transparent colour mixed with white. It does not have to be plastered on.

Without a doubt, used carelessly, white paint added to other colours can give a dull, chalky, 'heavy' appearance to a painting. Used with skill it can add considerably to the artists' colour repertoire.

Paint layer
Priming layer
Canvas or similar support

Final paint layer
White paint layer
Priming layer
Canvas or similar support

The result of mixing white into oil or acrylic paints will always be to not only lighten but also dull and 'cool' the colour.

Such colours are invaluable, but if they are the only type of tint ever employed, the results will necessarily be limited.

Where bright tints are required and the texture of the surface is important, specially applied white paint or an impasto paste will give the background white.

The final paint layer, if applied thinly will give bright, clear tints.

Paint layer
Priming layer
Canvas or similar support

Paint layer
Priming layer
Canvas or similar support

If bright tints on a relatively flat surface are required, there is no reason why a thin layer of paint should not be applied directly to the priming.

Many painters seem to be rather wary of this approach but it was employed very widely before surface texture became important.

When tints are created by applying the paint in thin layers, any ridges in the paint layer will appear darker. This is particularly the case with transparent paints. Light will be lost as it travels through the extra thickness.

Such ridges can be caused by the use of a coarse brush.

It is not only the watercolourist who might benefit by considering an alternative method of creating tints.

Oil and acrylic painters, who usually add white paint automatically in order to lighten their colours, should not overlook the possibility of allowing white under-painting, or white priming, to lighten thinly applied top layers. Much in the same way that a watercolourist will usually produce tints.

This can be particularly effective when using transparent colours such as Ultramarine Blue or Burnt Sienna, but can also be of value with *well made* opaque colours such as Cadmium Yellow Light or Cadmium Red Light.

I stress 'well made', as such colours are strong enough to be applied thinly without becoming too grainy.

1. Violet, applied thinly.

2. The same violet with added white.

3. Violet with added white plus a little violet red.

In every medium, brilliance is lost and colours are dulled and cooled by adding white paint.

The warmer colours in particular are cooled by white. The blues and greens, already cool, suffer less than other colours and retain their character reasonably well.

If need be, steps can sometimes be taken to counteract the cooling effect of the white.

A touch of a 'warm' colour can 'boost the temperature'. An excellent example to work with is violet.

When it is reduced to a tint by being applied thinly, violet stays close in 'temperature' and character to the saturated colour (1). The same violet however, mixed with white paint, takes on a different character and is dramatically 'cooled' (2).

Just by adding a little violet-red to the violet tint, we can counteract the white paint's 'cooling' influence (3). The slightly 'warmer' red will increase the temperature of the otherwise cooled violet.

There are, however, few instances where this approach can be employed.

A slight shift in hue always takes place when colours are made lighter. This is more noticeable in some colours than in others.

A particular blue, for example, will become a lighter, but also a slightly different blue when white is added. The shift is less pronounced when the background creates the tint.

This is one of the factors to take into account, but not be over concerned with, when mixing colours.

As they are made either lighter or darker they will tend to wander off slightly in another direction.

Please note.

I feel that the use of the terms 'warm' and 'cool' do not have a place when describing basic colour mixing. A 'warm' blue with a 'cool' yellow etc. can only be confusing. Is, for example, Ultramarine Blue a 'warm' or a cool blue? It's 'warm' against orange, but against Cerulean Blue?

However, the terms do have a value when used in other areas such as 'the contrast of temperature' in colour combinations and in the above approach to balancing a colour.

Lead or Flake White

White paints vary markedly in their characteristics and suitability and should be chosen carefully.

In use as a pigment since oil painting began, Flake White (white lead), has more than proved its worth. Due to its chemical reaction with drying oils, Flake White forms an extremely tough, durable and flexible paint film.

Areas of paintings hundreds of years old containing this extraordinary pigment have often remained intact whilst the rest of the work has long since deteriorated.

These qualities, together with its opacity, quick drying capability and buttery texture set it well apart from other pigments.

It is a warm and creamy white, qualities that it imparts to mixes.

Its slight warmth will cause less 'cooling' than other whites.

The drawbacks associated with this white are often exaggerated.

True, it darkens if exposed to Hydrogen Sulphide in the atmosphere, which makes it unsuitable for use as a watercolour, but made up into an oil paint, it is easily protected by a layer of varnish.

Problems can occur when Flake White is mixed with certain low-grade paints, especially poorly made Cadmium colours, Vermilion and Cobalt Violet.

No such difficulties arise with high quality paints. In fact, few modern paints carry the impurities which once caused such problems.

Titanium White

A relatively modern white, Titanium White, has removed the concerns associated with combining Flake White and certain poorly produced colours.

It is a lot *'cooler'* in mixes than Flake White and is extremely brilliant: the whitest of the whites. A useful covering paint, either alone or in mixes, its use rendering paint films opaque.

Absolutely inert, being unaffected by other pigments, light, heat, weak acids or alkalies and is generally considered to be permanent.

Although an excellent white, it has not completely replaced Flake White or Zinc White as it has neither the warmth of the former in mixes nor the transparency of the latter.

Titanium White is the principal white in acrylic paints, is used in oil paints and makes an excellent watercolour.

Zinc White - Chinese White

Zinc White, one of the most transparent of the whites, is very permanent and perfectly safe to use with all other pigments. *It is a pure, cold white.*

Used in oil paints, it tends to dry to a brittle film very prone to cracking. Often used for glazing purposes, either alone or in mixes with other transparent colours.

Unless you particularly wish to use a white for glazing, this is a poor buy as an oil paint, because the hard, brittle film it forms represents a *major defect.*

Whereas Flake White has lasted well on many old paintings, Zinc White has often led to the rapid deterioration of the work.

The watercolour paint, Chinese White, is a specially prepared, very dense type of zinc oxide with good covering power.

It is the principal white of the watercolourist although Titanium White is its equal.

Beware of cheaper grades labelled Chinese White, as they are often ordinary Zinc White.

Exercise 50 - adding white

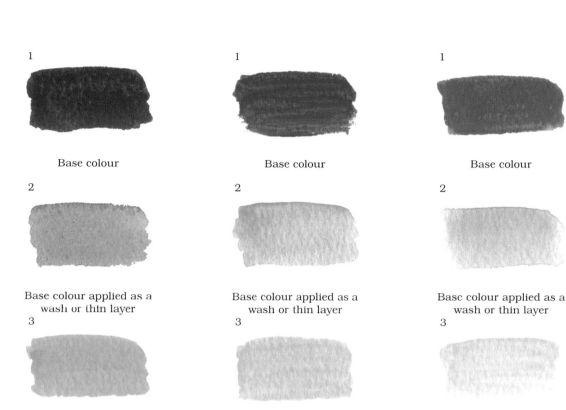

1

Base colour

1

Base colour

1

Base colour

2

Base colour applied as a
wash or thin layer

2

Base colour applied as a
wash or thin layer

2

Basc colour applied as a
wash or thin layer

3

Base colour mixed with
white

3

Base colour mixed with
white

3

Base colour mixed with
white

As already mentioned, the oil and acrylic painter should also consider using a white background to lighten colours.

Either painting thinly over the priming or over purposefully applied white paint.

The differences between such tints and those arrived at by adding white paint can be dramatic and are very well worth exploring.

In whatever media you are working, mix any colour from any of the exercises you have already completed and apply as illustration 1 above.

Thin a little of the colour for illus. 2. Add white to the colour and apply as illus. 3.

Use a variety of base colours, reds, greens, yellows, violets etc. It will be helpful to make notes on the two types of tint produced.

181

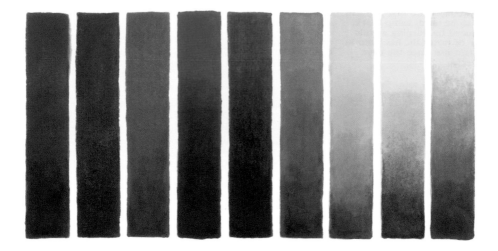

A mix of black and yellow results in a dark, dull green because most black pigments reflect from the green end of the spectrum. When the two are mixed the black absorbs virtually all of the colours normally reflected by yellow, apart from a portion of the green element. This will be 'safe because the black also reflects some green. The end results is that almost all of the light which arrives at the surface is absorbed apart from the small green content of both colours.

A black paint absorbs light very effectively and takes on a deeper appearance than a mixed dark. As with all colours, black will reflect a certain portion of the light and traces of all spectrum colours can be found.

Added to another colour, black pigment absorbs nearly all of the light reflected from that other colour.

Black is kinder to some hues than to others. It damages violets and blues less than the reds and immediately takes yellow-greens and yellow in a different direction.

It certainly will not lead towards the darker yellows that you have already produced.

Very many colours can be mixed using a hue, black and white. However, such colours lack 'life', are difficult to produce, impractical to work with and almost impossible to control as far as mixing is concerned.

In practice black invariably leads to dull, lifeless colours which kill most approaches to harmony.

Although some interesting colours can emerge when using black, I personally feel that it does not have a place on the palette.

Much better, I would suggest, to neutralise colours using the mixing partner (the complementary) and to create black where needed by a mix of Burnt Sienna and Ultramarine Blue.

The debate over whether or not black should be included in the palette continues, with strong feeling expressed by both schools of thought.

Those favouring the use of black argue that black paint must be used to depict extremely dark areas accurately.

Another view put forward is that black is a very convenient way to darken a colour.

Let us examine these two arguments, the first being that black paint must be used to depict very dark areas.

On the surface this appears plausible. However, most areas deprived of light are closer to dark grey than black and in fact black itself is seldom found in nature.

Many 'blacks', such as animal fur, bird feathers and fruits, are, on closer inspection, seething with subdued colour. Depicted with black paint they take on a dead appearance.

A mixed dark invariably looks far more natural, containing, as it does, some of the light that will be reflected from such surfaces.

Even the interior of an unlit room in the dead of night does not look entirely black but a deep, shifting, atmospheric dark grey.

If we shut our eyes in total darkness we do not experience a sensation of total blackness, faint lights seem to wander around in front of our eyes due to background activity in our visual system.

There is even a danger in depicting naturally occurring blacks with black paint.

If, for instance, a burnt tree stump is depicted with black, it seldom looks realistic because the effect of distance tends to blur detail and soften the black into a dark grey.

Were the painter to use black paint in depicting the tree stump, the viewer, *standing closer* to the painting than *the artist was to the tree,* would be confronted with a black that was too sharp and dense to be realistic.

Perhaps the strongest argument against its use to portray dark areas is that the final result often looks more like a hole in the painting surface than part of the work.

There is a distinct possibility that you will depict damage to your painting should you decide to use black unmodified by other colours.

These remarks, of course, are aimed at the realistic painter. There can be many occasions when black is employed in other types of work and there is no reason why it should not be used.

If we combine a colour with its complementary, we can readily and accurately depict the darks found in nature.

Black often upsets the balance of otherwise harmonious arrangements. What better way to darken a hue can there be than to add its complementary?

There is no such thing as an 'incorrect' colour and indeed some useful results can be obtained by using black.

It has to be said, however, that many find that black has the effect of 'dirtying' colours to such an extent that its use is seldom, if ever, considered.

It certainly turns colour mixing into an uncontrolled and unpredictable series of accidents, leading to a very restricted range.

Yet, with all that in mind, the use of black must remain an individual decision.

Many colour users automatically reach for a prepared brown rather than mixing one.

You will already have mixed a range of colours most would describe as 'brown'.

Such colours will emerge from a mix of complementaries.

For example, violet into yellow, blue into orange and green into red. An extensive range of browns can be easily mixed in this way. Most are simply darkened yellows, oranges and reds. You might, however, find the following prepared browns of value.

Raw Umber

Raw Umber is a particularly pleasant, cool, dark, slightly greenish brown. Some grades are fairly transparent when applied in thin layers. The product of different manufacturers can vary widely in colour.

It is lightfast and compatible with other pigments. Its use in colour mixing is rather limited, for this reason alone I do not feel that it has an important place in the limited palette.

Burnt Umber is a valuable earth colour which has a place in a wider palette.>

In a limited palette it can be closely duplicated by adding a touch of Ultramarine Blue to Burnt Sienna.

Burnt Umber is a warm, rich, fairly 'heavy' orange-brown prepared by roasting Raw Umber. Absolutely lightfast and compatible with all other pigments, it is a valuable and versatile brown, suitable for all media.

A very close match can, however, be mixed by adding Ultramarine Blue to Burnt Sienna,

for this reason alone it is perhaps of limited value in a restricted palette.

When Burnt Umber is mixed with Ultramarine Blue, the result is very dark because Burnt Umber can be considered a neutral orange and combined with blue we obtain a mix of complementaries.

Raw Sienna

Raw Sienna makes an excellent glazing colour due to its clarity and resistance to light.

A similar colour to Raw Sienna can be mixed from Yellow Ochre and a touch of violet.

Mars Brown is considered harsher by many to the natural earth browns.

Genuine Van Dyke Brown, an appalling substance, has no place on the conscientious artists palette.

Sepia is usually a simple mixture of Burnt Umber and a black.

'Sepia' is easily duplicated, without the use of black, from Burnt Sienna and Ultramarine Blue.

Raw Sienna is absolutely lightfast and compatible with all other pigments.

Being very transparent, Raw Sienna is an excellent glazing colour, a quality that is seldom made use of.

It is possible to obtain a similar colour by mixing Yellow Ochre and a touch of violet, but such a mix lacks transparency unless very thinly applied.

Raw Sienna has a place on many a palette as it is unsurpassed by modern synthetic products for beauty, luminosity and permanence.

Other browns can have a place, but be careful in their selection.

Mars Brown, a synthetic 'earth' colour, can be useful, but is harsher in colour than the natural earth browns.

Genuine Van Dyke Brown is a very inferior substance which has no place on the conscientious artists palette.

Sepia is usually a simple mixture of Burnt Umber and a black, easily mixed if you really want it from Burnt Sienna and Ultramarine Blue.

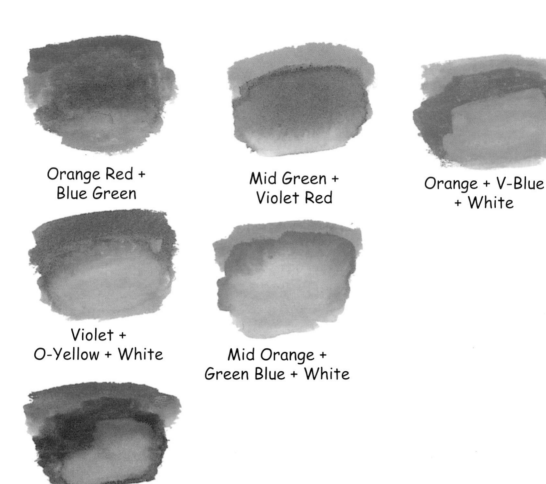

Orange Red +
Blue Green

Mid Green +
Violet Red

Orange + V-Blue
+ White

Violet +
O-Yellow + White

Mid Orange +
Green Blue + White

Orange Red +
Green Blue + White

It will be useful, as in the above examples, to select mixes that you would describe as 'brown' from earlier exercises and paint them out in a loose fashion.

When deciding whether a particular colour is a 'brown', remember that the general description of such colours is that they are darkened yellows, oranges and reds.

Thin some of the colours in order to obtain a tint and mix white with others for the alternative tint.

You will find some very interesting colours will emerge.

If the brown that you use in a painting, design or other type of work has been produced from colours already in use, the entire piece can be made to harmonise that much easier.

In every case, the fewer colours the better.

186

This technique was often employed by the Impressionists to great effect. The partial blending of the paints gave rise to many small highlights which added life to the work.

Although slow drying paints such as oils lend themselves to this technique, other media can be used also.

The paint already on the surface should be fresh and still wet. If you are working with paints which tend to dry quickly, several techniques can be employed.

Retarder medium can be mixed into acrylic paints to slow down their drying rate. Alternatively the retarder can be applied to the painting surface and the paints worked into it.

When using watercolours, dampen the paper beforehand to keep the colours moist and work reasonably quickly.

Although this method of applying and blending colours can be very useful, it relies entirely on an understanding of colour mixing.

As you can imagine, if colours are mixed directly on the surface with unpredictable results, the work will quickly become very 'muddy'.

Imagine, if you will, a situation where a blue had already been applied and the painter wished to create a bright violet.

If the blue happened to be a green-blue and orange-red were then mixed in, the resulting colour would be far from a bright violet.

Even if a bright violet should emerge by chance when working, it would quickly be spoiled if a touch of yellow should become involved. The possibilities of creating dull 'muddy' colours are almost endless. As any painter unable to control colour mixing will have discovered.

A certain amount of wet into wet mixing takes place in most normal work anyway as paints are applied to recent layers, so it pays to know what is going on.

With your present colour mixing skills you will be able use this technique with absolute control.

187

It will be invaluable practice to mix wet into wet on a trial basis before commencing work. Take any colour at random, either mixed or straight from the tube and apply it to a small area on the work surface.

Decide on the colour that you are looking for and mix in the appropriate hue. Mix some colours thoroughly as if you were blending on the palette.

Lightly mix others in a way that will leave small areas of both colours unmixed.

As you work, think of the likely results you would have been achieving without your advanced knowledge of colour mixing. You now have a very valuable technique at your finger tips.

Let *others* stir 'mud', waste expensive materials and produce work of a limited nature.

188

For exercise 21, the orange was adjusted to give a coloured grey with the blue. As the first mix gave a dull green, red was added. The effect of the red was to remove the greenness, red and green being complementaries. >

For the same reason, if you had already prepared and used a bright blue and then needed a duller blue, a touch of orange, which might be elsewhere on the palette, will do the trick.

A little violet removed by yellow, a quick way of achieving a mid violet from an existing mix.

A dark red (brown) made darker by the addition of (red absorbing) green.

Remove some of the yellow-green with a small addition of violet-red.

Take a mid-violet which you have already prepared from orange red and violet-blue. >

Change the blue to a green blue, add more red and you will have moved from a mid-violet to a greyed violet.

Add white to an orange red to cool and dull it. A tiny addition of green will move the mix to a dusky pink.

By now you should have a thorough understanding of the basics of colour mixing. To this understanding we can now add the finishing touch, the fine tuning of a colour.

This will allow you to alter a mix as you are working to obtain the exact requirement, it will also allow you to change mixes that you have already created on the palette for another purpose.

Rather than waste such prior mixes they can be given a new lease of life for use elsewhere.

When fine tuning you can either add a colour or remove it. The latter is probably the most useful approach. The above examples are only a start, as you become more familiar with mixing you can, if you wish, start to employ this practice as you work.

The following pages are intended
for those painters with an interest
in the more scientific aspects of
colour and colour mixing.

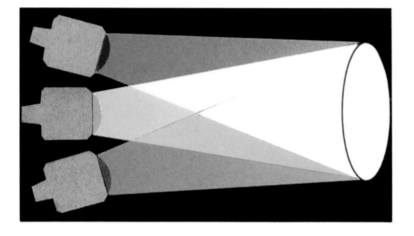

Light can be split up into its various colours (the full spectrum) and then recombined into light. Clouds and surf appear white for this reason as do white feathers.

White light can also be produced by mixing just three of the spectrum colours in light form. If we project *orange-red*, *green* and *violet-blue* light beams of equal intensity onto a white screen, they will combine into white light.

The various mixtures from these three will give almost any other colour *in light form.*

These three hues are known as the *additive primaries.* In the illustration above the additive primaries are shown overlapping; where all three do so (if they are of equal intensity), white light appears.

A blend of orange-red and green light, surprisingly, produces yellow; green and violet blue will form cyan, a greenish blue, and violet blue and orange-red will make magenta, a bluish red.

These by-product colours yellow, cyan and magenta are known as the *secondaries.*

In additive mixing, secondary colours are always brighter than either of the primaries that contribute to them.

This might seem strange as one would expect a mixture of say, orange-red and green to produce a darker colour; remember though, that we are working in coloured light.

When we mix colour in light form, brightness is always added. It is quite a different matter when we mix colours as pigments.

When balanced, the additive complementaries form white.

The Additive mixing wheel showing the Primaries of light plus the complementaries (joined by the lines).

The Additive Primaries also form white when correctly balanced.

There are several types of complementaries. We have explored pigment (subtractive mixing) complementaries in some depth. Now we will consider what are known as the complementaries of *additive* mixing. The mixing of light.

The criteria for additive complementaries is that they mix together to form white. They are to be found opposite each other on the traditional additive mixing wheel.

As already discussed, at the correct relative luminance the additive primaries (orange red, green and violet blue) combine into white.

So too will a balanced mix of any *primary* and its opposite *secondary*, a complementary pair.

Green/magenta, violet-blue/yellow and orange-red/cyan are complementaries of additive or light mixing.

You might wonder why only two colours instead of the three primaries can also give white. If you think about which colours are actually being mixed, the answer will be clear.

When, for example, the violet-blue (a primary) is combined with yellow (a secondary) it is essentially the same as mixing the violet-blue with orange-red and green, (the two colours that make up yellow).

When violet-blue and yellow are mixed, as long as their relative luminosity is balanced, it is just the same as mixing the three primaries.

This is the case when any of the other complementary pairs are combined. In additive mixing light is always *added*, hence the term.

Additive mixing has more applications for the physicist and the lighting technician, although it is relevant to the fully skilled painter and craft-worker to have a basic understanding of this form of colour mixing.

A colour wheel concerned with additive mixing, as opposed to the more traditional subtractive mixture wheel can be a valuable aid.

The interest to the painter comes with the way that the complementaries of light combine.

The differences between additive and subtractive mixing need to be understood when the former must be depicted by the latter. Such occasions are of particular interest to the realist painter.

During sunrise or sunset the sky often changes in colour from a yellow near the horizon to blue in the higher regions. This is a fairly common phenomenon.

By gradually mixing yellow into the blue during the course of a painting, an area of green is created between the two colours. You may think is normal enough. How else can it be painted?

But consider what is actually being portrayed: It is an area of the sky in which yellow *light* is blending into blue *light*.

As we know, coloured lights mix additively and since yellow and blue are additive complementaries, they move towards *white* when they are mixed.

Almost without exception such a scene is painted yellow - *green* - blue, not yellow - *white* blue, because the paints are allowed to mix subtractively.

Without an understanding of the differences between additive and subtractive mixing many mistakes like this are made, particularly when painting in the studio.

This is certainly the approach taken by all painters to whom I have set the task.

Without a doubt the sky does occasionally move to green in areas, but the next time that you observe yellow at the horizon and blue in the higher reaches, you will invariably notice a very subtle off white, almost a pale grey, where they blend.

What happens when a coloured *light* meets a coloured *surface*?

If a red light, for example, falls onto a painted surface which appears green (under white light), do the two colours mix *additively* into yellow because light is involved, or *subtractively* into a very dark colour because the result takes place on a painted, coloured surface?

Fortunately the answer is; subtractively.

The surface deals with the red light in the same way as any other light: it absorbs all colours apart from its own and since there is little, if any, green in the red beam of light, the beam is completely absorbed.

The surface takes on the same dark colour as a mix of red and green paint would have produced.

The orange light we observe at sunset changes 'local' colours through a process of subtractive mixing.

If it strikes a surface which would appear blue under normal light, that surface appears very dark. (Orange and blue also make a dark when mixed as paints of course).

If the orange light strikes a surface which normally appears yellow, the surface changes to a yellow-orange. It is fortunate that when coloured light strikes a coloured surface the colours do not mix additively, otherwise it would further complicate the execution of many a painting. As it is, we can simply mix paint and work away.

A

B

A, In a mix of violet-blue and green-yellow we are mainly concerned with the surviving green light (please see page 28 for a similar diagram).

B. If we remove the distracting violet-blue and green elements we can highlight the yellow and blue reflected at the surface which escapes absorption. Being light, and also Additive complementaries, the yellow and blue combine to form white light when balanced.

C

C. By combining diagrams A & B we can see that such a mix would produce green which is very slightly lightened at the surface.

A certain amount of additive mixing takes place at the *surface* of a paint film containing more than one colour because the reflected coloured lights do not come into direct contact with a surface capable of absorbing them.

They are therefore free to mix in pure light form. (Similarly, but on a larger scale, light reflected from dots of colour, as in Pointillism, mingle without fear of being absorbed).

Because coloured *lights* are mixing they must mix additively.

True subtractive mixing takes place when light is absorbed into the pigment particles beneath the surface.

At the surface of the paint layer a certain amount of colour is reflected that does not fall foul of another differently coloured pigment.

These released colours combine with each other *additively*. They are, after all, coloured *lights* and will combine as such.

When paints are mixed therefore, the result is a combination of additive and subtractive mixing. The exact relationship between these two mixing processes varies with the type of pigment and its transparency.

The precise relationship is best left to the scientist to determine. As far as the artist is concerned, paints mix in a predominantly subtractive way and give predictable results.

Ultramarine Blue PB29

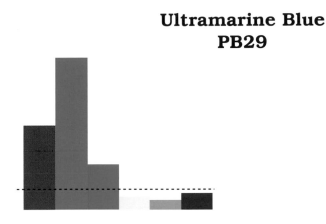

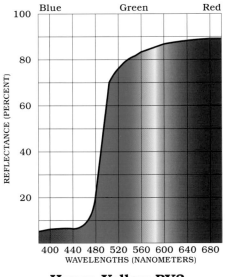

As described on page 24, Ultramarine Blue is a *violet-blue*. A large amount of blue is visible and the violet content is noticeable. Less obvious is the smaller amount of green which is also reflected. The rest of the spectrum colours are largely absorbed.

The above diagram is stylised in order to be easily followed.

For a more accurate description a 'Reflectance Curve' is used. The curve is the result of reading the reflected wavelengths with an instrument.

The numbers on the left of the graph indicate the 'amount' of light being reflected, the bottom line shows the actual wavelengths which are involved.

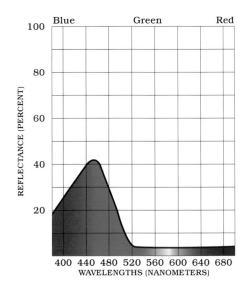

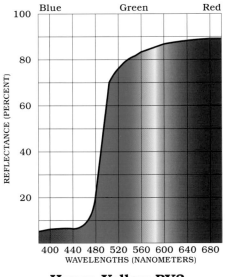

Hansa Yellow PY3

We can take the standard Reflectance Curve and add colour in order to make it clearer. In the case of Ultramarine Blue the curve is similar to the stylised version that I have used. In other colours the relationship is not quite so obvious.

My diagrams of earlier pages are meant to illustrate the *practical* application of reflected colours rather than the scientific.

The Reflectance Curves are not always easily read, a particular yellow, for example, might look as if it should be more of a red (as above).

195

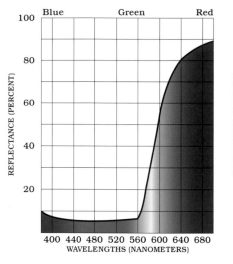

Cadmium Red Light
PR108

With a high reflectance percentage (left of graph) a bright colour is suggested. As the wavelengths are mainly in the red/orange region the graph indicates a bright orange-red.

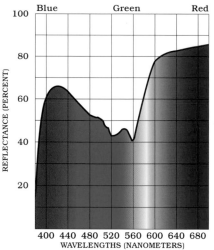

Quinacridone Violet
PV19

Quinacridone Violet reflects a high percentage of 'red' wavelengths but also reflects strongly in the 'violet' wavelength area. The smaller orange content tends to be smothered by the red element.

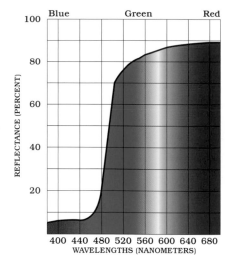

Hansa Yellow
PY3

Reflectance curves do not always read as one might expect. In the case of yellows, much of the red and green content blends within the eye to form yellow. This is added to the reflected yellow.

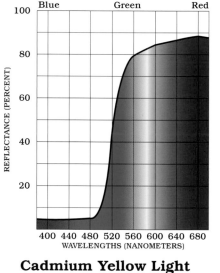

Cadmium Yellow Light
PY35

We do not have 'yellow' receptors in our eyes. Much of the yellow we see from this colour results from the red and green combining within the eye to form yellow.

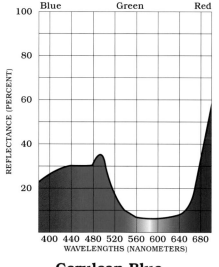

Cerulean Blue
PB36:1

In colour mixing Cerulean Blue is best described as a blue which reflects blue followed by green and violet. This description fits practical applications and led to my stylised interpretation on the 'Colour Bias Wheel'.

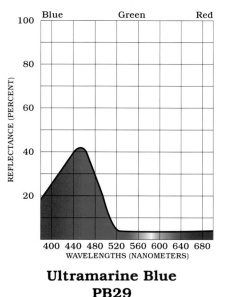

Ultramarine Blue
PB29

Ultramarine Blue reflects strongly in the 'blue' wavelength area followed by a strong violet content and a lesser green element. As the graph indicates, colours such as yellow, orange and red are absorbed.

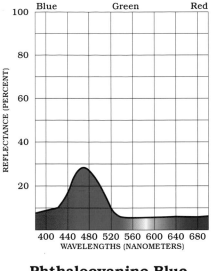

Phthalocyanine Blue
PB15

As Phthalocyanine Blue is very dark as it emerges from the tube, a little white was added to develop the colour. Without this the line would be somewhat straighter.

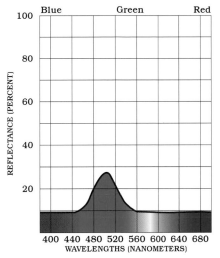

Phthalocyanine Green
PG36

Phthalocyanine Green is also a very dark colour when applied heavily, due to its transparency. Again, white was added to develop the curve.

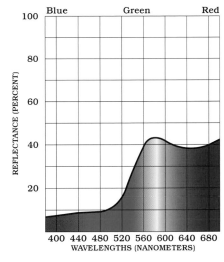

Yellow Ochre
PY43

Being an orange-yellow, Yellow Ochre has a similar reflectance curve to Cadmium Yellow Light. As it is a subdued orange-yellow it reflects a lower percentage of light across the range.

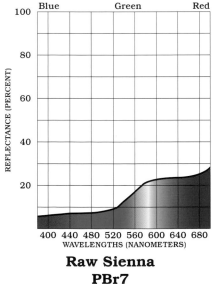

Raw Sienna
PBr7

Being a neutralised orange yellow, Raw Sienna has a similar reflectance curve to both Cadmium Yellow Light and Yellow Ochre. However, as it is darker than Yellow Ochre even less light will be reflected.

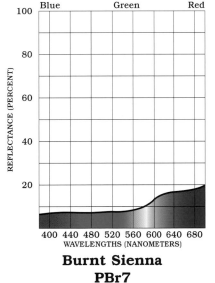

Burnt Sienna
PBr7

As the entire reflectance curve sits near the bottom of the graph a dark colour is indicated. Only small 'amounts' of each colour being reflected. A dark red with a high orange content.

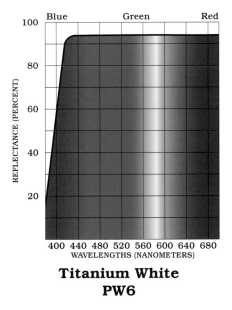

Titanium White
PW6

As the curve runs close to the top of the graph it suggests a very light colour.

As virtually the entire spectrum is reflected that colour can only be white.

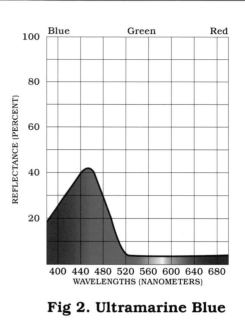

Fig 1. Burnt Sienna

Fig 2. Ultramarine Blue

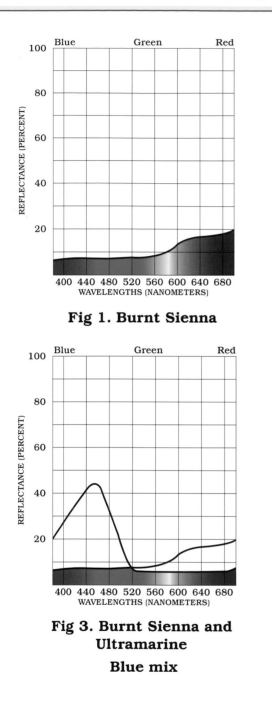

Fig 3. Burnt Sienna and
Ultramarine
Blue mix

Fig 4. The end result

The Reflectance curve grids can be superimposed in order to predict the eventual mix.

By combining the Ultramarine Blue and Burnt Sienna grids we can see that the blue will absorb most of the wavelengths normally reflected by the Burnt Sienna. As the blue reflects only a tiny 'amount' of orange, for example, it follows that it absorbs the rest. This it will do in a mix.

Conversely, the Burnt Sienna reflects only tiny 'amounts' of blue and violet. In such a mix it will absorb most of these wavelengths.

The final result is shown at fig 4. As only very small 'amounts' of light are being reflected the colour can be predicted as being close to black. As these colours are also transparent the line will drop even further. Reading such combinations in depth requires particular skill, which you may have, otherwise it is best left to the scientist.

Artist; Romey T. Brough

Artist; Jeremy Ford

However the skill of the artist or craft worker is expressed, the visual content is subject to the behaviour of light.

Not to have a basic grasp of this behaviour has to be severely limiting.

To have that understanding gives control and the possibility of producing very advanced work.

Artist; Craig Letourneau

We have studied the behaviour of light and subtractive colour mixing in some depth and, for many, it will have been hard work to take it all in.

I realise that there will be an abundance of painters and art teachers who will feel that such detailed information is superfluous and is not required by the practising artist. That such knowledge only hinders expression.

I come across this approach frequently, usually from unskilled painters who believe that they are good.

To this approach I would argue:
The painter works with materials dependent for their colour on reflected light. To depict an object (a flower for example) in a piece work is to depict reflected light.

The painter, therefore, works with reflected light to depict reflected light.

Highlights, shadows, reflections, changes caused by distance, the colour of clouds and water etc. are all aspects of light.

The painter is very poorly equipped therefore without a basic understanding of the properties of light.

It can be further argued that, instead of art students being encouraged to indulge in free 'expression' from day one, (as they so often are), they should first be taught the basics of light physics.

Eventually they may be in a position to be truly expressive in whatever form of work they choose.

A range of products have been designed and books and home study courses published to help bring about a fuller understanding of colour and technique.

We also offer paints (watercolours, oils, acrylics and gouache) watercolour brushes, colour coded mixing palettes, DVDs, children's books and workbooks.

For further information please go to:

www.schoolofcolour.com
www.schoolofcolor.com